IMAGES
of America

MONROEVILLE
THE SEARCH FOR
HARPER LEE'S MAYCOMB

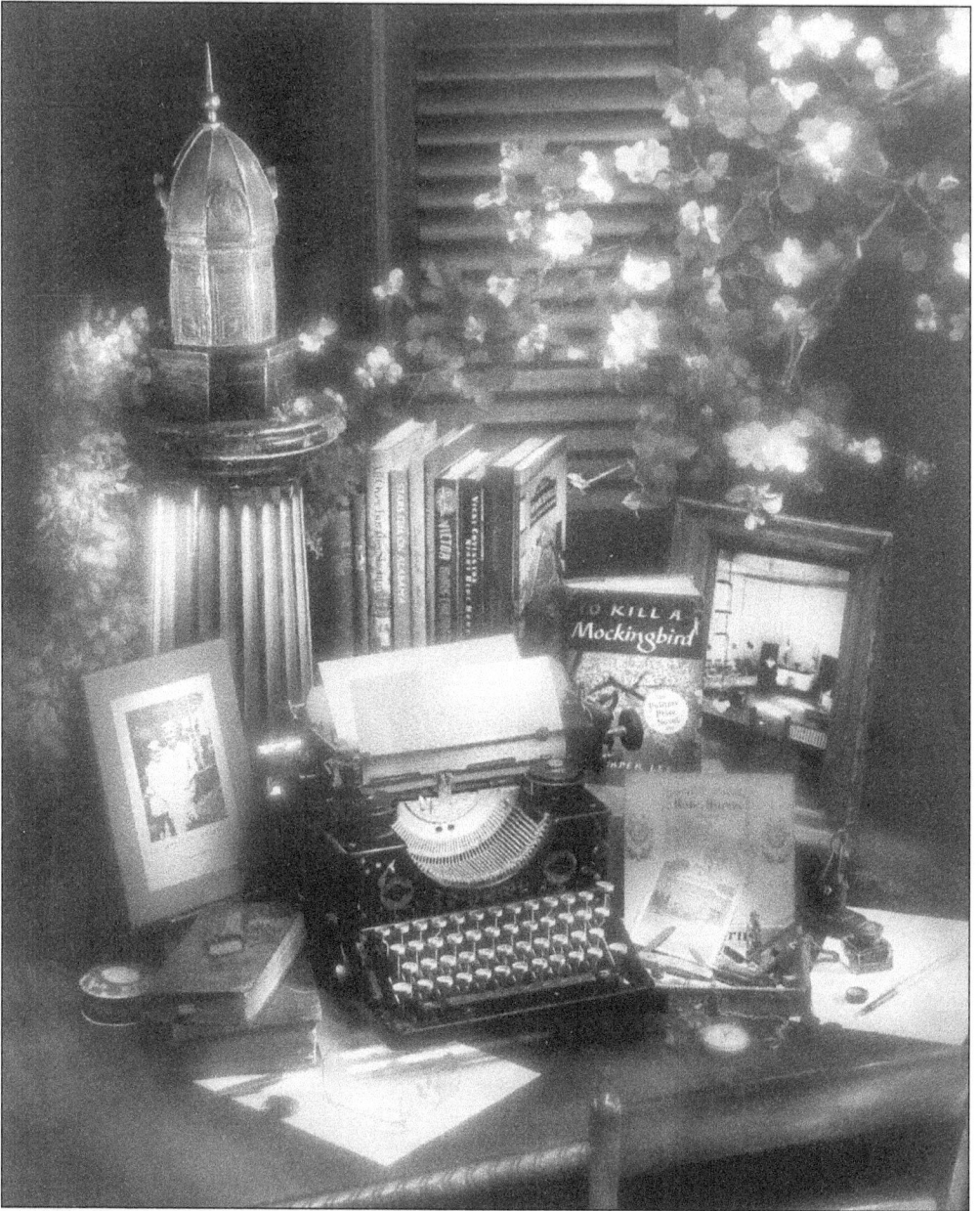

This print was produced by Monroeville's Alabama Southern Community College for the college-sponsored annual Alabama Writers Symposium, held in May. The Clock Tower Bronze by sculptor Frank Fleming is presented to each year's winner of the Harper Lee Award for Alabama's Distinguished Writer.

IMAGES
of America

MONROEVILLE
THE SEARCH FOR
HARPER LEE'S MAYCOMB

Monroe County Heritage Museums

ARCADIA
PUBLISHING

Published by Arcadia Publishing
Charleston, South Carolina

Library of Congress Catalog Card Number: Applied for.

For all general information contact Arcadia Publishing at:
Telephone 843-853-2070
Fax 843-853-0044
E-Mail sales@arcadiapublishing.com
For customer service and orders:
Toll-Free 1-888-313-2556

Visit us on the Internet at www.arcadiapublishing.com

CONTENTS

Introduction 7

1. Scout 9

2. The Neighbors 23

3. The Mysterious Neighbor 29

4. School 37

5. Calpurnia 45

6. Town 53

7. Courthouse 91

8. Museum 117

Photo Credits 126

Acknowledgments 127

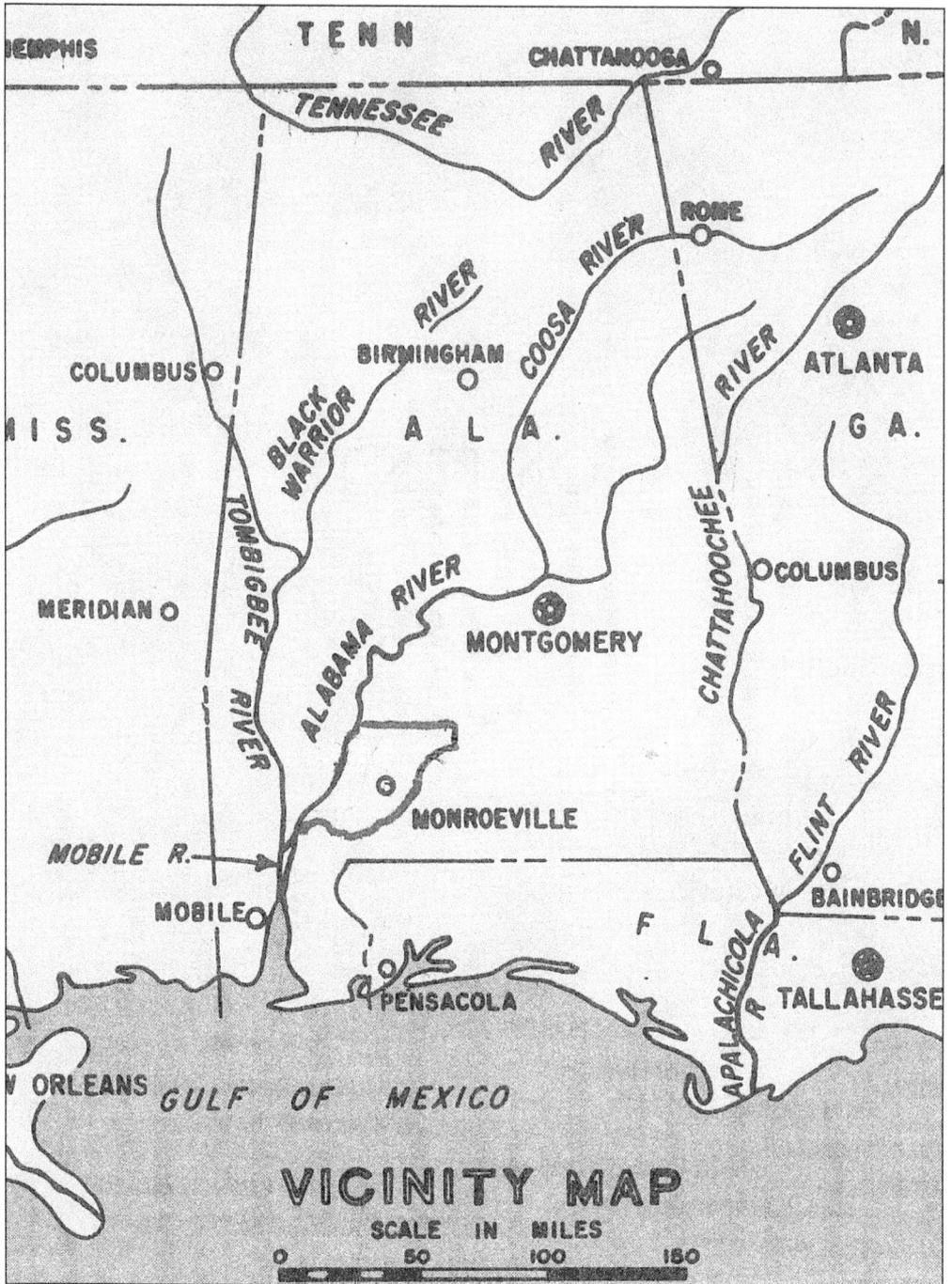

VICINITY MAP
SCALE IN MILES

0 50 100 150

INTRODUCTION

Monroe County is in the southern part of the state of Alabama, bounded on the west by the Alabama River. The Alabama River flows from Montgomery, the state's capital, to Mobile, the state's sole deep-water port. Monroe County is situated half-way between these cities.

For many years, transportation centered on the river, beginning with the Native Americans traveling by canoe and continuing to the steamboat era of the nineteenth century. The principal product of Alabama was cotton, which was shipped to Mobile from the many plantations along the river. Supplies for the plantations were delivered to the steamboat landings. Steamboat travel ended when the railroads became more accessible in the early 1900s.

In the 1930s, train travel continued in Monroe County, county roads were improved, and a bus station operated in Monroeville. Today, an interstate highway is as close as 20 miles, yet the town is two hours by car from any major city. This isolation helps preserve Monroeville's small-town atmosphere.

For 39 years, visitors have come to Monroeville in search of the Maycomb described in Harper Lee's *To Kill a Mockingbird*, leaving without even a glimpse into Scout's world. The townspeople were not eager to answer any questions about the book or its author, Nelle Harper Lee. They strictly guarded her privacy and their own.

The courtroom, made famous by the 1962 movie, was usually closed since the old courthouse was only open one or two afternoons each week. Gone was the 1930s look of old Monroeville. Streets had been widened, storefronts added, and fast food restaurants built where the 1930 town limits once were.

The opening of the Old Courthouse Museum in 1991 under the direction of Kathy McCoy, a newcomer to town (originally from Kentucky), gave visitors some hope of catching the glimpse they so desired. The museum became the focus for these tourists to Monroeville. Now, the Old Courthouse is open six days a week and contains permanent exhibits on the two most famous Monroeville residents—Nelle Harper Lee and Truman Capote, as well as rotating exhibits that convey the history of Monroe County and the South.

This book, *Monroeville: The Search for Harper Lee's Maycomb*, was born in response to the many questions asked by the steady stream of visitors. Some of these visitors are teachers or lawyers making the pilgrimage to Atticus' courtroom, some say *To Kill a Mockingbird* is their favorite book of all time, some just want to see a little bit of Maycomb, and some look for Truman Capote's roots and inspirations.

Every year in May, those attending the museum's production of *To Kill a Mockingbird* are easily transported into the fictional, small town called Maycomb and can watch Scout's life come alive. The Mockingbird Players is an amateur, all-volunteer group dedicated to presenting an authentic production of the two-act play adapted by Christopher Sergal. All the actors are locals, lending a truth to the Monroe County dialects and mannerisms. Playgoers believe Miss Maudie when she describes Atticus. They even boo Bob Ewell as he leaves the courtroom. They leave the play and Monroeville with an eerie feeling of having been to Maycomb.

The town center is still the "Square," dominated by the Monroe County Courthouses, old and new. It is surrounded by the same store buildings Nelle Harper Lee and Truman Capote grew up with. Their neighborhood looks different now, but a little imagination is all it takes to find Maycomb here.

We invite you to find Maycomb in this collection of photos—old and new—of the people and places of Monroeville.

One

SCOUT

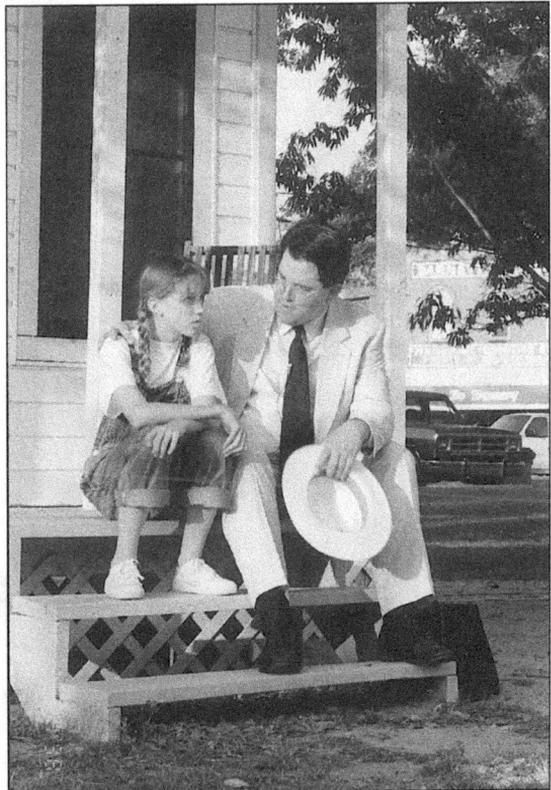

Scout receives Atticus' words of
wisdom. In 1998, Andrea Godwin
played Scout and Jimmy Blackman
played Atticus in the annual
production of *To Kill a Mockingbird*. The
Mockingbird Players and Kathy McCoy,
director of the Monroe County Heritage
Museums, bring the story to life
each May in a production at the Old
Courthouse Museum in Monroeville.

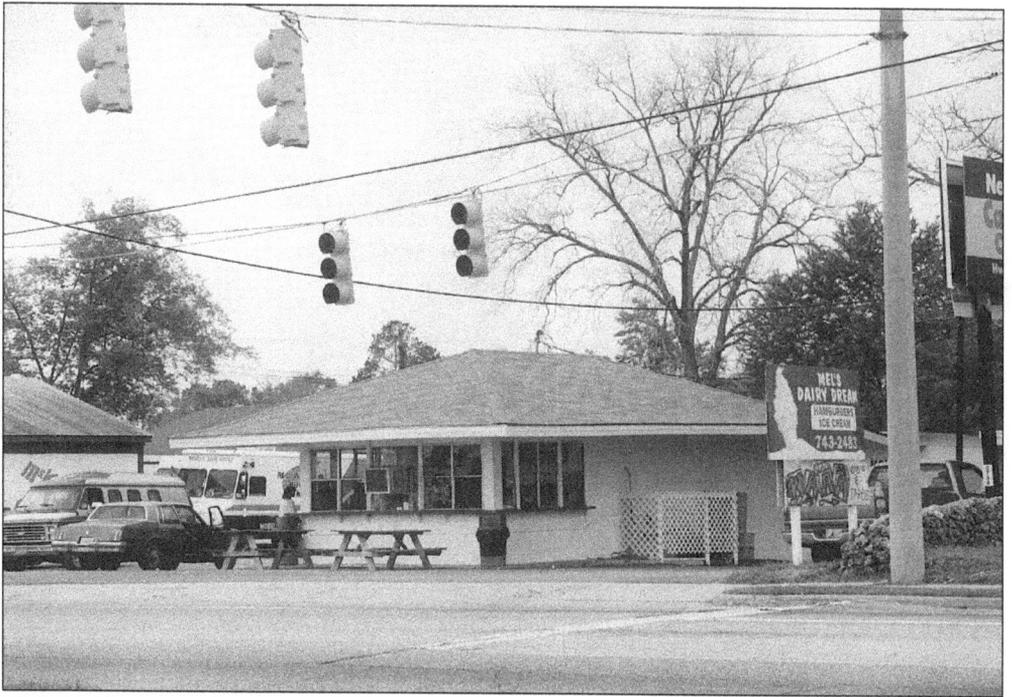

Mel's Dairy Dream is located on the site of the Lee home. Harper Lee was born in 1926 and lived her whole life in the house on South Alabama Avenue until she left for college in 1944. In 1952, Mr. Lee and his oldest daughter, Alice, moved about six blocks west near the new high school. His wife, Frances, and son Ed had died in 1951, and the two younger daughters, Louise and Nelle Harper, had moved away. The house on South Alabama Avenue was later torn down to make way for Mel's.

The Lees' home is the middle house pictured on the left side of the street. To reach the town square, one would travel up South Alabama Avenue, shown here.

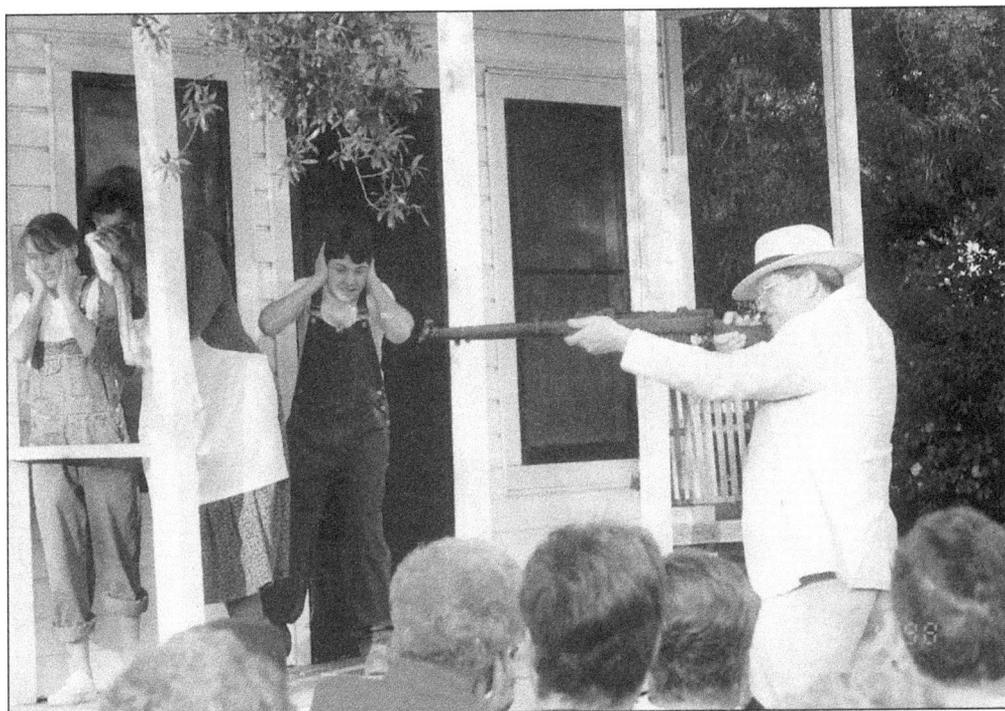

Here, Atticus (Jimmy Blackman) shoots the mad dog in Act I of the annual production of *To Kill a Mockingbird*.

"I never saw Mr. Lee with a gun," recalls Mr. Blass, "and I don't think he ever went hunting or did things like that. But a man who worked with Mr. Lee at the *Monroe Journal*, Mr. Ed Salter, did. I had occasion to go dove shooting with him one morning before school. He went out hunting with us in his black dress shoes, his suit, his vest, and his dress hat. That just seemed to be the way that age man did in that time. They were always fully dressed. He shot many doves that day, and afterwards we took him back to town, and he went into his office to work."

In the 1930s, several cases of mad dogs were reported. The *Monroe Journal* printed articles warning the public about rabies. Two adults and two children were reported in the May 24, 1934 newspaper, taking rabies treatment. The article stated, "This could be avoided if the vaccine was given to dogs." The June 28, 1934 issue ran a story entitled "Mad Dog Warning Issued."

Walter Nicholas, a dentist in Greenville, recalls one mad dog incident in Monroeville. He spent summers visiting his aunts' home across the street from Harper Lee. One summer when he was here, his Aunt Velma's dog contracted rabies. As this was the favorite dog of the neighborhood, the destruction of the dog was traumatic for all the children, including Nelle. (Walter's Aunt Maggie Dees was the secretary to A.C. Lee. His Aunt Velma Dees was a school teacher who tutored Nelle Harper Lee and Truman Capote during the summer months.)

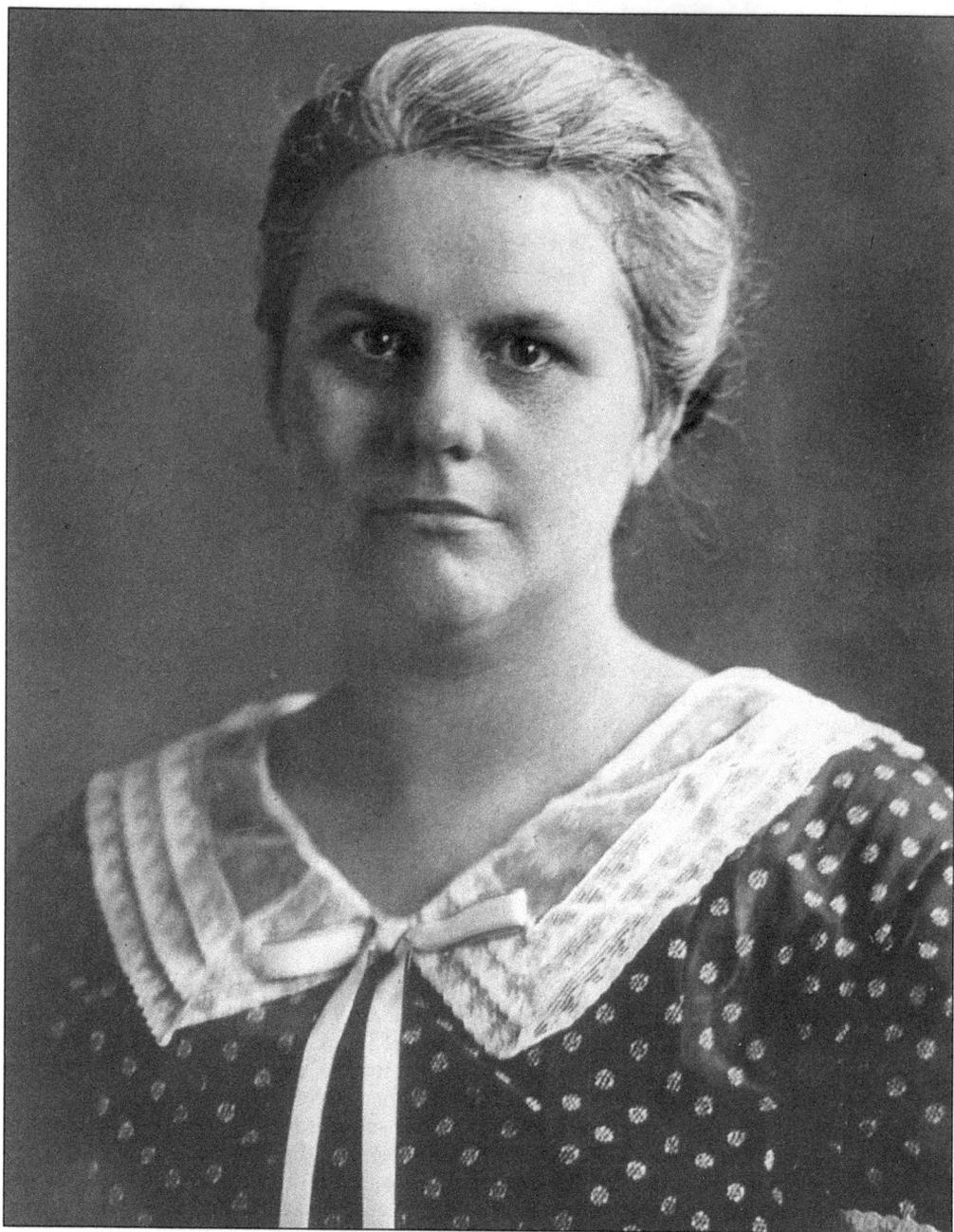

Frances Cunningham Finch Lee, Nelle Harper's mother, was an accomplished pianist. She died in 1951, the same year her son Ed died. Of her three daughters, Alice continues to live in Monroeville and practice law; Louise lives in Eufaula, Alabama, and Nelle Harper has an apartment in New York City, but comes home for visits.

"Nelle's mother would be sitting in a swing on their front porch every day when I carried her the newspaper," remembers A.B. Blass Jr., local businessman and childhood friend of Nelle. "She always had on a freshly laundered cotton dress, and I would get off my bike and hand her the newspaper, and she would say, 'You're certainly a nice young man.'"

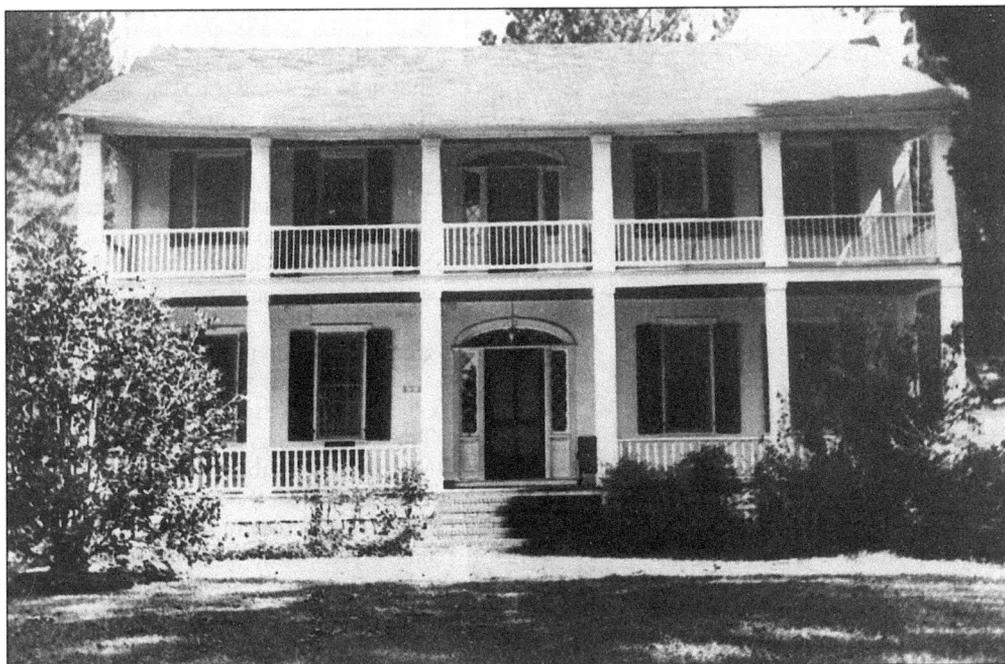

Mrs. Lee's mother's family, the Williamses, owned a plantation on the Alabama River. The town, Finchburg, is located 20 miles northwest of Monroeville. Mrs. Lee's father, J.C. Finch, was postmaster when young A.C. Lee worked as bookkeeper for a lumber mill there. The home at Finchburg has remained in the family.

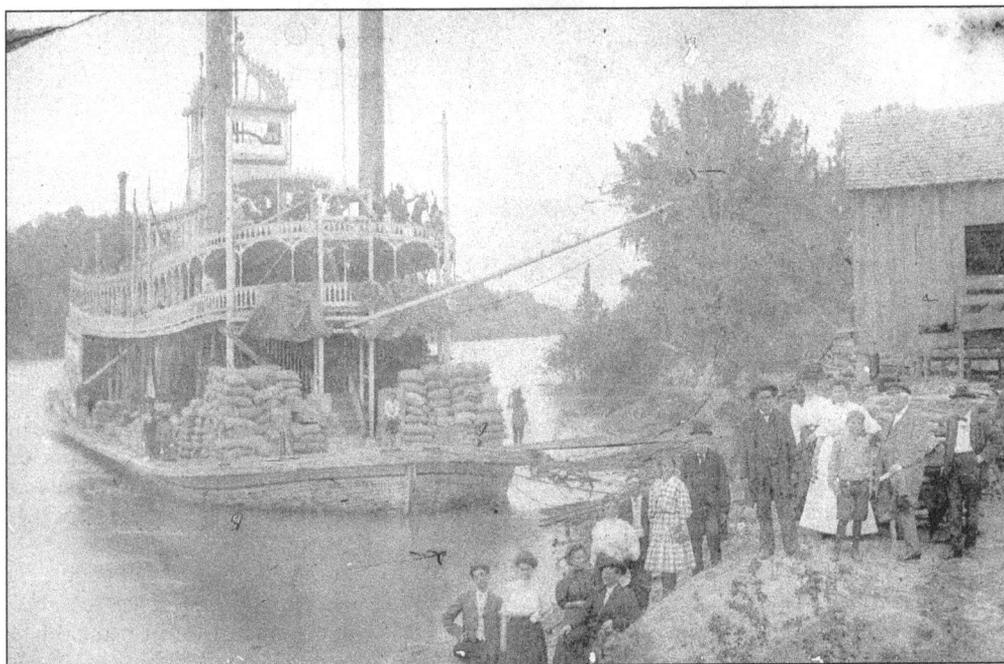

Finchburg had a steamboat landing at which cotton from the plantation was loaded for market.

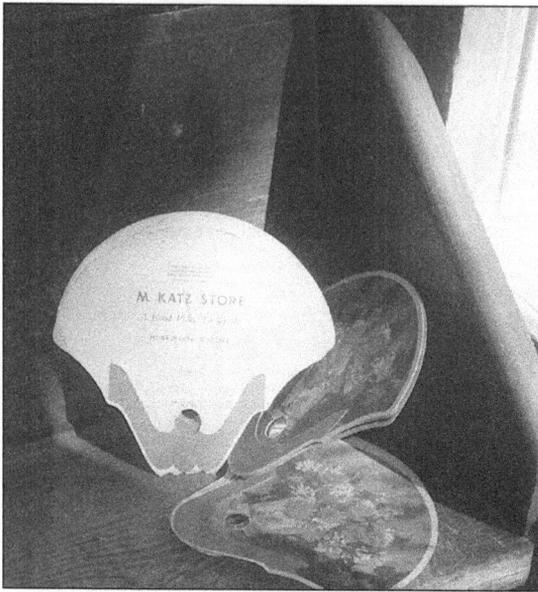

Bell's Landing, a steamboat stop north of Finchburg, was typical of the towns that grew up along the Alabama River during the steamboat era. Three Protestant churches were established inland from Bell's Landing at Tinela—the Baptist, the Presbyterian, and the Methodist-Episcopal Church South (as it was known before the split of the denominations). The small chapels for each were filled with graceful wooden pews, carved pulpits, and occasionally an ornate pump organ (such as the one shown below). These furnishings were shipped from Mobile by steamboat to the landings.

"We were Methodists, but we went to all three churches," said Jane Hybart Rosborough, who lived in Tinela, near Bell's Landing.

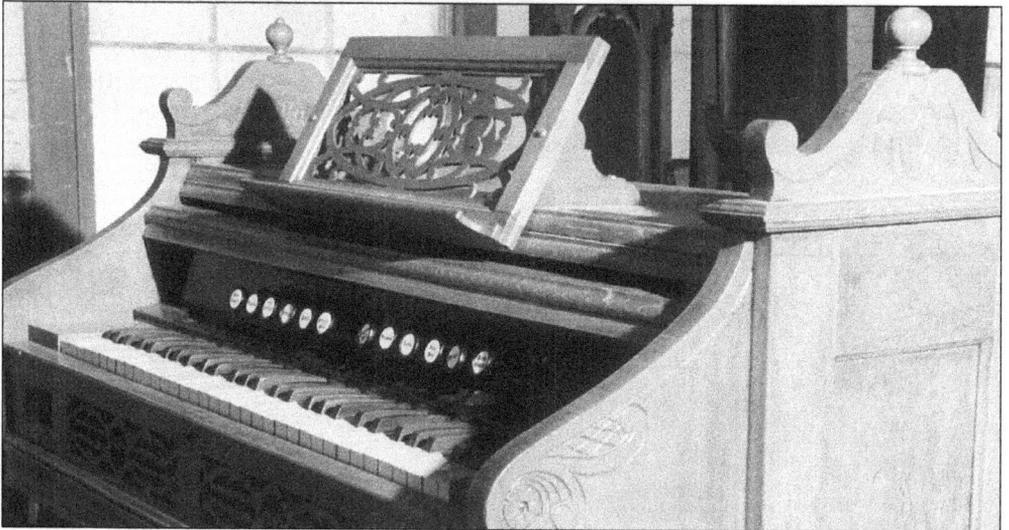

Amasa Coleman Lee, pictured on the facing page seated third from the right, was born in 1880 and grew up in northwest Florida. He came to Finchburg in 1905, where he met and married Frances Finch. They moved to Monroeville in 1913. He was a bookkeeper, lawyer, newspaper editor, and state legislator.

"Mr. Lee played golf regularly. We had a good golf course even back then," recalls George Thomas Jones, retired businessman and local historian. "I caddied for Mr. Lee for 15 cents for the first round and 10 cents for the second. He used a small cloth bag with only a few clubs, and had an unusual golf stance and swing—and my wife played with Nelle for years. Golf is big in Monroeville."

"People called Mr. Lee, 'Coley,' " says A.B. Blass Jr. "In Kiwanis, we had to call people by their given name. We were told to call him 'Coley.' You can imagine how hard it was for a boy right out of college to call this man whom I had looked up to all my life by his first name. I had to call him 'Coley'; either that, or I had to pay a fine of a quarter. It wound up costing me about a dollar a week. I couldn't call him anything but Mr. Lee."

14

A.C. Lee was an active member of the Monroeville community.

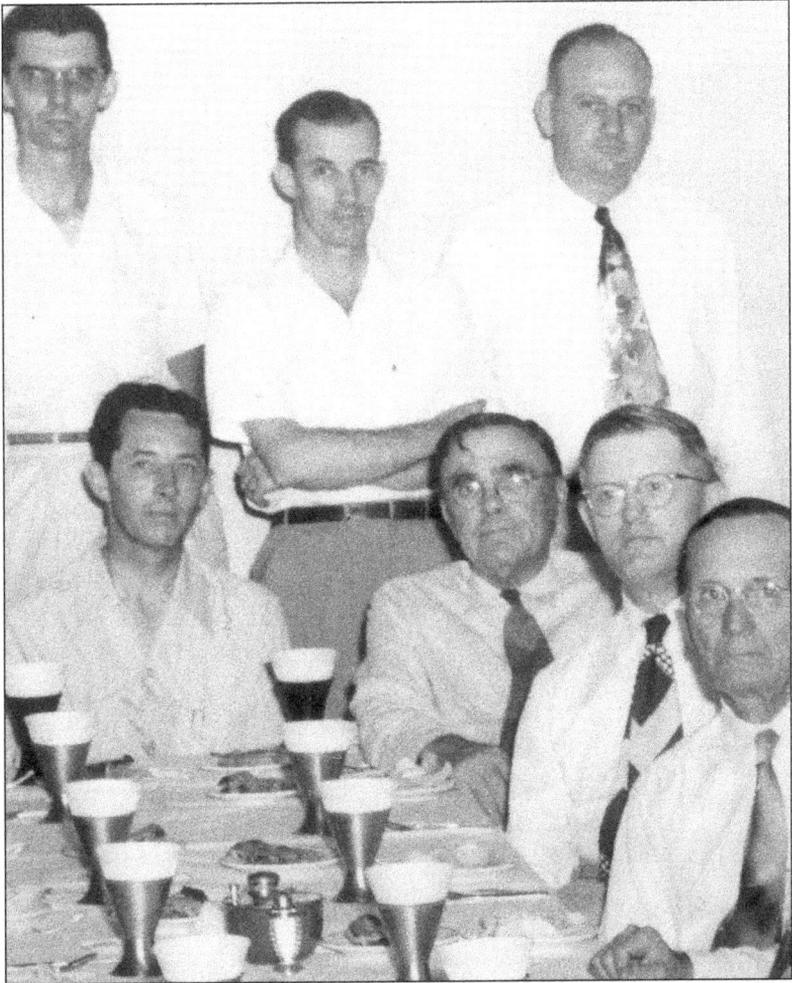

Mr. Blass recalls, "When Gregory Peck accepted the Oscar for his role in the movie, he had in his hand A.C. Lee's watch, which Harper Lee had given to him when her father died. They say that after the book came out and was so popular, people would ask Mr. Lee to sign the book, and he always signed it 'Atticus.'

"Charles Kiselyak came to Monroeville to work on a documentary in 1997," Mr. Blass added. "It's called 'Fearful Symmetry,' and is included with the Universal Studios' re-released, wide screen version of the movie, *To Kill a Mockingbird*. No changes were made to the photography of the original movie. The documentary was financed by Oprah Winfrey, because she said she admired the book.

"Mr. Kiselyak came to my house to interview me for the documentary," Mr. Blass continued. "Charles said, 'Nelle gave me nearly a week. I understand that's rare.' I said, 'It's more than rare.'

"She went around with him and went to everybody's houses to be interviewed, except mine. He said, 'Nelle said she didn't need to come to your house,' and I sort of felt hurt. He said, 'No. She knows you're not going to say anything she doesn't go along with.'

"Anyway, Mr. Kiselyak said, 'I got to see Gregory Peck and spend the day with him.' [He had just come from California.] 'A sad thing,' Kiselyak said, 'Gregory Peck was walking through the airport and he ran into somebody. When he stopped to look at his watch, it was gone. He said he just could hardly stand the fact that he had lost Atticus' watch.' "

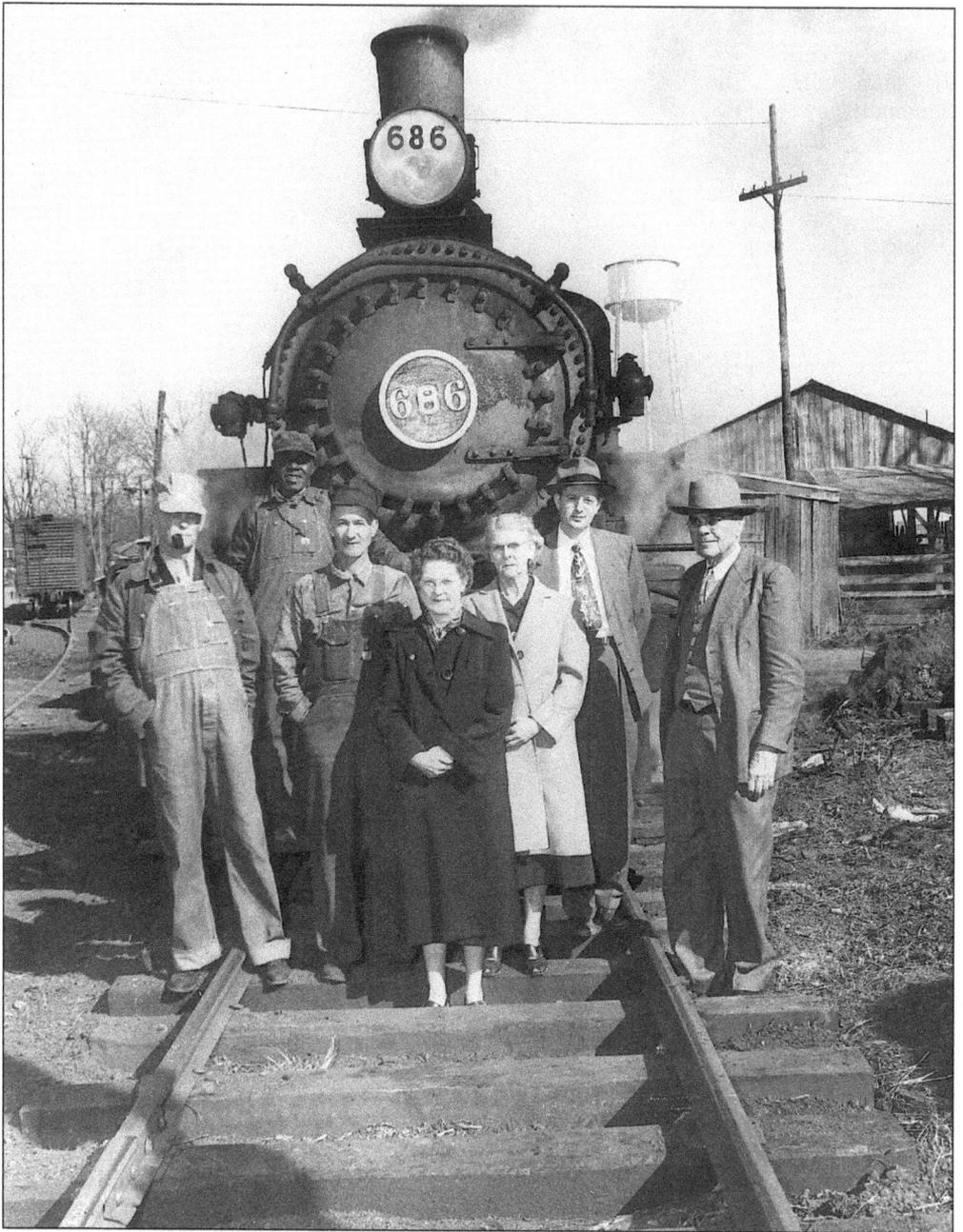

A.C. Lee is shown far right with the old 686 steam engine of Monroeville's Manistee and Repton Railroad. The photo was taken on the engine's last day of operation in 1952, before being replaced by a modern successor, the diesel engine. Barnett, Bugg and Lee, Attorneys at Law, purchased the stock of this railroad company in 1913, and Lee was the general manager until his death in 1962. Pictured from left to right are, Rob Lee (engineer), Abe Cunningham (flagman), J.P. McDonald (fireman), Miss Annie Straughn (Western Union operator), Mrs. Bessie Stacey (station agent), John Barnett (owner), and Mr. Lee.

16

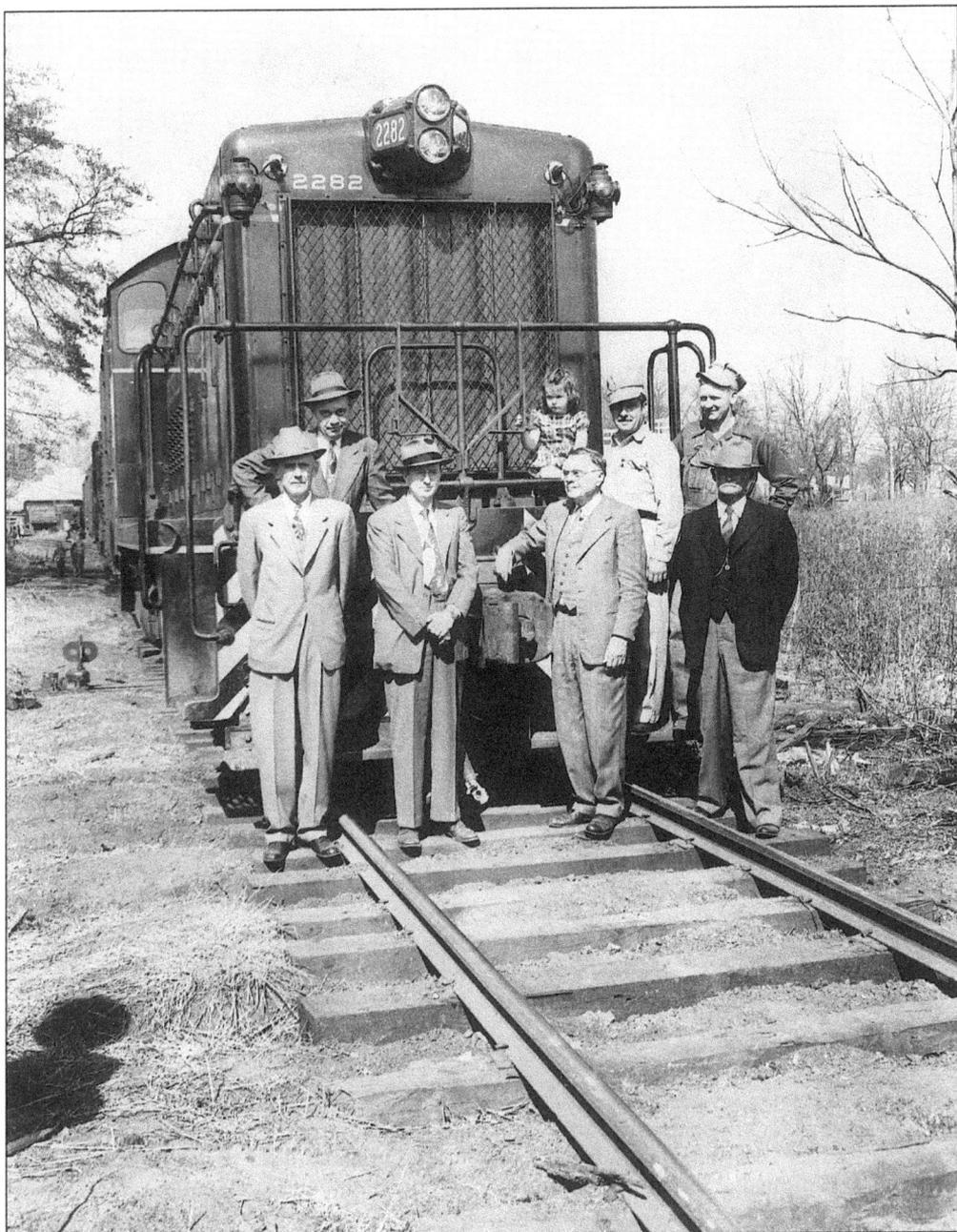

Mr. Lee is standing on the track, second from the right, with the crew and staff of the M & R Railroad Company, in front of the diesel engine that replaced the old steam engine 686. Pictured from left to right are, Claud Day (L & N commercial agent), R.R. Mayhall (L & N assistant trainmaster), John Barnett (owner), A.C. Lee and his granddaughter Molly Lee (seated on the engine), Mr. Johnson (L & N engineer), Mr. Ptomey (L & N conductor), and Rob Lee (engineer).

Nelle Harper Lee was the harried editor in this photograph in the 1947 University of Alabama yearbook. Harper Lee edited the *Rammer Jammer* during the 1946–47 academic year. Harper Lee went to Huntingdon College in Montgomery for her freshman year of college (1944–45).

A.B. Blass Jr.'s girlfriend also attended Huntingdon College, and Blass remembers traveling to Huntingdon one weekend to pick her up. "I had been going with the same girl since the 8th or 9th grade, and later was married to her for forty-three years. That day, Nelle saw my car come up, and she proceeded to put her suitcase in my car (and I'm there to pick up my girl who I'd not seen for a long time). And I told her, 'Nelle, I'm sorry, but I'm here to take Sarann home.' (There was another Sara Ann who married Nelle's brother, Ed.) She said, 'Well, that doesn't matter to me. There's plenty of room.'

"I said, 'But Nelle, I haven't seen her in a long time. I may not go directly home.' She said, 'So what?' I said, 'So what? Nelle, you've never gone with anybody. You don't know. I just have to talk to her some.' And she said, 'Well, I'm going.' And I said, 'No, you're not.' I took the

suitcase and put it out on the ground. And she got really mad at me. She said, 'When you go to the University, I'll have you blackballed. You won't be able to get into any fraternity, you won't be able to do anything.'

"So Nelle didn't speak to me for about a year after this!"

Nelle then transferred to the University of Alabama in Tuscaloosa. There, she wrote a column in the *Crimson-White* (the college newspaper) during the summer term 1946. In the school year, Fall 1946 through Spring 1947, she was the editor of the college humor magazine, *The Rammer Jammer*.

The *Crimson-White* ran a story on October 8, 1946, entitled "Little Nelle Heads Ram, Maps Lee's Strategy." The article begins, "In case you've seen an intellectual looking young lady cruising down University avenue toward Pug's dressed in tan, laden with law books, sleepy and in a hurry and wondered who she is—she's Nelle Harper Lee.

"Miss Lee is editor of the *Rammer Jammer* (if you've never heard of the *Rammer Jammer*, it's not Miss Lee's fault), a law student, a Chi Omega, a writer, a Triangle member, a chain smoker, and a witty conversationalist." The article ends, "Lawyer Lee will spend her future in Monroeville. As for literary aspirations she says, 'I shall probably write a book some day. They all do.' "

Jane Hybart Rosborough, native of Monroe County, lived in Tuscaloosa at this time, and remembers that all of the students looked forward to the latest *Rammer Jammer* issues.

Nelle left the University for New York after Spring Term 1949. There she worked as an airline reservationist, wrote in her spare time, and came home often for visits.

Riley Kelly, Monroe County resident, author and friend of Miss Lee, remembers Nelle's returns to Monroeville. "Nelle would come home while she was writing the book and sit on that porch of theirs and tell us about the editors in New York. They couldn't believe the stories and situations in the book were really the way things were—and are—down here. She would have them call Alice or A.C. to verify that something she wrote really could have happened that way down here."

After its publication in 1960, the book was chosen for three American book clubs and the British Book Society, and stayed on the bestseller list for months. In May of 1961, it won the Pulitzer Prize for fiction. The first paperback edition of the book was published in 1962 by Popular Library, which sold more than three million copies of the paperback in the same year. The book has been translated into more than 30 languages and has never been out of print.

In 1960, the movie rights were bought, and the movie was released in 1962. It won three Academy Awards: an Oscar for Gregory Peck as Best Actor; Best Screen Play; and Best Art Design.

Ms. Lee's reaction to the awards was reported in the April 10, 1963 edition of the *Montgomery Advertiser*. About Peck's Oscar award, "I am extremely happy that he won the award," she said, "I was very much surprised in terms of the competition." In reaction to the other awards: "Both were richly deserved and very important awards to me," she said.

Harper Lee and Gregory Peck are shown in the Wee Diner in 1962 during his visit to Monroeville. Mr. Peck wrote a letter to Frank Meigs, owner of the Wee Diner: "Thank you for your splendid meals while my wife and I were in Monroeville. We intend to spread the fame of your incredible t-bone steaks." (Frank Meigs's daughter, Sally Meigs Montgomery, plays Miss Maudie in the annual production of *To Kill a Mockingbird*.)

In 1960, the first edition of *To Kill a Mockingbird* came out with this photo taken by Truman Capote on the back cover of the dust jacket.

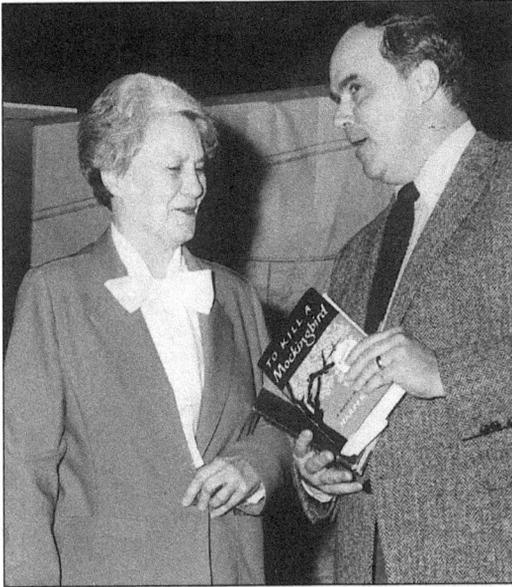

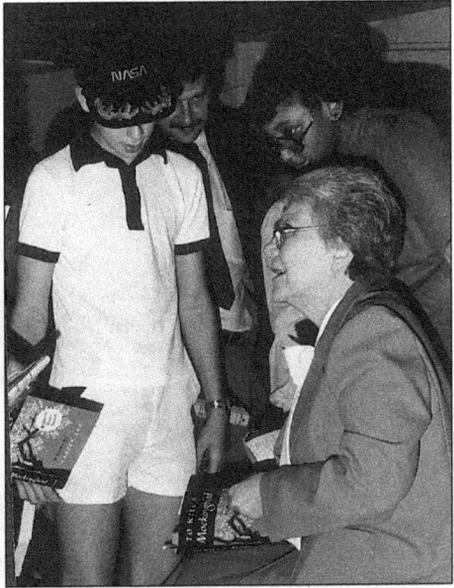

Harper Lee is shown at left with H.H. "Hank" Conner Jr., at the Alabama History and Heritage Festival in Eufaula, Alabama, in 1983, and at right, autographing her books for students attending the festival. Ms. Lee presented a paper on Alabama's history entitled "Romance and High Adventure" at the festival, which was published in the 1985 *An Alabama Humanities Reader: Essays and Stories From the 1983 Alabama History and Heritage Festival.* Three short essays had appeared in magazines earlier: "Love—In Other Words," *Vogue*, April 15, 1961; "Christmas to Me," *McCall's*, December 1961; "When Children Discover America," *McCall's*, August 1964.

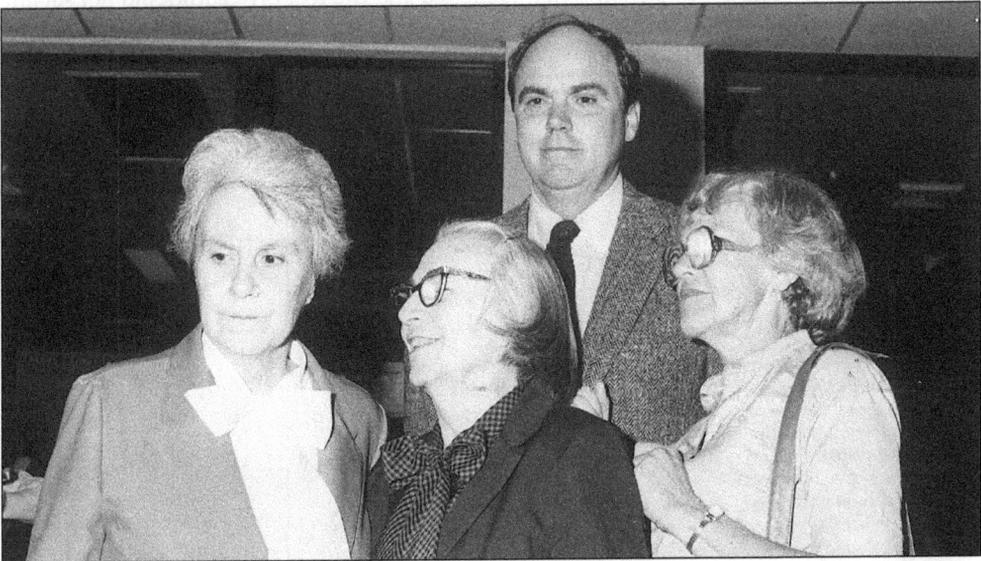

Harper Lee is shown at the festival, one of the few public appearances she has made since 1962, with her sisters Alice Lee (center) and Louise Conner (right), and nephew Hank Conner.

"Harper Lee is not the recluse some reporters make her out to be," says friend A.B. Blass Jr. "When she is in Monroeville, she goes about town to the shops, restaurants, and to church and social gatherings with friends."

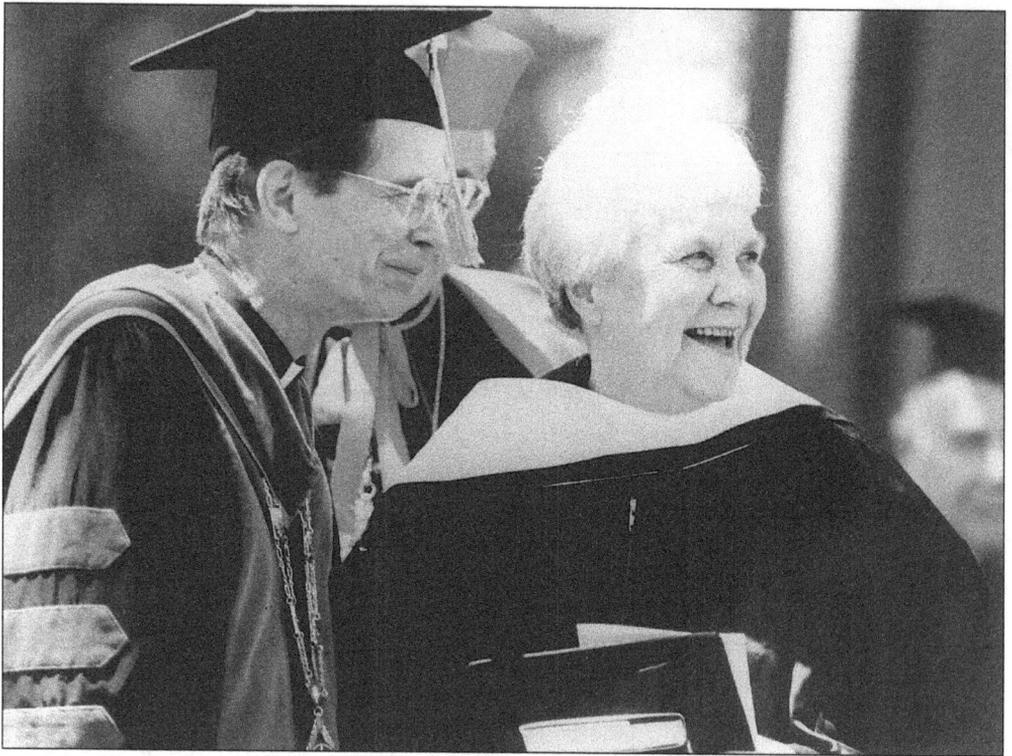

In 1997, Harper Lee received an honorary Doctor of Humane Letters from Spring Hill College in Mobile, Alabama. The Associated Press published a report of it in the *Montgomery Advertiser* on May 13, 1997: "The appearance was not publicized and the reclusive author did not submit to any interviews, but Harper Lee graciously—and quietly—accepted an honorary degree and a standing ovation at Spring Hill College's graduation."

COMMENCEMENT 1997
HONORARY DEGREE CANDIDATES

HARPER LEE
Doctor of Humane Letters

Presented by: Margaret Davis, Ph.D.
 Assistant Professor, English

You were born April 28, 1926, in Monroeville, Alabama, blessed with an imagination and sensitivity that would create one of the enduring masterpieces of the twentieth century. Your Pulitzer-Prize winning *To Kill a Mockingbird*, about the Southern cultural ironies of the mid-30s and the families who sustained tragedy and achieved grace, has burned the souls of generations of readers.

With 30 million copies in print, with translations that circle the globe, your words continue to enlighten our lives; for your characters' struggle for equality and compassion is one we must be engaged in, a struggle that will always challenge our conscience, and always educate our hearts.

For your lyrical elegance, your portrayal of human strength and wisdom, Spring Hill College is pleased to bestow on you this day the degree of **Doctor of Humane Letters**, *honoris causa*.

In 1962, she was the first woman since 1942, to receive an honorary doctorate from Mount Holyoke College, South Hadley, Massachusetts.

22

Two

THE NEIGHBORS

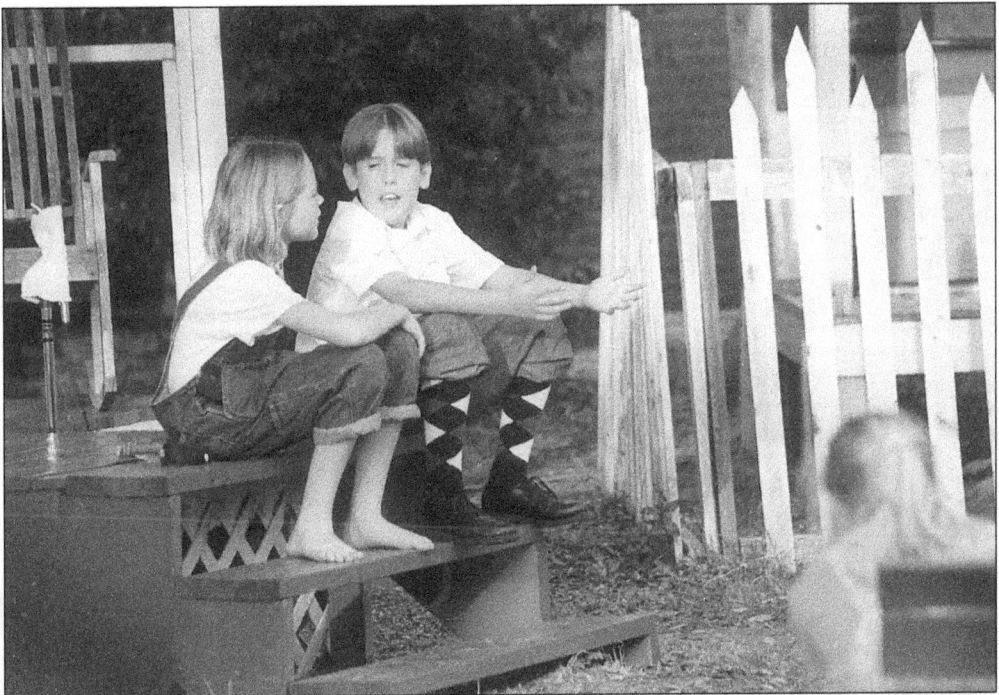

Scout and Dill are pictured here on the set in the annual production of the play (Haller Smith and Shane Doughtery). Scout's friend Dill is believed to be Harper Lee's childhood friend and next door neighbor, Truman Capote. In an interview published in the *Birmingham News*, September 30, 1977, Truman's aunt, Mary Ida Carter, said, "That's Truman, for sure. And Nelle's right about the size. She was bigger than Truman. Lots bigger."

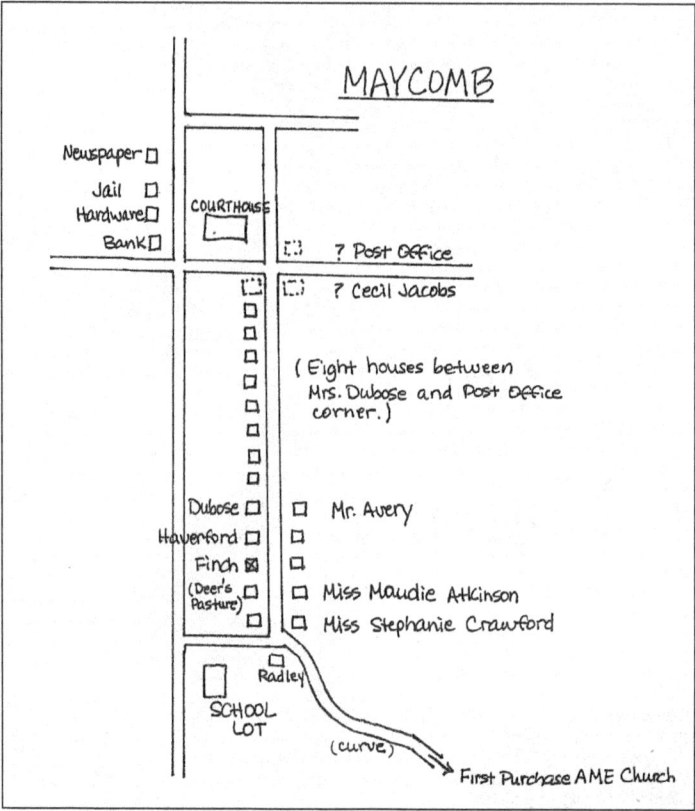

MAYCOMB

Newspaper □
Jail □
Hardware □ COURTHOUSE
Bank □

[.] ? Post Office

[.] [.] ? Cecil Jacobs

(Eight houses between
Mrs. Dubose and Post Office
corner.)

Dubose □ □ Mr. Avery
Haverford □ □
Finch ⊠ □
(Deer's □ □ Miss Maudie Atkinson
Pasture) □ □ Miss Stephanie Crawford

□ Radley
SCHOOL
LOT
(curve) First Purchase AME Church

This is a map of the Finch's neighborhood, interpreted from the book. A 1930 Monroeville map (see p. 125) is included in a self-guided walking tour brochure available at the Old Courthouse Museum.

The historic marker in this photo was erected by the Monroe County Heritage Museums on the site of Truman Capote's childhood home. This home was located next to the Lees' home, where Mel's Dairy Dream now stands.

The Faulks, three single sisters and a bachelor brother, lived in a home next door to the Lees. They took in Truman's mother and her siblings (three sisters and a brother) after their parents died. The Faulks were the cousins of their father. After Truman was born in New Orleans in 1924, his mother brought him back to these cousins who had raised her. She eventually moved to New York City and married Joe Capote, who adopted Truman. Truman was sent to boarding school, spent summers in Monroeville, and continued to visit here throughout his life. He died in 1984.

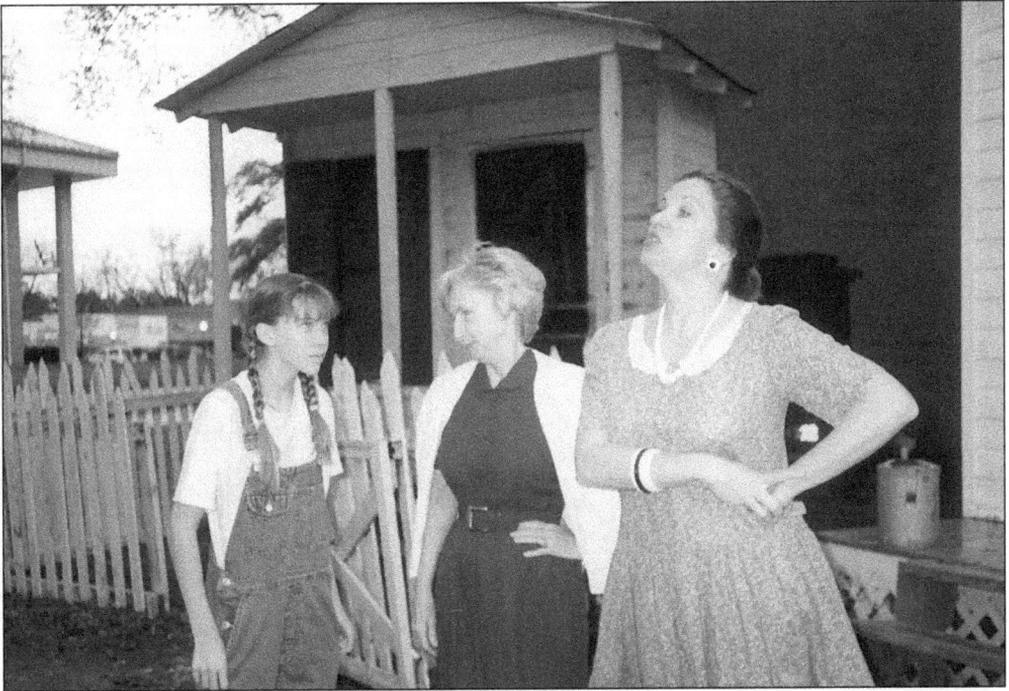

Miss Stephanie Crawford, played by Dawn Hare (right), explains Maycomb family "streaks" to Miss Maudie Atkinson, played by Sally Montgomery (center), and Scout, played by Andrea Godwin (left).

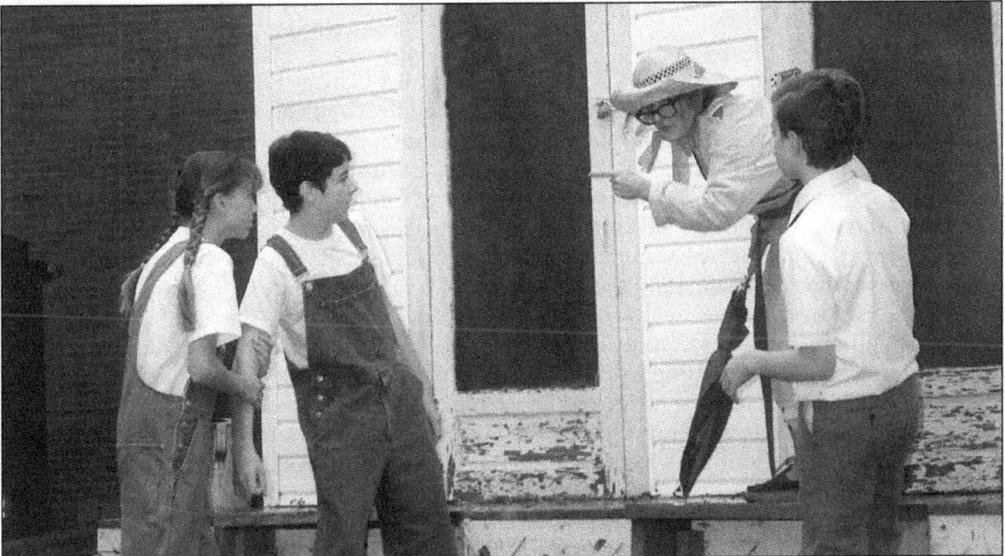

Mrs. Henry Lafayette Dubose, played by Sherrie McKenzie (on the porch), vehemently tells the kids what she thinks about Atticus' defense of Tom Robinson. Scout (Andrea Godwin), Jem (Joey Grabill), and Dill (Watson Black) shrink from her fury.

Left: "Sook" Faulk was one of Truman's cousins. *Right:* Truman is shown all dressed up as a young boy in the Faulk's garden. In the background is the Watson home; Mrs. G.W. Watson took in "boarders." Gladys Watson Burkett, a local English teacher, grew up there.

Dr. Margaret Murphy, local Alabama Southern Community College English Department Head, conducted the 1988 Capote Seminar, held in Monroeville. "Truman Capote's cousin, 'Sook,' had an illness during her childhood which affected her some, but she managed the entire Faulk household," explained Dr. Murphy. (Her doctor, Dr. Eddins, who still lives here, remembers sending her morphine dose to her when she needed it.) "Truman spent a great deal of time with her and portrays her as the one who made all the fruitcakes in 'A Christmas Memory.' "

"Sook's sister, Jenny, owned V.H. & C.E. Faulk, a millinery shop on the Square, called 'Miss Jenny's' by everyone. (The building was later used by Morgan Furniture Company.) She and her sister Callie ran the store together.

"Truman always had fancy clothes, unlike the other kids in town," says Dr. Murphy. "When the children would go swimming in the creek, Truman had a full Hawaiian bathing suit and jacket. One of our teachers said he looked like a 'bird of paradise in a flock of crows.' "

Truman Persons, as he was known then, was very agile and was noted for turning cartwheels down the sidewalk in front of the house. "Since he was small," says Dr. Murphy, "some of the larger kids would pick on him. As a result, when someone big would try to pick on him, he would turn a cartwheel and ask the bully if he could turn one. This confused the bully, and the next thing you knew, Truman was able to avoid a fight because he had diverted the attention of the bully."

The old Faulk house burned in 1940. Local resident George Thomas Jones, remembers that fire. "It was one of the coldest spells we've ever had. We'd had several days of sub-zero weather,

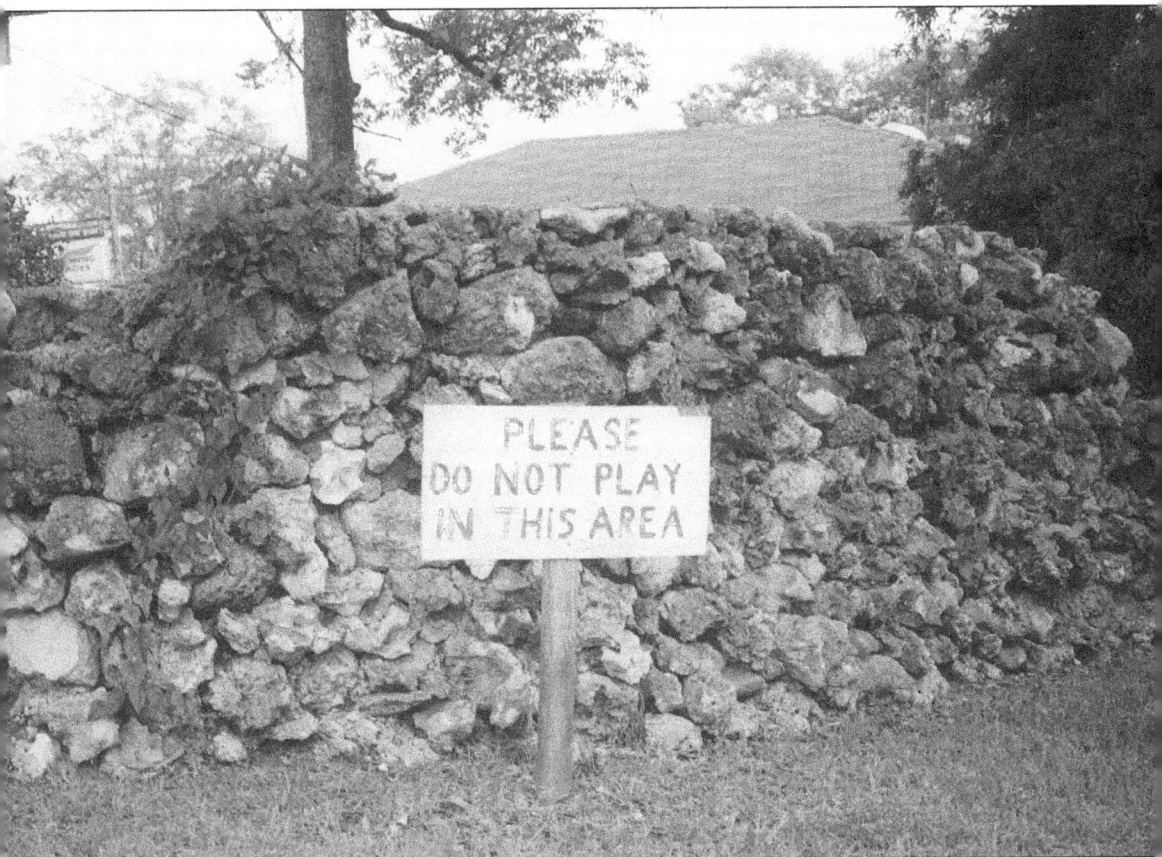

Pictured here are the remains of the Faulk's rock-walled garden; the old fish pool mentioned in Chapter Six of *To Kill a Mockingbird* is behind this wall.

and the night of the fire it was 11 degrees, fahrenheit. John Coxwell was a volunteer fireman and told me that he'd gotten wet in the spray from the fire hoses, so, when he got home that night, he took his coat off on the porch. It was so cold, it stood up by itself—and stayed that way for three days!"

The Monroeville Fire Department has always depended on volunteers. In the early years, though, the fire trucks were not dependable, especially in cold weather. "I remember one house fire," says Mr. Jones. "It was close to the fire station. The truck wouldn't crank, but there was a carnival set up next to the station, so they got the elephant to push the truck over to the fire."

The Lees' neighborhood was typical of small-town life all over the South. Everyone knew everybody, and everyone knew everybody else's business. No one bothered to lock their doors when they went "up town" to shop or tend to business. In times of sickness and death, or in times of trouble, neighbors brought food to help sustain the family during the crises.

"All the Monroeville houses have porches," says Norman Barnett, whose family owned a hardware store on the Square from 1904 to 1989, "and places to sit on the porches. My mother and the other ladies of town would get their work done in the morning, then get dressed and go out about 2 or 3 o'clock in the afternoon to visit. My mother wouldn't think a thing about walking clear across town to sit and visit with her friends on their front porches."

Lall Hybart Swift, who grew up near old Bell's Landing at Tinela, wrote, "We were front porch people. Any time we could, we would retreat to the old glider with our work, whether it was sewing, shelling peas, or silking corn."

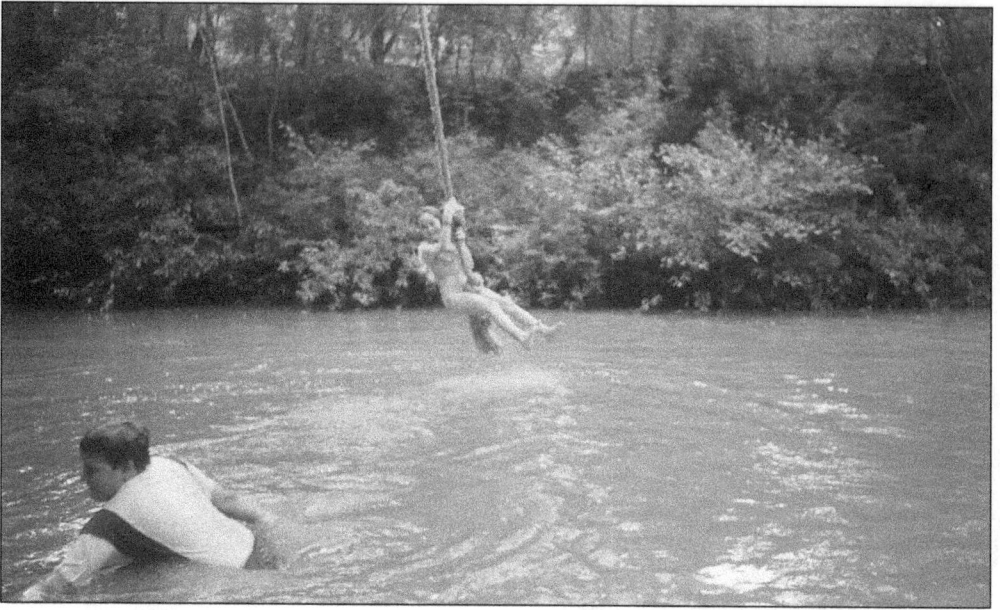

Swimming in the creeks has always been a fun pastime for children. Several creeks around Monroe County have good, deep swimming holes, and offer cool recreation in the hot summertime.

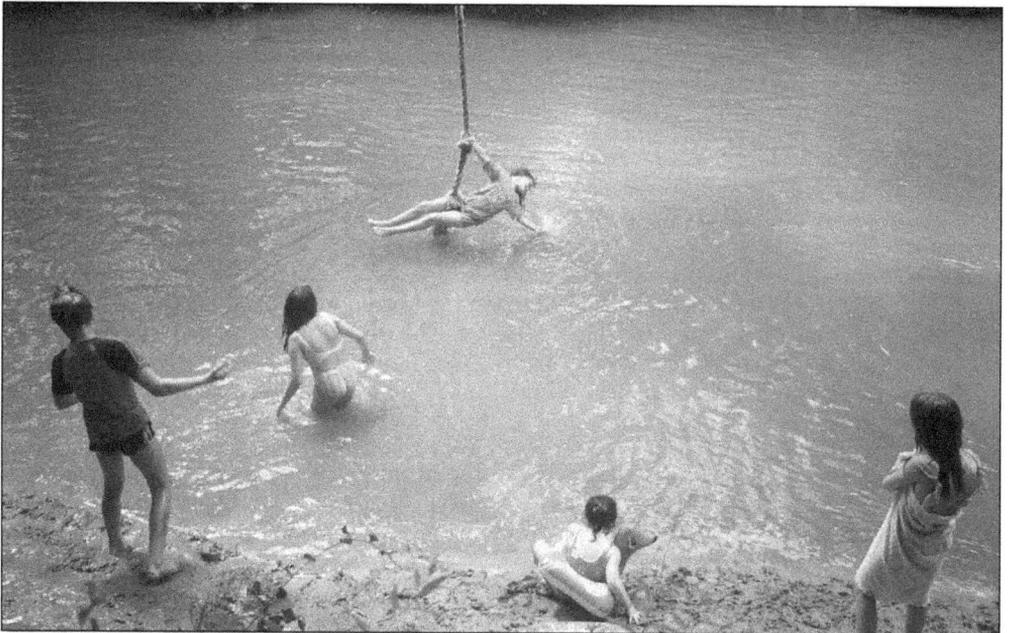

This swimming hole, in Hybart in the northwest corner of the county, is located on Tallachee Creek. There was also a good swimming hole on Limestone Creek only 2 miles out of town, past the old dump, called Parker's Eddy, where everybody also went to fish in the 1940s.

Three

THE MYSTERIOUS NEIGHBOR

Robert Champion plays the mysterious
Boo Radley in the annual play based on
Harper Lee's book, *To Kill a Mockingbird.*

A.B. Blass Jr., who delivered newspapers in Monroeville, recounted his route around the Lee's neighborhood.

"I delivered papers on this street, and I stopped at Mrs. Lee's house. Then I would go to the next house, and I would throw the paper on the porch. Then I would go across the street, where the dark, shuttered house was. All of us my age were afraid of it.

"Well, I got up enough nerve to get up real close to the house and throw the paper on the porch. One day I threw it and it hit near the door, and I saw this hand come out to get the paper. So I got off my bike and mustered up my courage and went up and kicked it a little bit further. He knew I was there, so he didn't do anything. The next day, I went up and threw it right where he could get it, and I watched his hand come out.

"You see, we'd never seen this person, except for maybe an eye through a hole in the slats of the shutters. After about a week or two of courage, I went up and took the paper and knocked against the door and dropped it on the floor. And he reached down and got it. I was taking the paper every afternoon about 4 o'clock. Finally, I got to where I would knock on the door with the paper, and he would reach out and take it out of my hand.

"The school ground was directly behind the mysterious house," Mr. Blass continued. "If the children that played on the school yard would kick the ball over the fence, nobody would go over and get it. All of us were afraid to ride down this street at night.

"After the book came out," says Mr. Blass, "the thing that was really strange to me was people would ask me, 'How about the book? Do you think this is typical?' I would say, 'I think this could have happened in any small town in south Alabama.'

"I have a librarian friend in Mississippi to whom I gave an autographed copy, and she said, 'Oh, A.B., this could have happened here. We have a similar "strange" situation here in Mississippi.'

"I talked to somebody in Florida, and it's the same thing there, too."

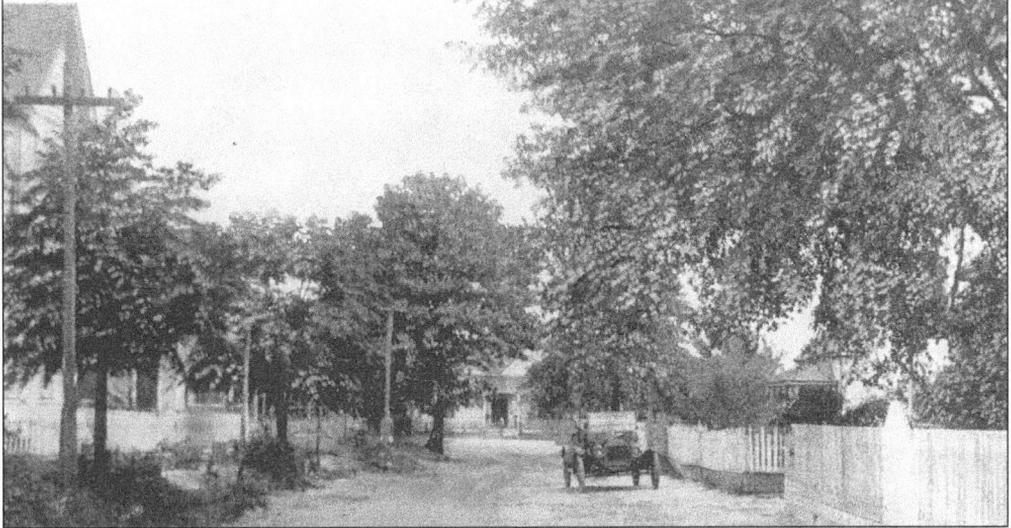

Street Scene, looking South,
Monroeville, Ala.

This is South Alabama Avenue in about 1915. The Lees' house was about where the car is. "When I was delivering the papers in 1939," says Mr. Blass, "the picket fence was gone (it had sidewalks then), and the street looked a lot different. At the far end, you can see a house facing you. The street turned left there and went out of town. The street to the right there led to the school."

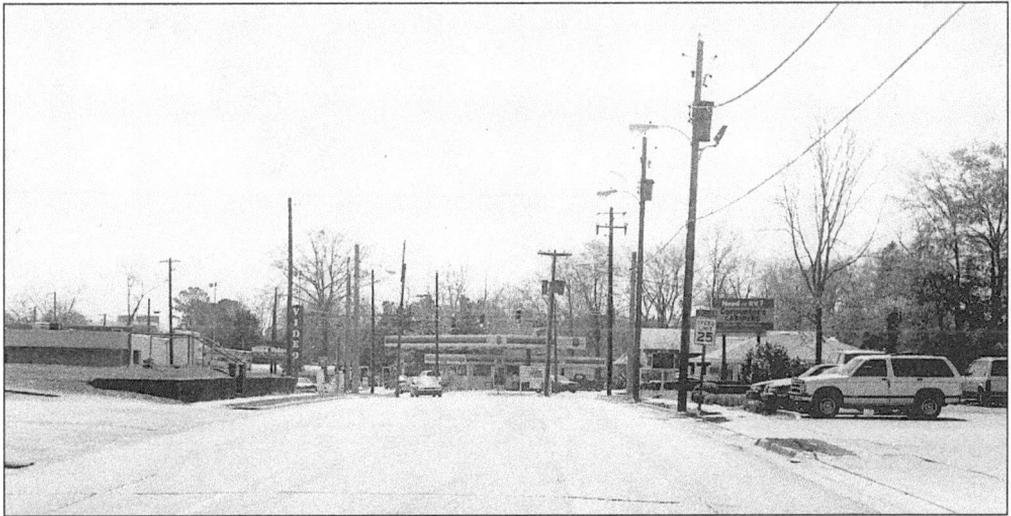

South Alabama Avenue looks different now. The Cannon Oil Co. is located where the dark, shuttered house stood. The side street to the right of the gas station leads to the school. This side of the gas station, on the right, is where the Lee house stood, and next to it is the Faulk lot, where Truman lived.

31

The mysterious, intriguing house stood behind the school on the school block, where all the trees are seen, near the school bus lot. The street that runs between South Alabama Avenue (on the right) and South Mt. Pleasant Avenue (on the left) is now called Oak Street. (See town map on page 123.)

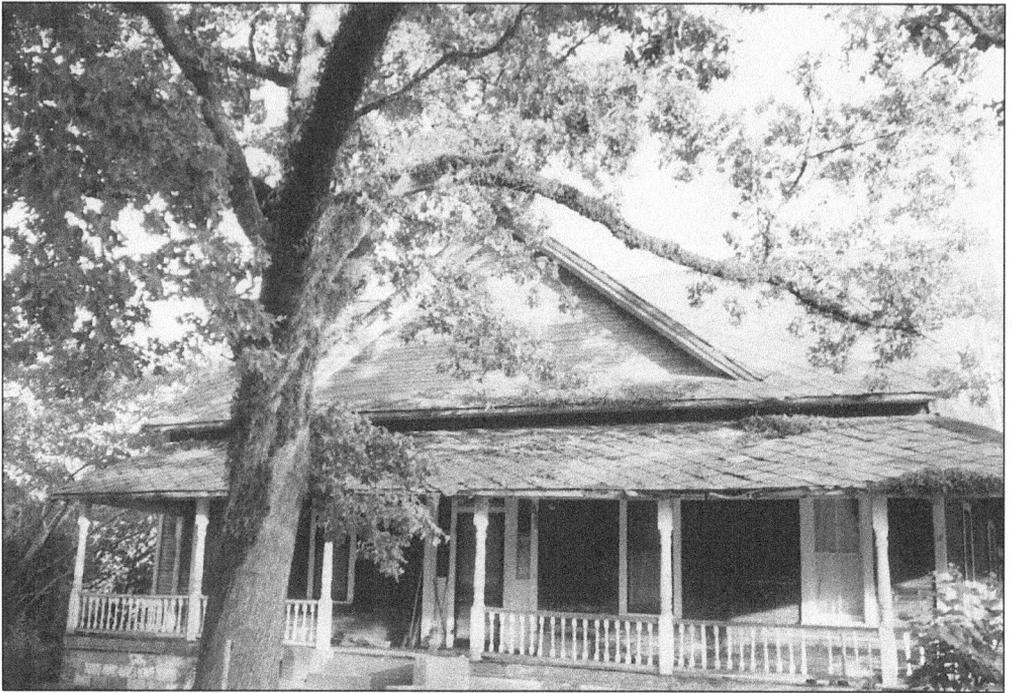

"The house of the mysterious neighbor was something like this one," remembers A.B. Blass Jr., local resident.

"I became a hero there one night," Mr. Blass recounts. "My dad was called there to put in a radio; the father had died. We went in about 9 o'clock on Saturday night to install a radio for the lady. I had to take an antenna wire out and attach it to the big oak tree. The lady told me you can go right through this door (going west toward the school) and carry the wire out. (I was about 14.) I opened the door as his mother told me, and when I went in, her son was standing behind the door, and I ran straight into him. I think I was more afraid than he. We both ran in different directions. Then the lady said, 'Oh, that's allright. Just go on through.' And I took the wire and finally got to the window and took it outside."

Collards are grown for their leaves, which are boiled down and served as a vegetable, called "greens." Many families grow them in their gardens. Collards are planted in the spring, and are best picked in the fall after the first frost. They generally will last all winter, if the weather is mild.

34

A.B. Blass Jr. shows a doll given to him similar to the two shown in the movie.

A.B. Blass Jr. recalls, "When I was growing up in Mississippi (in 1934), I had a friend who was a Baptist preacher's daughter. She was seven years older than I was, but she took a liking to me. Everyone said she was sort of strange, but she would come to my house and teach me things like cooking and she would help me make a tepee tent. One day I went into the tent, and on the little shelf, she had left this doll for me.

"In the movie, there are two dolls in a box in the opening sequence. Mine is almost identical to those. This was given to me by somebody that I think was just like Boo; it is just like the dolls that were given to Scout and Jem."

In the book, Scout and Jem make several references to unexplained happenings, such as hot steams and hoo-doos. In Monroe County, many people are fascinated by the supernatural. Several people in the Scratch Ankle and Franklin communities, northwest of Monroeville near Finchburg, have seen a "light" in the area at different times. Storyteller A.B. Blass Jr. remembers hearing about it and relates the following story.

"We have some strange, unexplained things that happen around here. I have a friend, whom I believe with all my heart, and he came into my store one day and told me this story. His daddy was dying and he was there with him at their house in Scratch Ankle. All of a sudden, a light came in through the window and sat on the bedstead. It stayed with them until Doc Smith got there and said, 'John, your daddy's gone.' "

Many people in that community have seen the "light." One man reported seeing it hovering over the trees beyond his pasture. A woman said it came in the car with her late one night on her way home from town. Another man said he saw it in a grove of pecan trees late one night recently—"just bouncing around in the tops of the trees, sort of reddish-orange and round."

Jane Ellen Cason, who lives up in the northern part of the county, has a neighbor who believes in "hoo-doo." "She told me she was going to Selma to buy a necklace from the hoo-doo man up there for her brother to wear at his upcoming court trial," said Ms. Cason. "Later, she told me it had worked. He had received a very light sentence from the Judge."

These concrete steps poured in the 1930s lead up to the present elementary school from South Mt. Pleasant Avenue. The side street (Oak Street) leads to South Alabama Avenue. In the 1930s, all the schools for the white students were located on this sizeable lot. The black students' school was located about two blocks east. In 1934, the newspaper reported Monroe County school enrollment to be "3973 white, and 4826 Negro." Population records show the 1930 Census counting 30,070 in the county, and 4,292 in Monroeville.

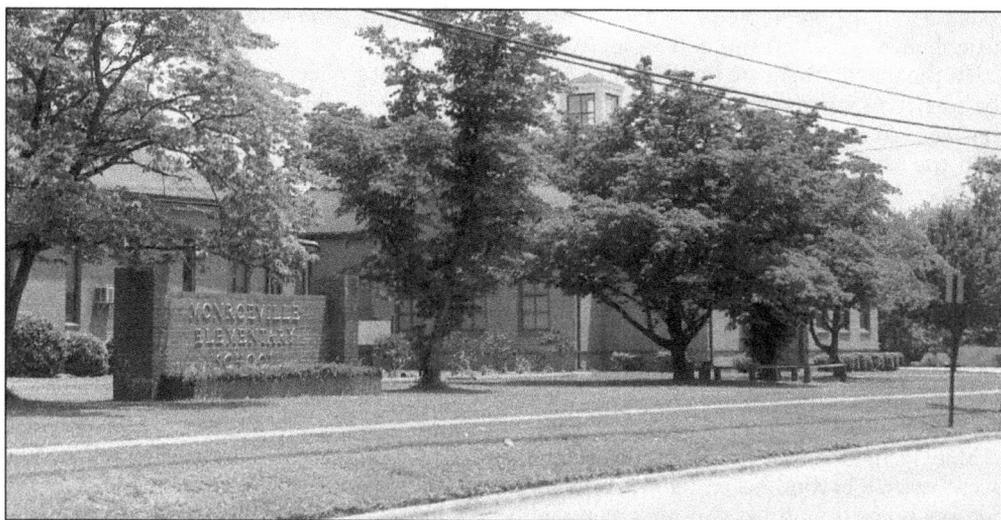

Today, this is the Monroeville Elementary School, kindergarten through third grade. In the nineteenth century, this was the site of the private Monroeville Academy. In 1910, the governor of Alabama set up the public school system, and ordered a high school built in every county. A new school was built here in 1914. By 1930, this block held buildings for grades 1-12. In 1936, a new high school for white students was built about four blocks west of here.

Four

SCHOOL

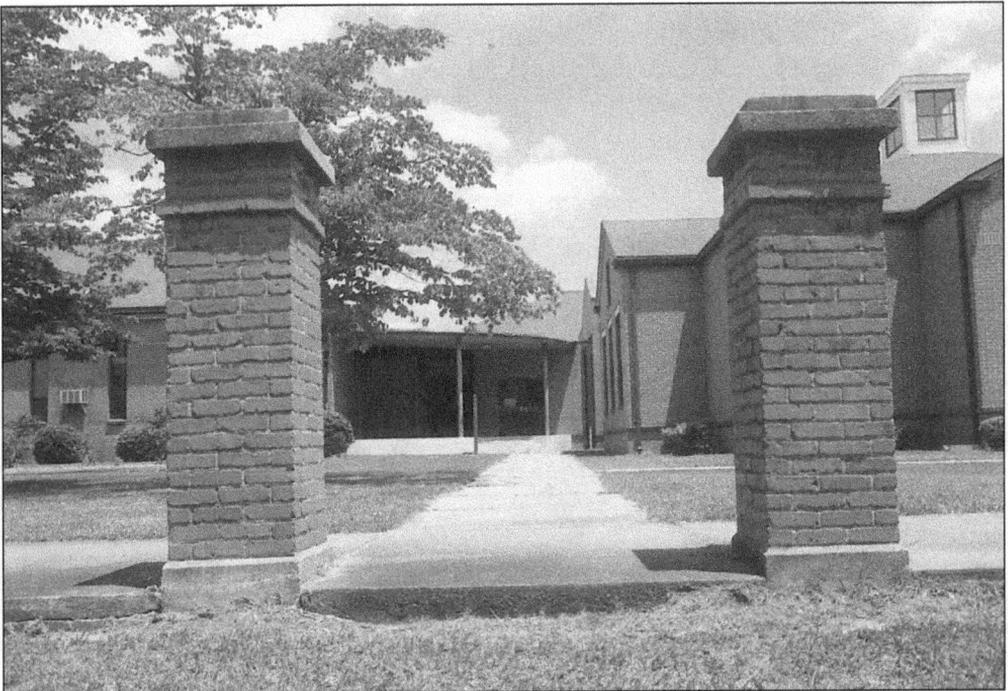

These pillars remain from an entrance to the old school. "At one time chains hung between the pillars, and young girls would often sit on them and the boys would push them," recalls A.B. Blass Jr.

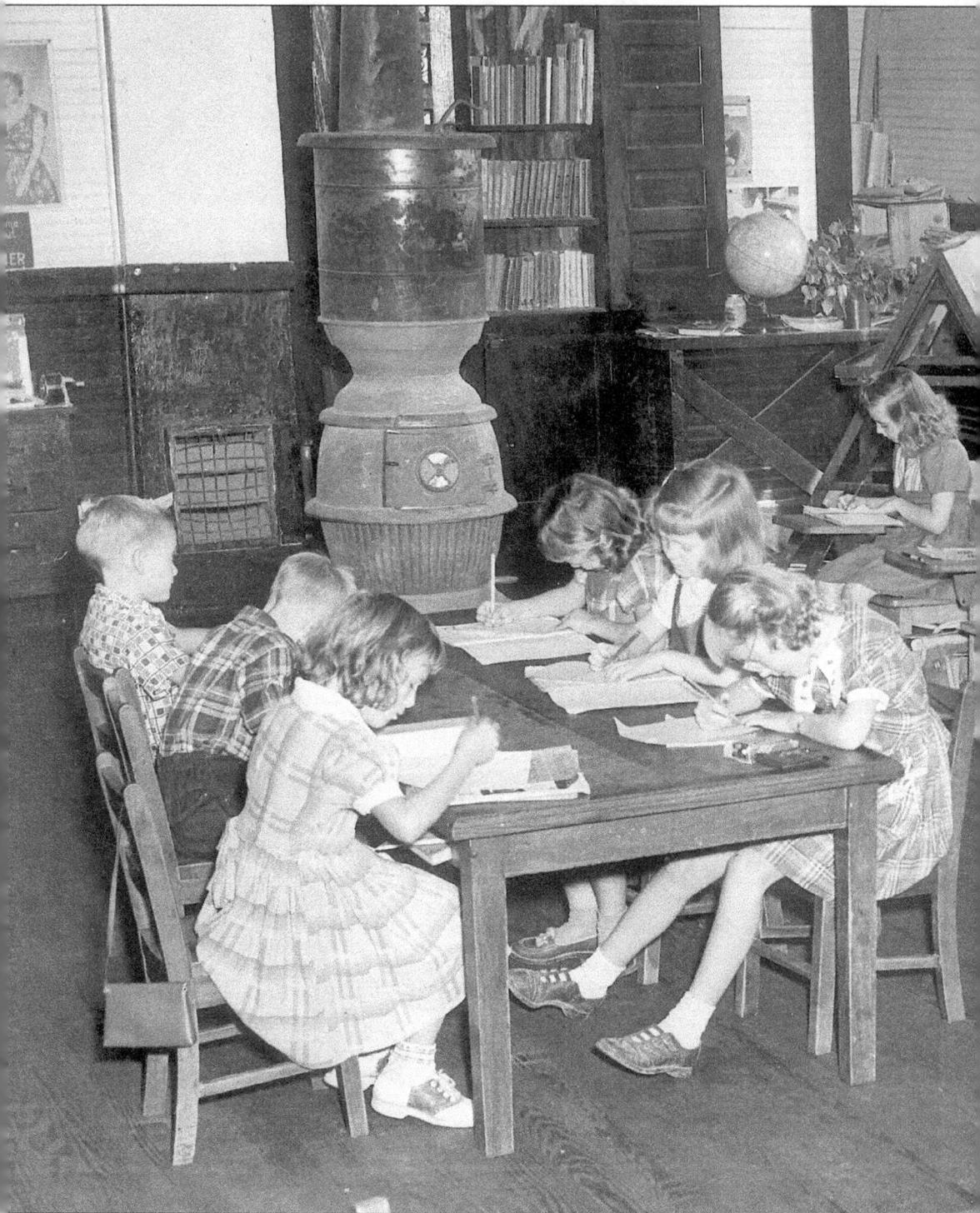

Teacher Mary Roberts is shown in a typical Monroeville classroom in the 1940s. A regular part of the school curriculum included current events, remembers Jane Hybart Rosborough of Tuscaloosa, who went to school here and was in the same class as Harper Lee. Most kids

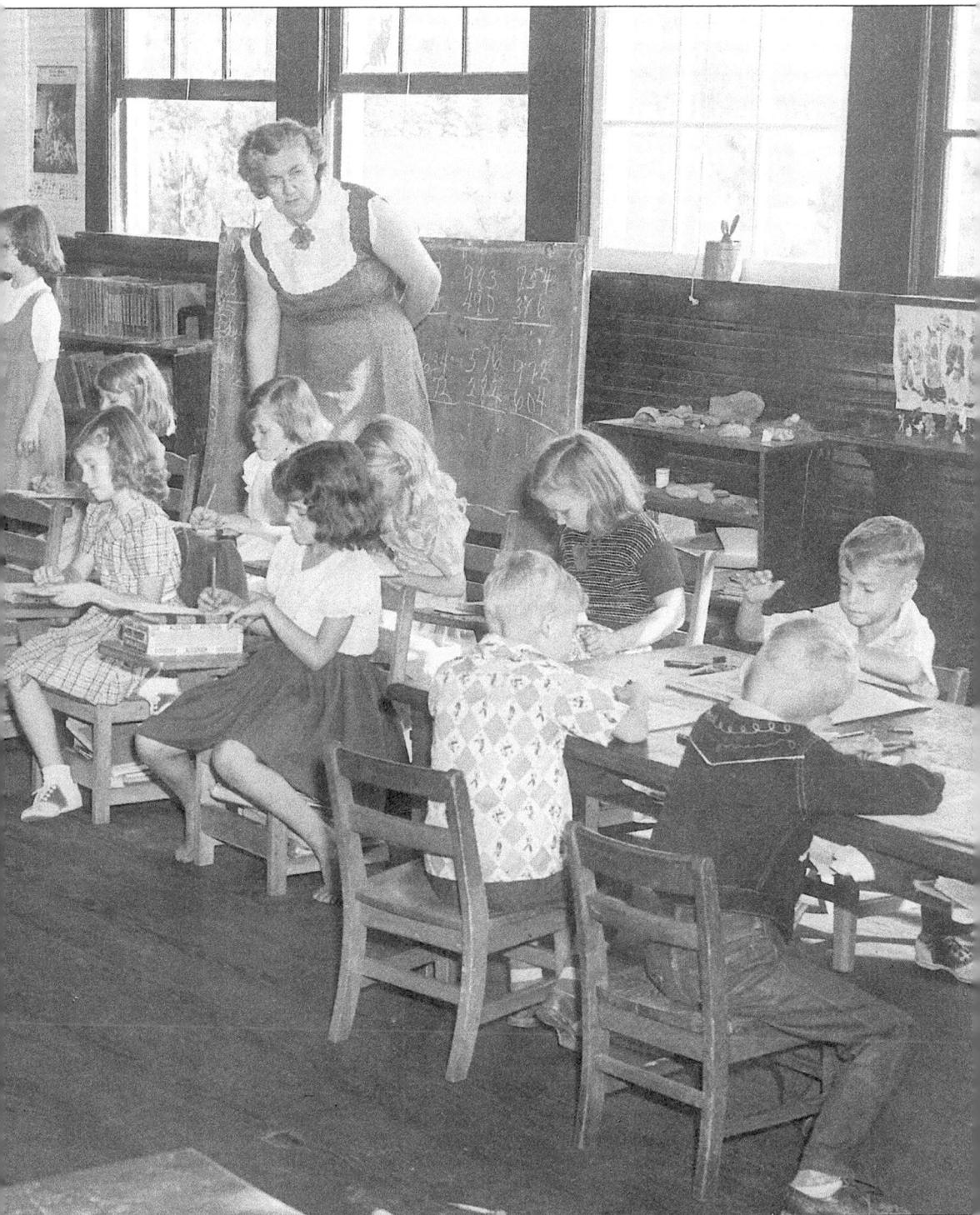

used the *Mobile Press-Register* or the *Montgomery Advertiser-Journal*, but some families read the *Grit Paper*. It was subscribed to by some folks in Hybart where she lived. "It was more like a Farmer's Almanac."

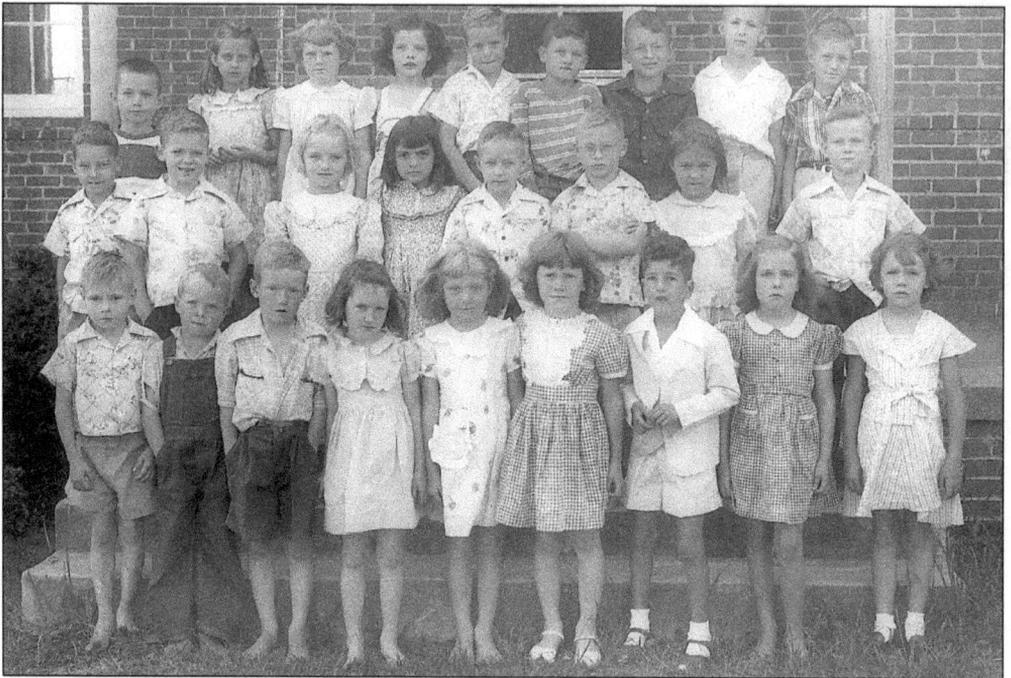

Many pupils came to school barefooted. Charles Ray Skinner remembers a year they all came barefooted. "A preacher's family in town had so many children, they couldn't buy shoes for all of them. So, our mothers and the teacher decided we'd all go barefooted. It was the best year I had—not having to wear shoes all the time."

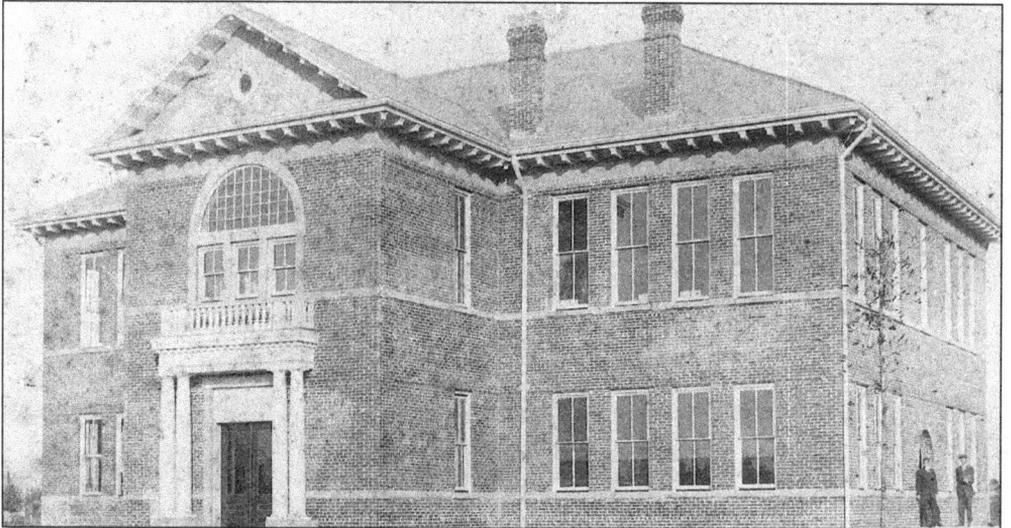

The old grammar school is where Harper Lee attended grades 5 and 6. It was originally built for grades 7-12, but was used for elementary grades after the high school students were moved to a new high school in 1936.

"One year there was an agricultural parade," recalls Jane Hybart Rosborough, "in which schoolchildren were dressed up to represent products of the county. I wore a fertilizer sack and wasn't happy about it. My friend Sara Ann McCall was a ham. Sara Ann later married Harper Lee's brother, Ed. Their son is a dentist in town now."

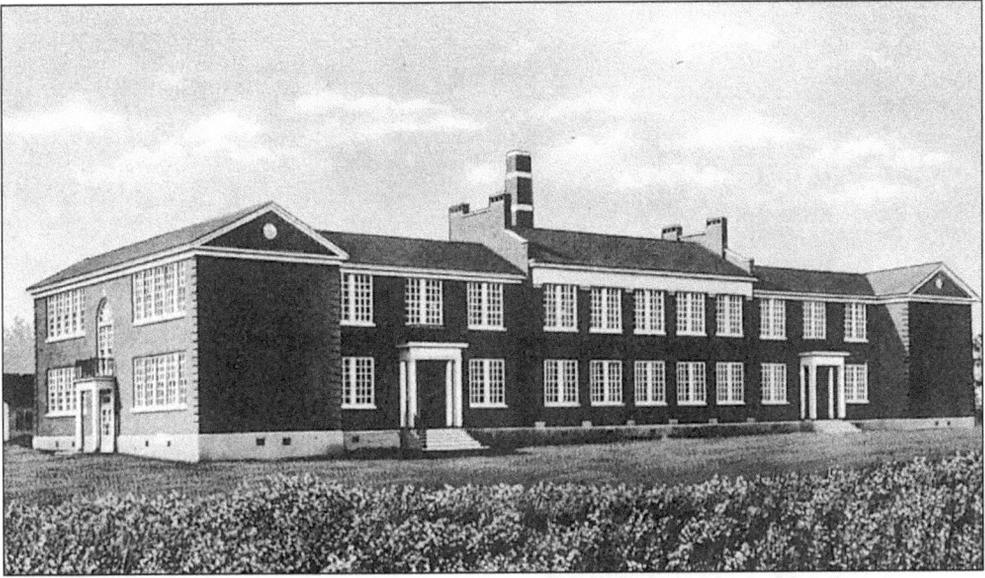

The new high school was built in 1936, about four blocks away from the other schools. Harper Lee graduated from this school in 1944. A.B. Blass Jr. was one year behind Harper Lee in school. "Nelle spent a great deal of time in the library of this school."

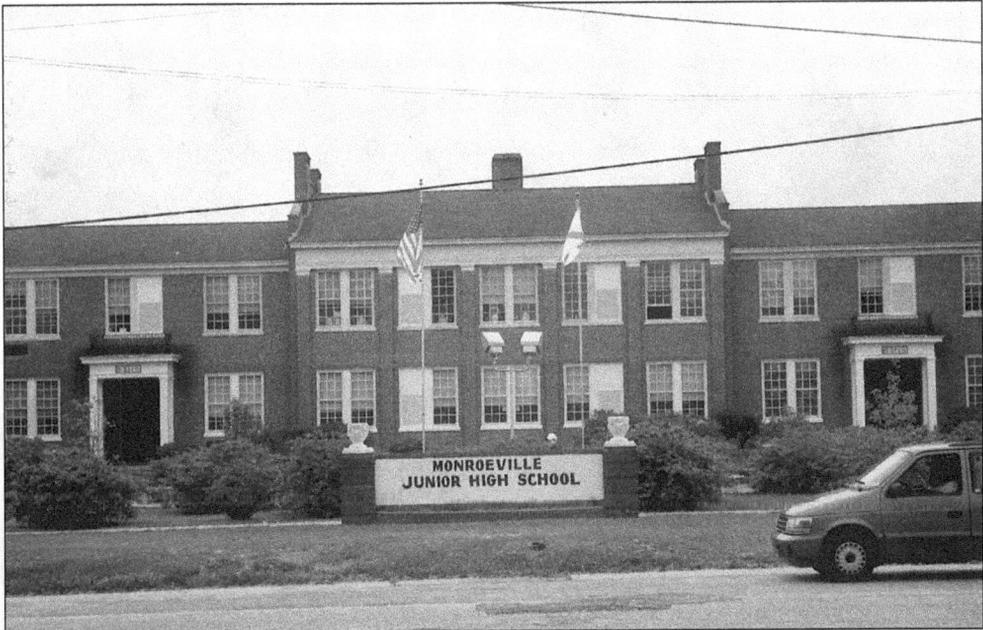

When the newest high school was built south of town in the 1980s, this became the junior high school. John Tucker, a respected black educator from Monroe County, was the first principal of this junior high school. School integration was implemented in the county in 1968. Today, all eighth grade English students who attend this school study *To Kill a Mockingbird*, and all county eighth graders attend a "Young Audience" performance of the play at the Old Courthouse Museum.

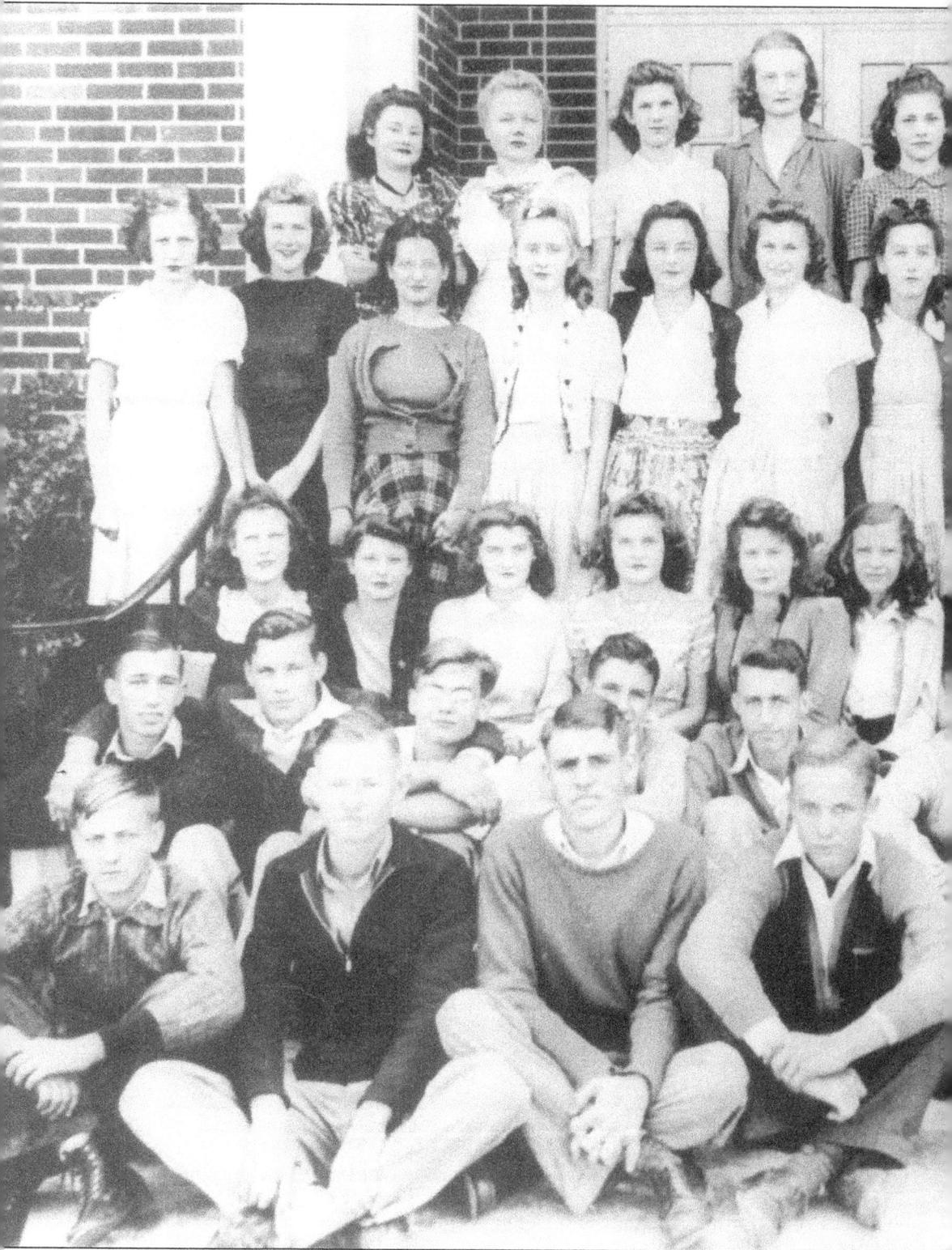

Shown here is Monroe County High School's tenth grade class of 1941–42. Harper Lee is standing far right on the fourth row. Jane Hybart (Rosborough) is standing fifth from the right in the fourth row, next to her best friend Nancy Riley (Murphy), fourth from the right. Sitting, third row, far right is Sara Ann McCall, who married Harper Lee's brother. Anne Hines (Farish), Monroeville's present mayor, is in the back row, far right. Dr. Rayford Smith Jr. is in the second row, fourth from the right. Mrs. Burkett is in the middle of the back row. She taught English for many years in our county. She was one of the best English teachers in Monroeville and taught all the high school students. She became head of the English Department for Patrick Henry Junior College, established by Governor George Wallace in 1965. Rivard Melson, a local artist and retired attorney, remembers her. "Mrs. Burkett was a tough teacher, but she always motivated me to do my best. She could inspire students to excel beyond the mediocre."

43

The football field was behind the high school building, pictured at left.

The Monroe County Heritage Museums has many visitors every week from all over the country and the world. Visitors also include some local and former residents with stories of past happenings and characters of Monroeville. Many say, "We want these stories recorded for posterity."

One such visitor, Cecil Ryland, from Atlanta, came in the Museum's office in 1998 and said, "I've got a great story for you! It's about the book, 'To Kill a Mockingbird.'

"It would have been about the spring of 1959," he began. "I was something of a teacher's pet of Mrs. Gladys Burkett at Monroe County High School. Mrs. Burkett was doing a proofreading of the novel one day, and she talked to me about what she was doing with the novel, and what it was about. She said, 'This is going to be a real best seller. I've just finished proofreading it, and I need you, if you would, to take it back to Nelle Harper.' And so, I gathered up the manuscript in an old stationary box, and took it and went knocking on her door. Nelle Harper Lee came to the door, and I said, 'Here's your book.' And she said, 'Thank you.' Little did I realize that I held a little bit of history in my hands, nor do I think Mrs. Burkett realized that she spoke a prophetic word about the book.

"So, that's my story of my few moments of fame—holding that famous manuscript in my own little hands."

Many young girls in town wanted to grow up to be a majorette and twirl a baton for the high school marching band.

Five

CALPURNIA

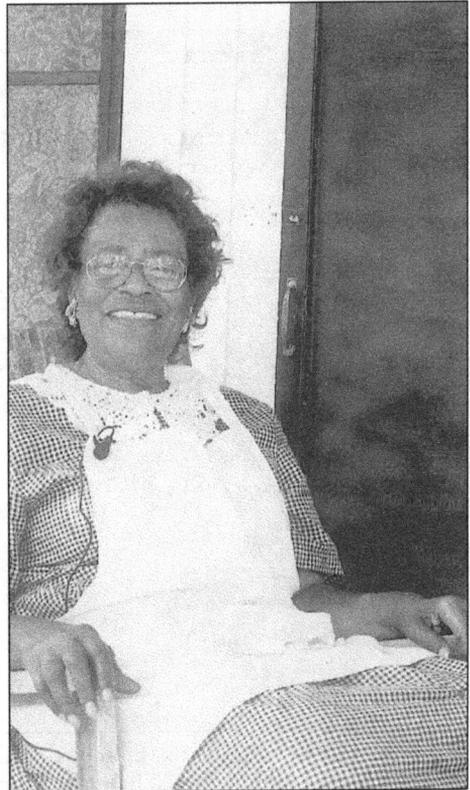

Since the inception of the annual *To Kill Mockingbird* play, Calpurnia has been portrayed by Lena Cunningham, a retired Monroe County teacher.

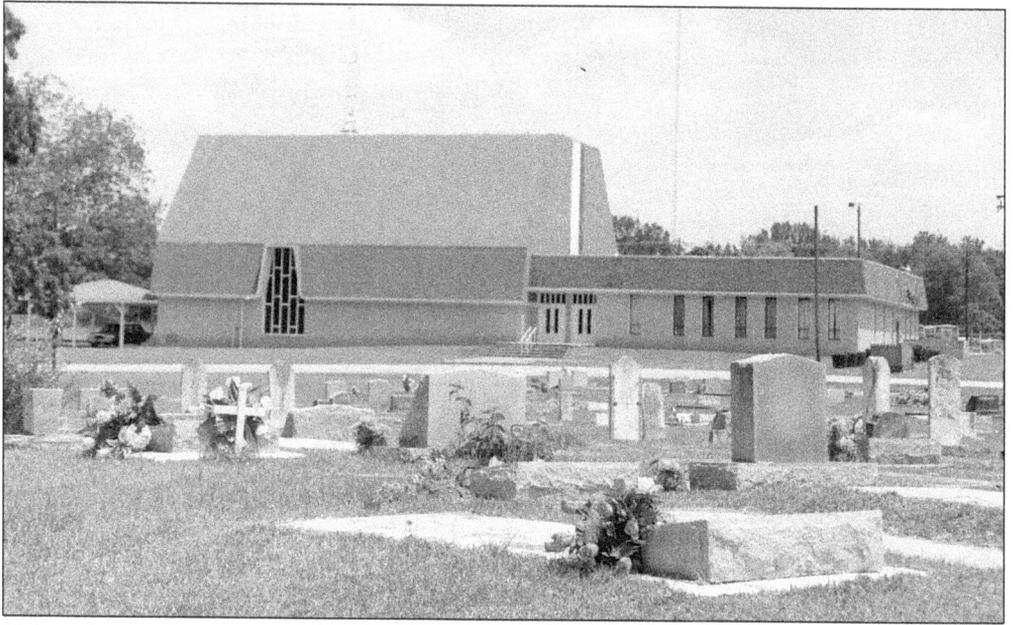

Calpurnia may have attended a church like this one, Morning Star Baptist Church, located in the neighborhood two blocks east of the Lees' neighborhood. It was organized in the early 1880s. This building was erected in 1969.

Mt. Zion African Methodist-Episcopal (AME) Church is also in the neighborhood. This concrete block building probably replaced an earlier wooden building.

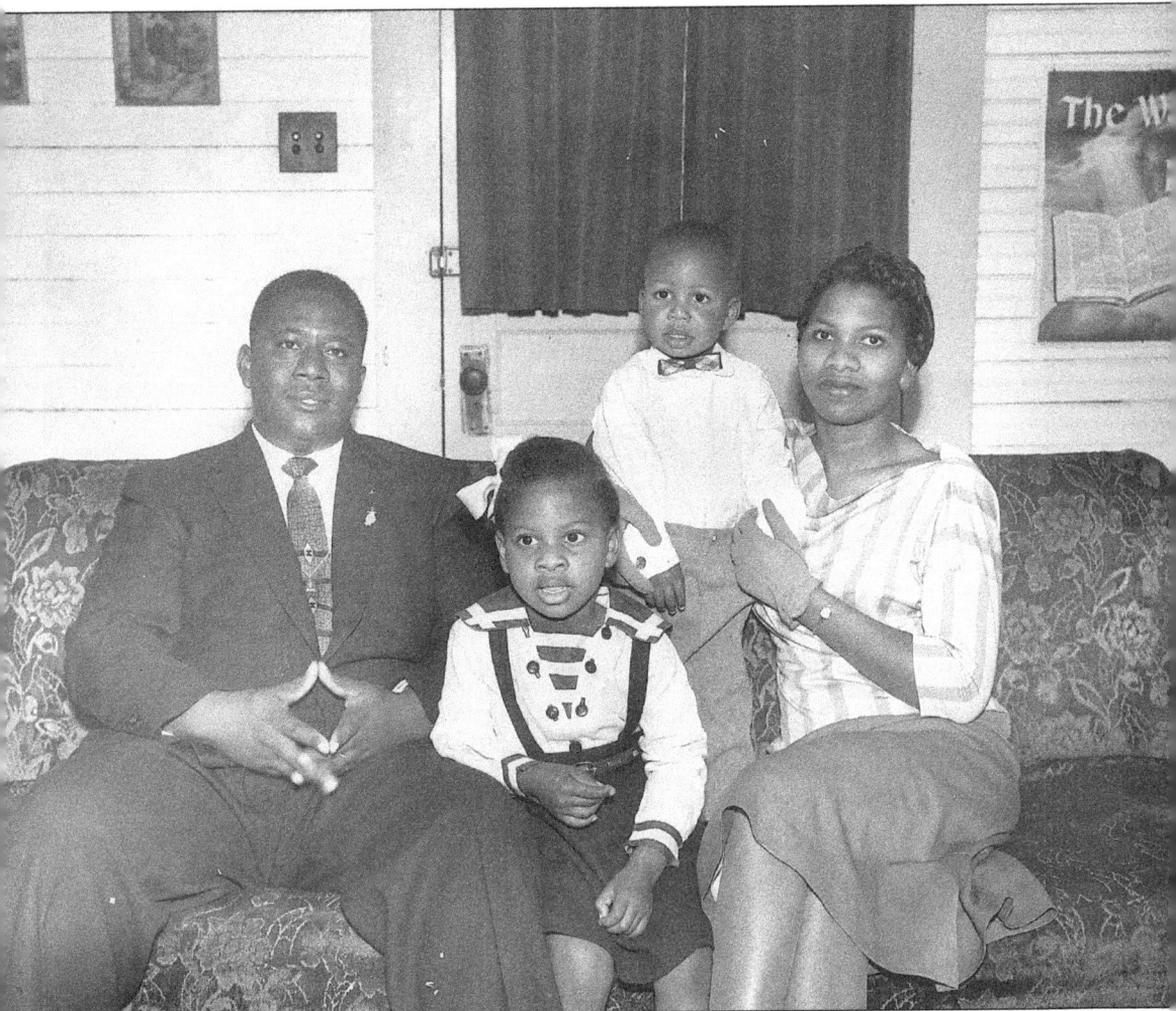

This is the Rice family in the 1950s. Mr. Rice was a vocational agriculture teacher at the school for blacks in Monroeville. His wife, Lillie, was the daughter of the pastor of Morning Star Baptist Church.

Calpurnia, the housekeeper in the book, was probably a composite of domestic women workers during the 1930s and 1940s. These women typically worked for families who could afford to have help in the home to cook and clean, preserve the garden produce, and care for the children. These black women generally lived a few blocks east of South Alabama Avenue, across the railroad tracks, and always walked to work. Few people had cars in the 1930s.

In the book, the children attended church with Calpurnia. When they questioned her about how they sang, she told them that the black congregations 'lined' the hymns because the members did not have hymnals and could not read.

"In the 1930s, blacks did have public schools and could read," says Mary Tucker, local retired teacher, whose husband was the junior high principal. "Lining had become a tradition from the time after slavery when they couldn't read. In lining, the song leader gives the first line, and the congregation sings it, and then the leader gives another line, and the congregation sings that line. Still, today, it is a tradition that a lot of the black churches line at least one hymn during a service, such as 'Amazing Grace.' "

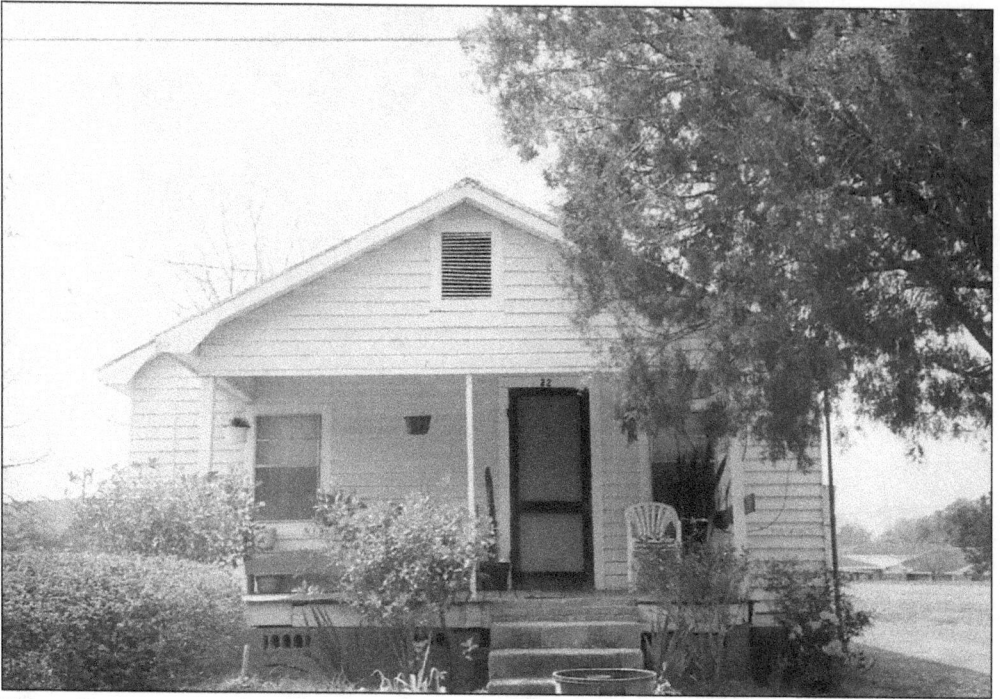

Shown here are examples of wood-frame houses built in the 1930s and 1940s. Originally, they may not have been painted, which was not necessary with buildings constructed of heart-pine lumber. It did not rot easily, so it was left to weather naturally to a grey color. These photos were taken today, showing the improvements that have been made over the years to the homes.

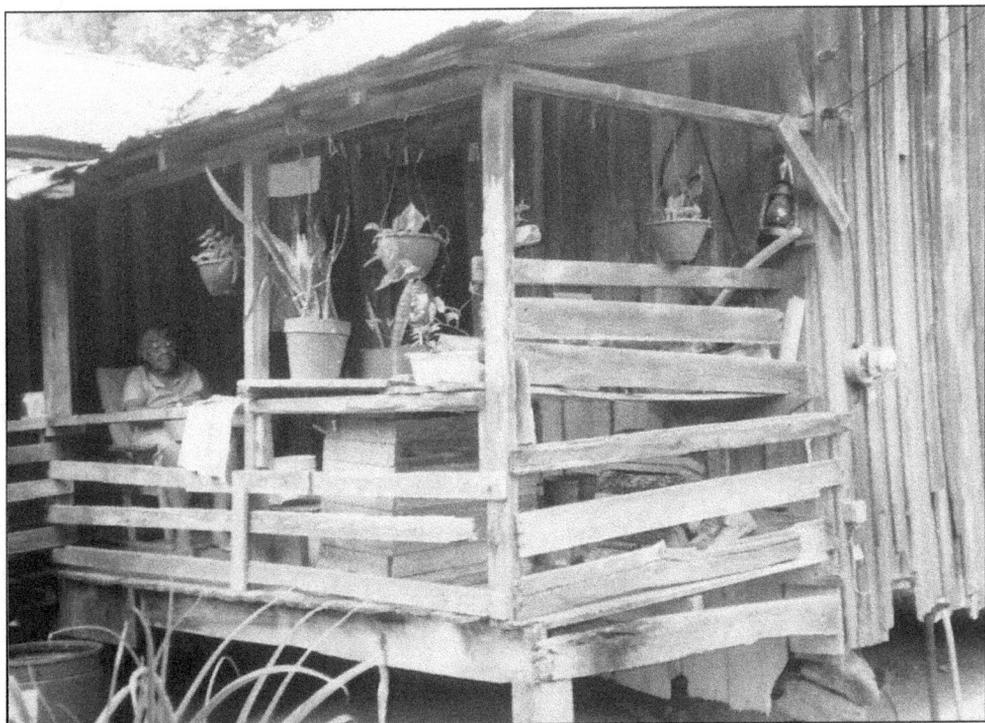

Rural cabins, such as these (top and bottom), are disappearing from the county back roads.

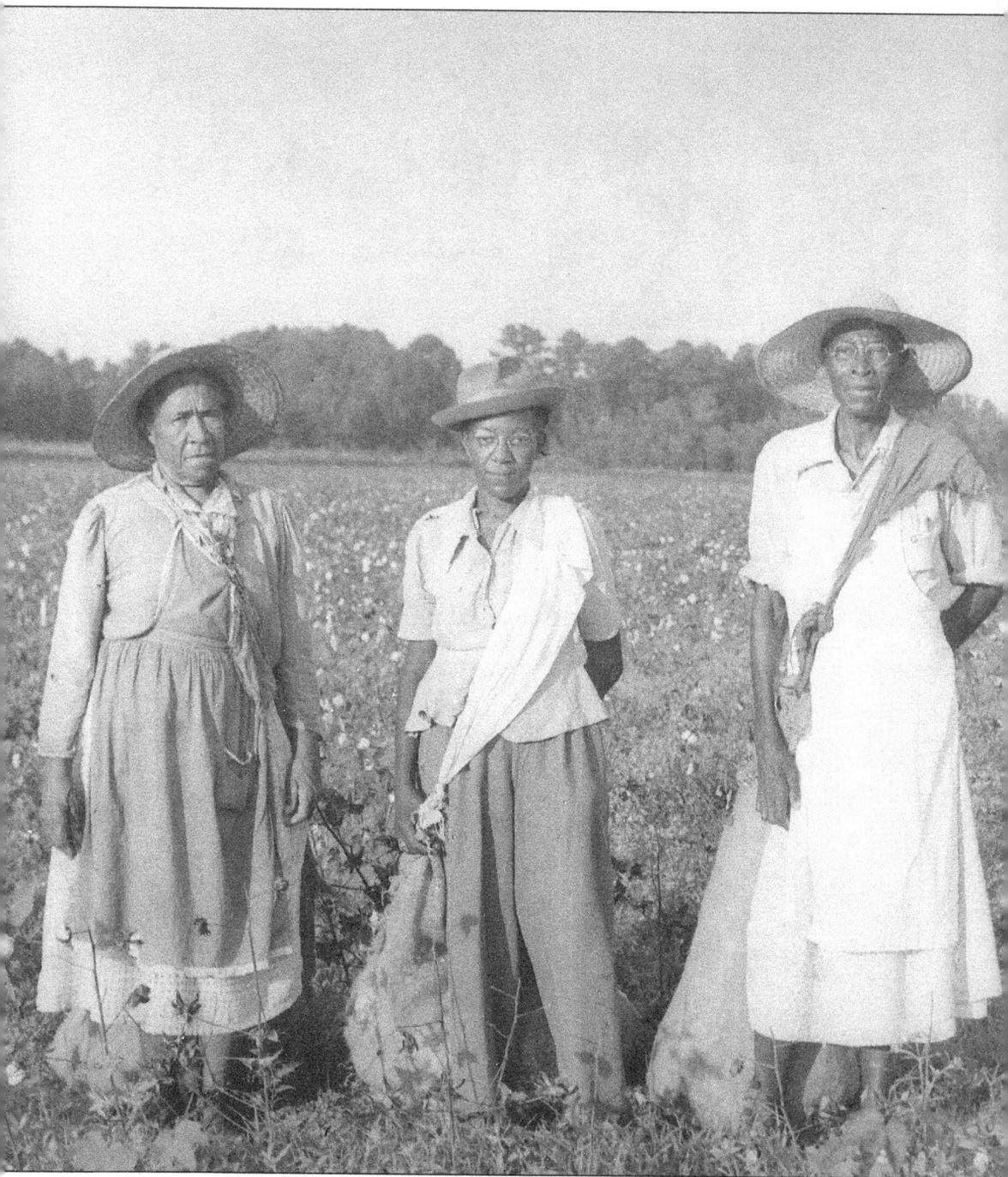

In contrast to women who did domestic work in town, there were women who were field hands. Women not able to work in homes had no other choice. Men usually plowed with mules, but women sometimes plowed, as well as "chopped" (hoeing to thin the stand of crops and to weed the rows) and picked the harvest.

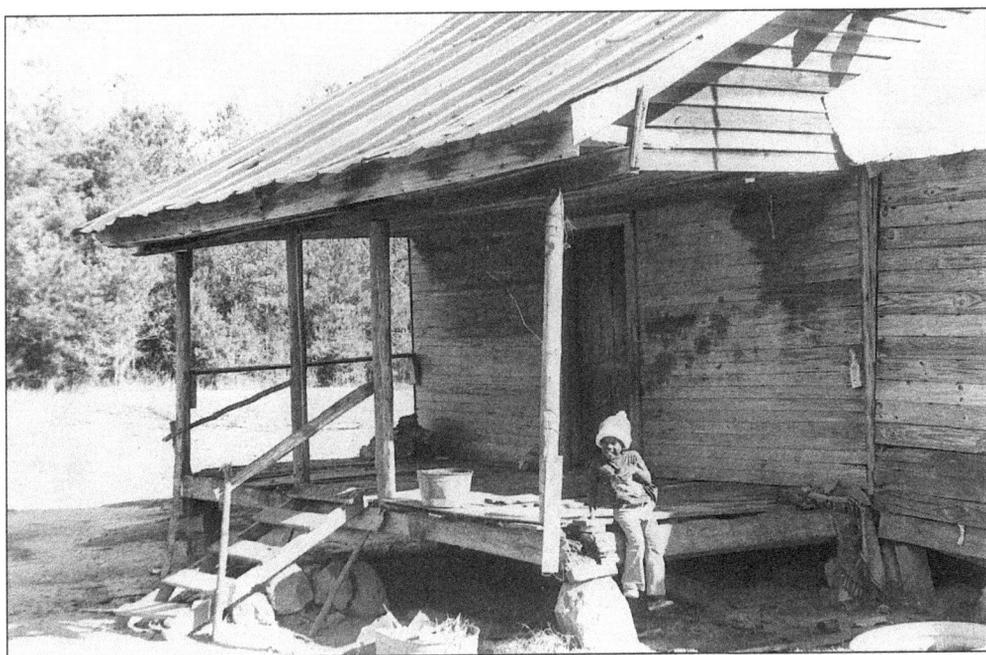

Typical field workers of the 1930s lived in the country in houses similar to this. This photo was taken in the 1970s. This house sits on stone pillars and has a "swept" yard; a "brushbroom" kept it free from leaves and grass. Having no lawnmower, it was the best way to keep down the underbrush and keep the snakes out.

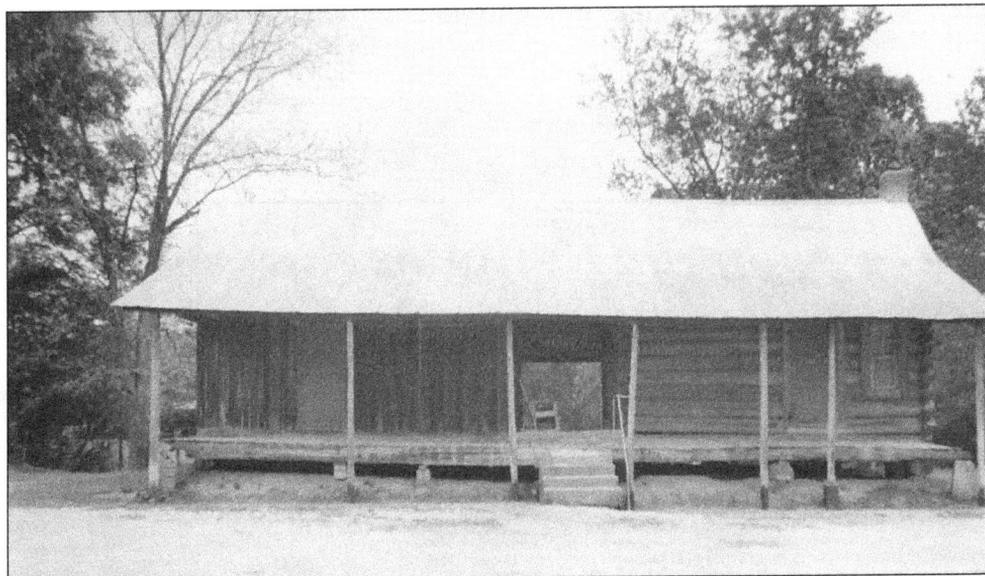

This dogtrot log cabin is located in Scratch Ankle, north of Monroeville, near Finchburg. It was a common building style in the early 1800s. The breezeway was the coolest place during the summer. In the book, *To Kill a Mockingbird*, Mrs. Dubose lived in a dogtrot.

Union High School was built in the 1950s as the public school for black students. At Christmas, clubs at school brought gifts for needy families. Union High, in the Clausell community west of town, was formed from the Rosenwald School on Drewry Road and the Bethlehem Industrial Academy in Clausell, both private schools.

Mary Tucker, local retired teacher, recalls Harper Lee visiting this school. "That was where I first met her, when she came to the school to talk to the principal about giving a scholarship for a needy, worthy student. She gave the scholarship, and the student who received it attended college and graduated."

"She visited me twice one year," says Mrs. Tucker. "It was when my husband passed away in 1984, Nelle and her sister Alice came to my home to visit. The children were not home at the time. She said she wanted to meet them, to call her when they got back. I called, and she and Miss Alice came back to visit with us."

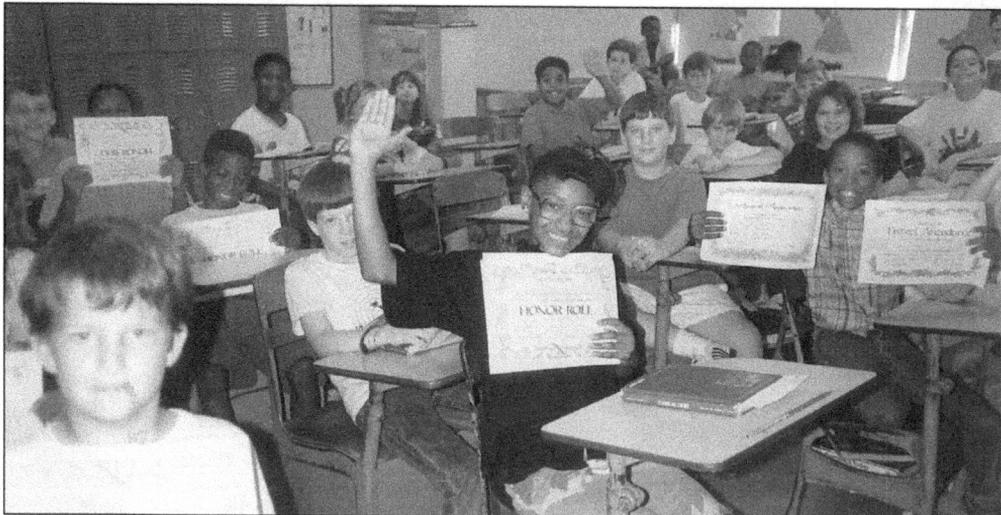

Monroe County schools were integrated in 1968. This is a class in 1989 at the Monroeville Middle School, located across the street from Morning Star Baptist Church.

Six

TOWN

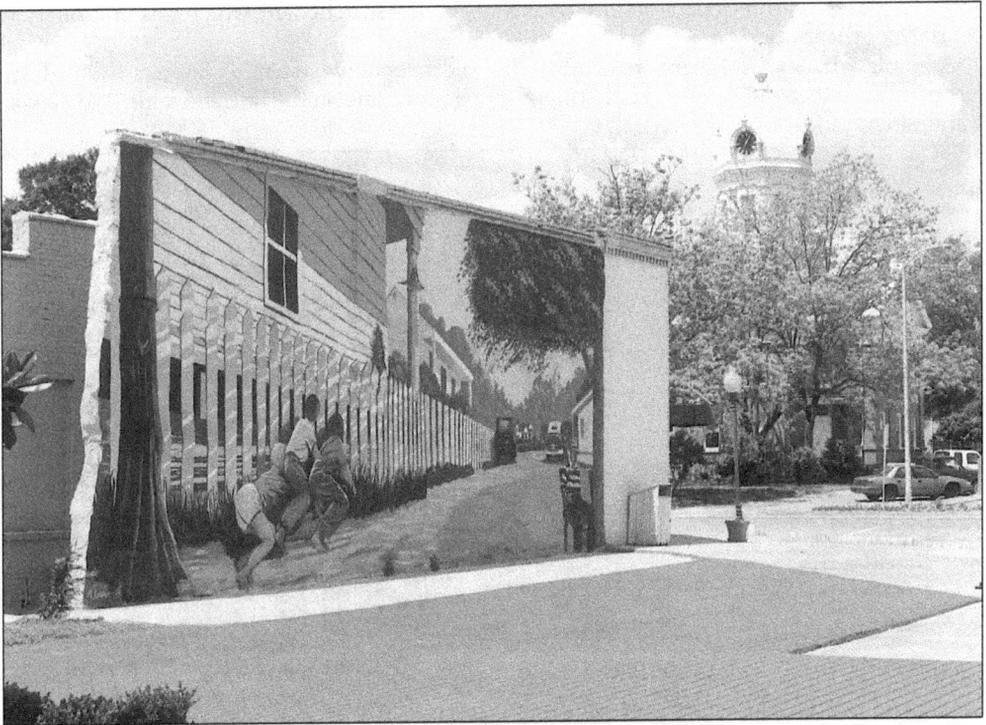

In 1998, The Monroeville City Council commissioned our first mural, the Maycomb Mural. It was painted by Baldwin County artist Bill Harrison, with the help of the art department students from Alabama Southern Community College in Monroeville. Visitors have been delighted to see Scout, Jem, and Dill peeking through Boo Radley's fence.

Looking north up South Alabama Avenue, toward the downtown square, Nelle's and Truman's houses are behind us. The building on the left is owned by B.H. Stallworth Jr., whose father was once an owner of the independent, private Monroeville telephone service, which began in 1898. In the 1930s, three operators alternated duty on the switchboard, which was "information central" for the town.

A.B. Blass Jr., local resident, remembers the old telephone system. "One day I dialed my girlfriend's number and before it could ring, the operator came on the line and said, 'A.B., if you want Sarann, she is over at Jean's.' "

The Jones Hotel was on this street, too. In this photo, it is the two-story building with columns. When we say hotel, it brings to mind hotels like we have today, but that's not what these were like. They were more like boardinghouses.

54

The B.H. Stallworth Building is the only original building left on this street today. Across the street was the Simmons' City Hotel, another boardinghouse.

This 1903 courthouse is the older of the two courthouses on the Square now, so it is always referred to as the "old" courthouse. Actually, Monroe County had a courthouse at the previous county seat of Claiborne, on the river, before Monroeville was a town. An early probate judge, Henry W. Taylor, in office from 1826 until 1832, received the land grant for 80 acres to establish the town of Centerville, later called Monroeville. The new town had a log courthouse, built in 1832, then a brick one, built in the1850s, both of which burned.

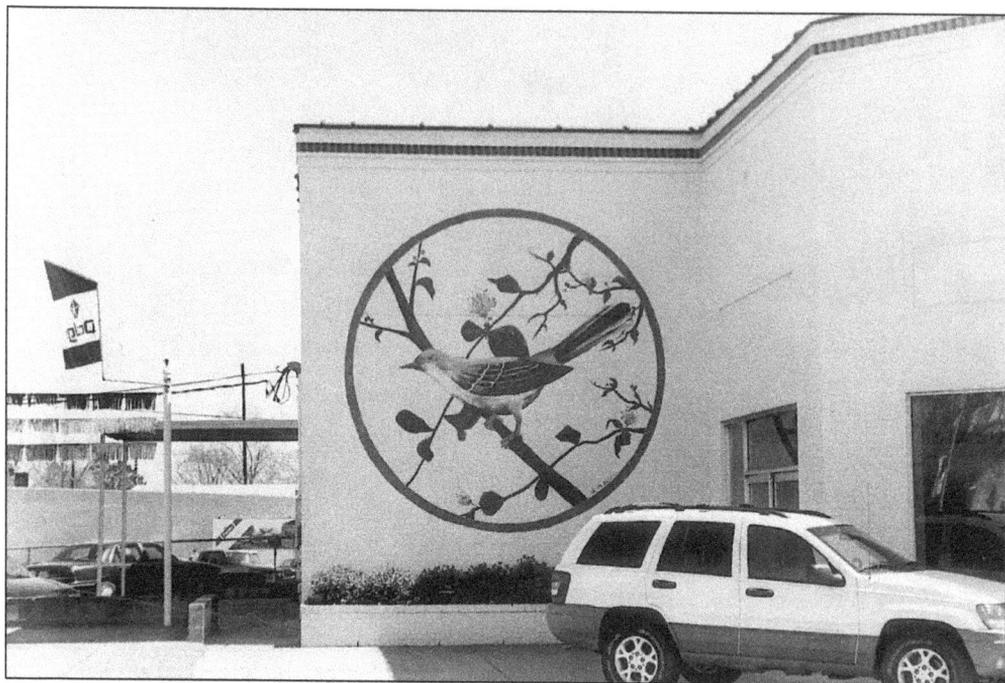

The local car dealership, on the southeast corner diagonally across from the Square, has a mockingbird mural on the wall, painted by local college student Steven McNider.

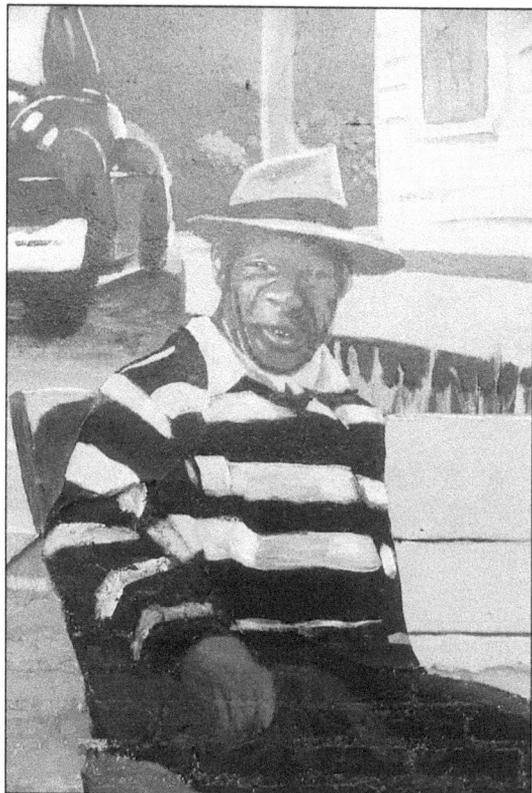

In the corner of the Maycomb Mural is a local character. His name was Ras Meggerson. George T. Jones, weekly columnist for the *Monroe Journal*, wrote in "Other Views," February 26, 1998, "Many unusual people spawn from unusual backgrounds. So it was with Ras, whose single mother, being unable to support her large family, gave him to the Charles Johnson family at Franklin when he was four years old. Ras shared living quarters with the three Johnson lads, along with the daily chores, going to the swimming hole, and the strict discipline of the family, until he was about 17.

"At this time county officials deemed Ras liable for his share of the Road Tax. Unable to pay and not wanting to work on the road crew in lieu of tax payments, he migrated to Peterman where he found lodging and board and a weekly salary of 50¢. Shortly afterwards he moved to Jockey Bottom in Monroeville before making his final residence in the Mexia area." He died in 1991.

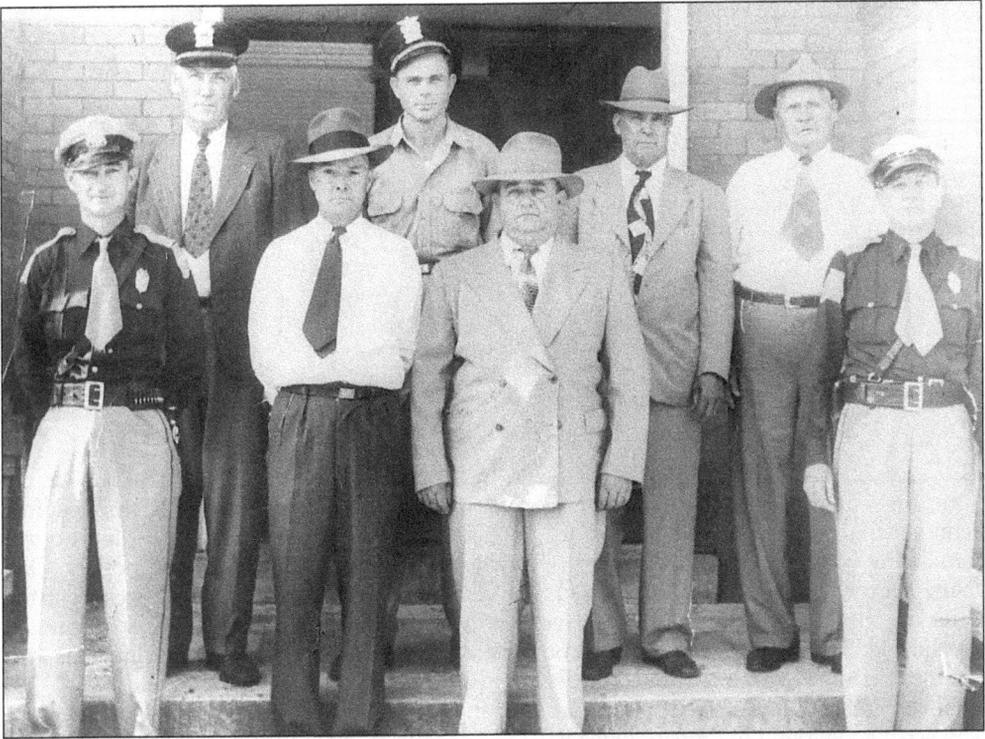

Here, officials pose on the courthouse steps in the 1950s. From left to right are as follows: (top row) Alex Stevens (police chief), Marvin Andrews (city police), Newt Kennedy (deputy sheriff), and Napolean "Pone" McNeil (deputy sheriff), a regular boarder at one of the establishments on South Alabama Avenue; (bottom row) Angus Whitley (state trooper), Charles Cole (mayor), Earnest Nicholas (sheriff), and Pete Kennedy (state trooper). "In the 1930s," said Norman Barnett of Barnett and Jackson Hardware, on the Square from 1904 to 1989, "there were no city policemen, only a night watchman for the Square."

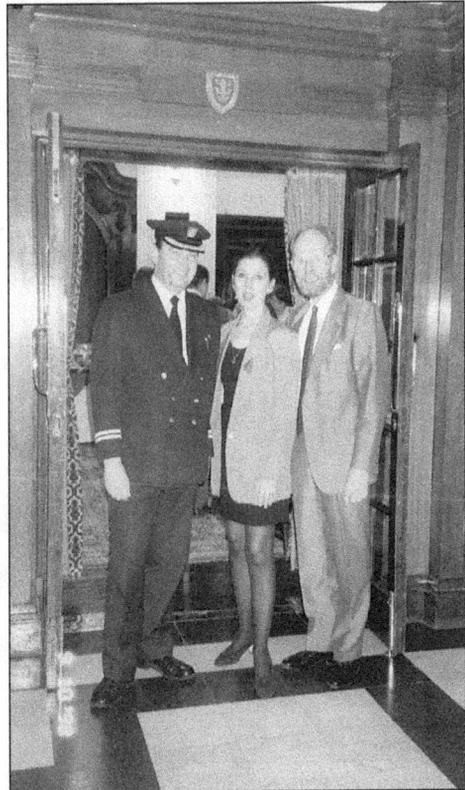

In England, Museum Director Kathy McCoy poses with the Kingston upon Hull Town Beadle (on left), and Roger Gilbertson, of Hull. The beadle's job was to keep order at the official reception for the Museum's Mockingbird Players, who were invited to Hull to perform the play *To Kill a Mockingbird* in 1998. Harper Lee mentions Maycomb's ancient beadle in chapter one of her book.

"One time in the early 1930s, a Mr. Barbey who owned Vanity Fair Mills in Redding, Pennsylvania, stopped at this station to get gas," said A.B. Blass Jr. "At the time he was considering building a mill down south. They made nylon and silk gloves and hosiery. One young man who worked there impressed him very much with the service to his car: putting water in, checking all the fluids, and washing the windshield. Mr. Barbey was so impressed that he said, 'I'm going to come back through here again.' He came back through and met with leading citizens. Through their meeting, Vanity Fair came to Monroeville."

Chuck Pelham, local retired Vanity Fair executive, said, "U.S. Representative Frank Boykin, who was a good friend of Probate Judge E.T. 'Short' Millsap, was touring Mr. Barbey. It was no chance stop here in Monroeville."

The Monroe Mills Plant, which was eventually opened in 1937, was influential in changing the county's economics from agricultural to industrial. A.B. Blass Jr., local businessman, says, "When the 'silk mill' first came, I was working in my daddy's store, and men from Scratch Ankle, up near Finchburg, would come in and say, "I'm doing fine, Mr. A.B. How're you? I tell you now, I like that new mill. You know, I got a wife that works at that mill and she brings home money, and I bought me a new truck. You can't beat that—havin' a wife workin' in town and you can hunt and fish all the time in a new pickup truck. I sure like that Vanity Fair."

V.J. Elmore's Five & Dime Store is seen on the south side of the Square.

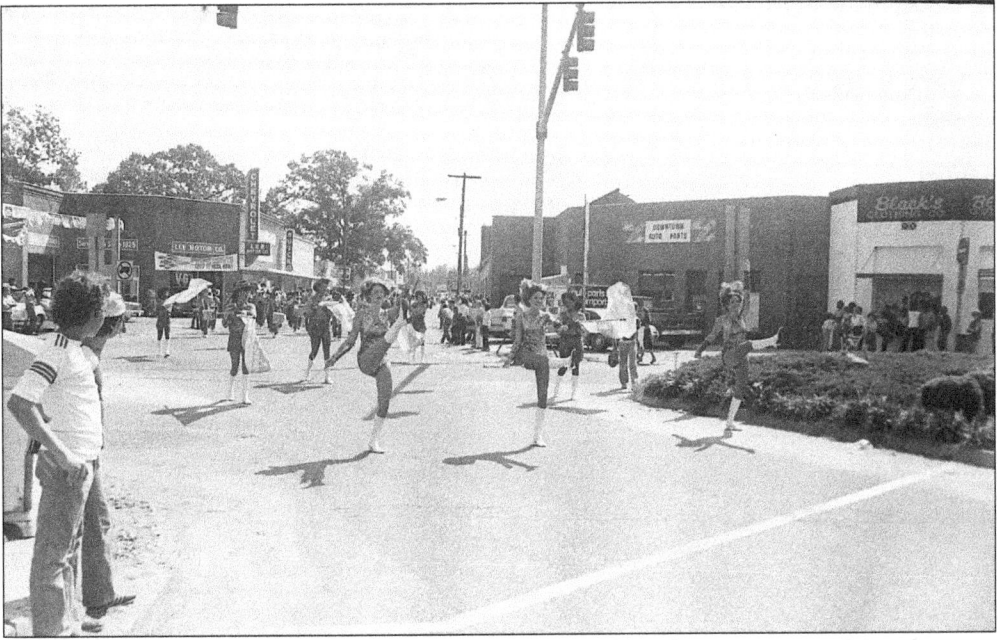

Parades are a Monroeville tradition, with all local school bands participating. Majorettes are always a featured section of the bands. On the corner, in the 1940s, was the Sinclair station. Another gas station, Ward's, was across from it. Norman Barnett, whose hardware store was on the Square, recalled, "Mr. Ward was an expert mechanic and in the 1930s, when an airplane had had to make a forced landing in a pasture near the school, he rebuilt the engine for the pilot, who was then able to fly out of here. People were really excited by airplanes then. Even in this little town, many airplanes would land on a grass strip and give people rides."

This photo shows the southeast corner, diagonally across from the courthouse lawn, as it is now.

The building that now houses Hanje's Furniture Store was V.J. Elmore's Five & Dime Store in the 1930s.

M. Katz Dry Goods Store was a large department store on the south side of the Square. A.B. Blass Jr. says, "It was 'the' store in our town in the 30s and on afterwards, too, until it closed in 1986. The story was that Mr. Katz came into town with a push cart and sold dry goods, buttons, and needles, and he pushed it to all edges of our county. He liked the town so much, he brought his family to live here in 1914. He built this store and ran it with his children, four boys—one of them is still here now. The Katz family was very helpful in our town. They gave to everything, to any charity. Anybody who was taking up money could go to the Katz store and get the biggest gift there."

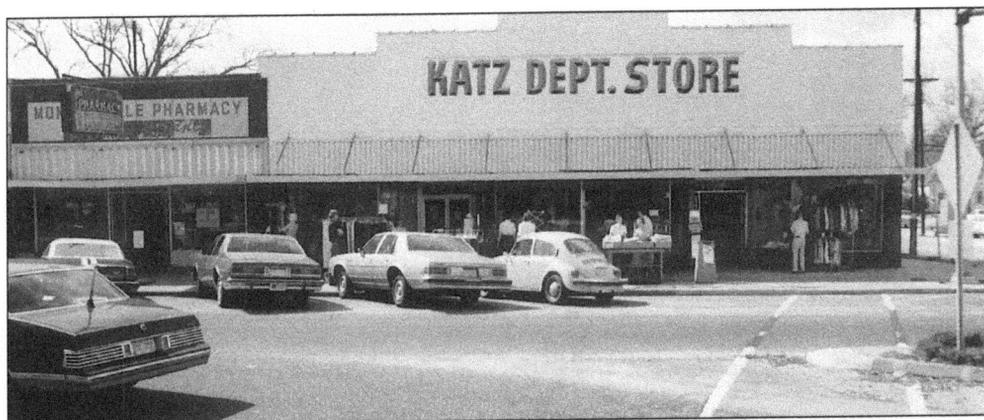

Next to Katz Department Store was the Monroeville Pharmacy. "When you would go in the drug store," according to Mr. Blass, "the men would sit around the little wire tables with marble tops and drink fountain cokes that came in a glass. The soda jerk would mix them. You could make them strong or weak by how much syrup you put in it. The men would go in and say, 'Give me a dope.' (When Coca-Cola was first made, the original formula started in Atlanta with cocaine in it. That's why it was called Coke. Later on they found that cocaine was not good and took it out of the formula.) I have been in that drug store many times with Nelle Lee, and she drank coffee most of the time. We all met there after school.

"One more thing about the drug store. We would all play baseball between this drug store and another store. There was a large lot there back then. The first time I saw Truman Capote, he was driven up in a limousine by a black chauffeur. He got out of the car, and he was a little older than me but smaller. He asked if he could play ball, but we said, 'No, you can't play.' He said, 'Would you like a treat?' We asked, 'At the drug store?' He answered, 'Sure.' We said, 'Fine.' So he carried us to the drug store (about 7 of us) and we sat on the stools and he said we could buy anything we wanted and told the druggist, 'Charge it to my mama.' After that, Truman was readily accepted on the team and played with us."

For the town's Centennial Celebration, May 1, 1999, local resident Harvey Gaston dressed as Meyer Katz and stood by the old store, telling the Katz family's history. One story he told (which had been related by David Katz, grandson of Meyer Katz, to Monroeville native George Thomas Jones) was of Meyer Katz's dealing with the local Ku Klux Klan. In the 1920s, some klansmen came in the store to buy some white sheets. They were joking around about buying them from a Jewish merchant. Katz replied, "That's all right because you know who I am and I know who you are. And, you know that if you buy them somewhere else you will have to pay more for them."

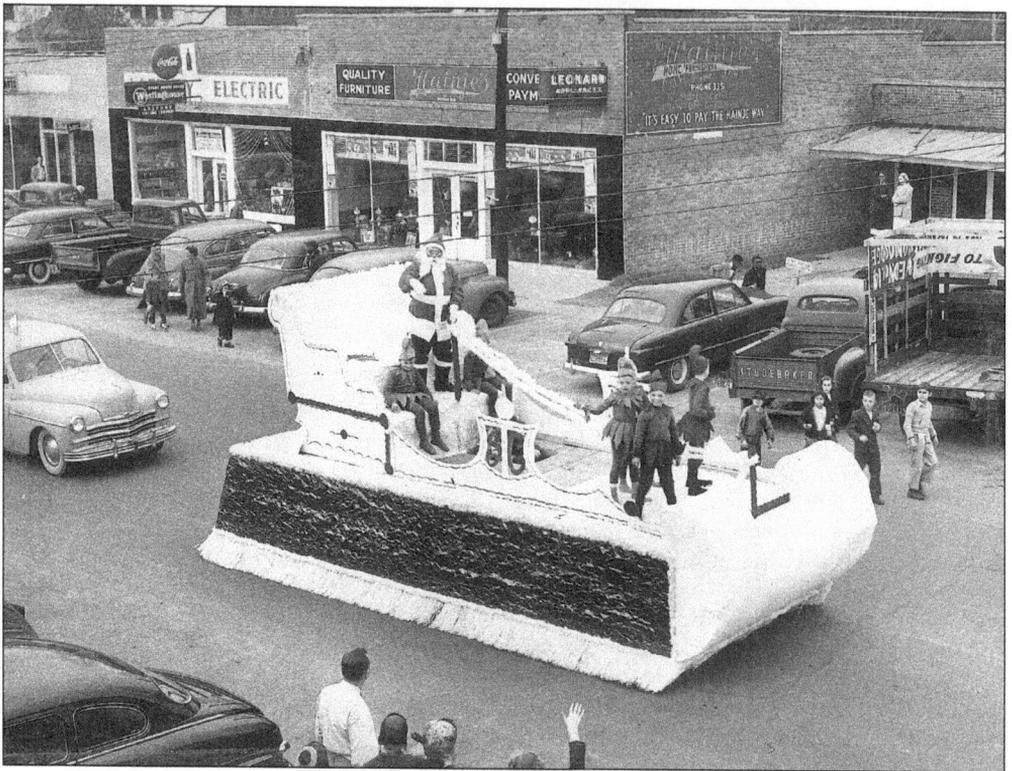

The Santa float for the 1952 Christmas Parade is shown on West Claiborne Street, just off the Square, across from the bakery. The Christmas Parade was an annual event for a long time, starting in the early 1940s. Later on, it was put on by the Kiwanis Club.

"In 1959, there was one scheduled—about the eighth we had done," said A.B. Blass Jr., of Monroeville. "I was committee chairman, since I was the President of the Kiwanis Club, and we had bought a ton of candy to give away. I was going to have to play Santa Claus that year, and we had it all lined up to go.

"Then, I was approached by a man who was a member of the Ku Klux Klan. They had been getting stronger for about a year. They had been meeting at the local coliseum. They would come through town at night and block the roads. They had their uniforms on, their hoods on, and they had lights on in the cars. The blacks were afraid to come into town to do their business. At the time, we didn't think too much about it; we thought it would go away, but it didn't. It became stronger.

"They came to my store and told me, 'We're not going to allow you to have that black band in the parade.' And we said, 'Look, we've had them in the parade every time we've ever done it. We've got all the bands from all the schools in the county—about seven. And we've always had that band. It's one of the best ones.' He said, 'Well, you're not going to have it this year.' And he called them the 'N-word', and said, 'We'll see about it.' So I said, 'Well, they're going to march.' That night, they threw a brick through the principal's window at home and on it, it said, 'We will kill your people. Blood will flow.'

"The principal came to my store the next morning, and said, 'Mr. Blass, I cannot allow my people to march.' So I got our committee together, and we said, 'If we can't have that band like we proposed to do, we'll just stop the parade.'

"So I contacted the *Monroe Journal*. The editor put the word out fast and we began to get calls from the Associated Press and all the daily newspapers. And they came down to interview us."

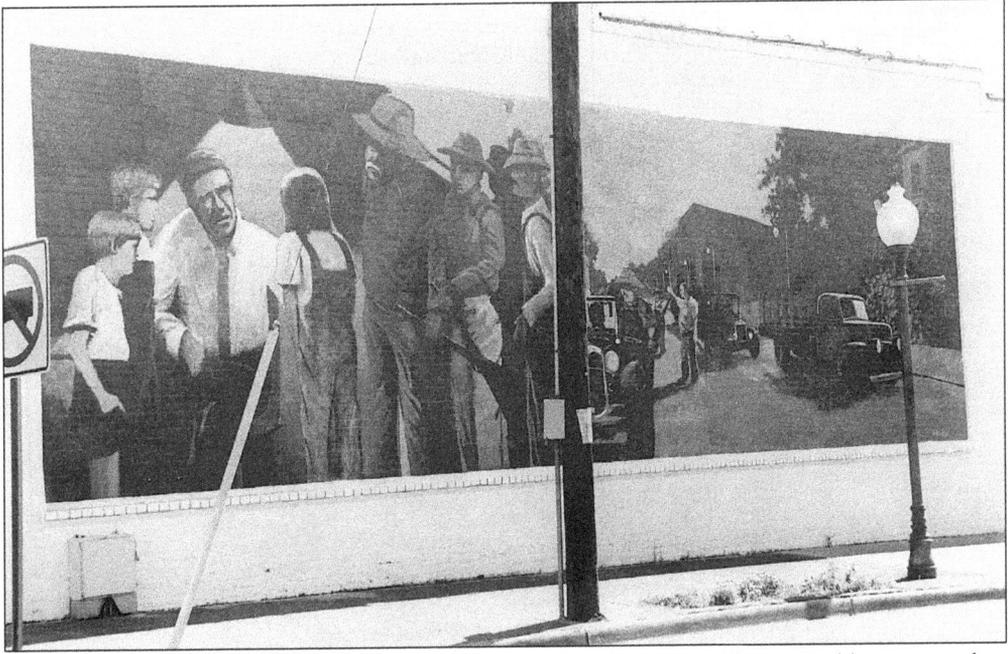

Going south down South Mt. Pleasant Avenue, on the side of the old Katz Building, is another mural painted by Bill Harrison of Baldwin County.

The Sweet Tooth Bakery, today, is on the southwest corner diagonally across from the Square. Lunch (we call it dinner, though) is a tradition there. Southerners like their big meal in the middle of the day. The buffet overflows with three kinds of meat every day, including fried chicken, smothered porkchops, and beef tips in gravy, among other favorites. Greens, either turnips or collards, and cornbread are served every day, and all the vegetables are well-cooked and seasoned.

In the 1930s, there was a bakery two doors down from there in the two-story building, called Thompson's, which Truman Capote called Puckett's Bakery in his novel, *The Grass Harp*.

"It's pretty hard to beat **NATURE**"

Mighty Mules *Hitched to a dynamometer (a strength testing machine) these powerful mules record their strength for the photographer.*

HERE is a famous pair of mules—mighty creatures with the pulling strength of a pair of four-legged giants. At a recent university test, they threatened the world's pulling record.

What makes these mules unusual? Mother Nature gave them something—her own natural balance of many elements; strength, staying power, the willingness to work. So in actual value, these sturdy mules stand out from ordinary mules—there's just no comparison.

And Nature gave a natural balance to Natural Chilean Nitrate, too—a natural balance of

many elements that combine to make this nitrogen fertilizer a reliable food for your crops.

Natural Chilean is known for its quick-acting nitrogen, of course. But nitrogen is only one of its vital elements. Because of its *natural* origin, Chilean Soda also contains, as impurities, such elements as iodine, boron, magnesium, calcium and some 28 others. And always remember that these vital elements are present in Chilean Soda in Mother Nature's own wise balance and blend.

For better crops . . . Natural Chilean Nitrate.

Natural Chilean
NITRATE of SODA
NATURAL AS THE GROUND IT COMES FROM
● *With Vital Elements in Nature's Balance and Blend* ●
RADIO — "UNCLE NATCHEL & SONNY"
FAMOUS CHILEAN CALENDAR CHARACTERS
See announcements of leading Southern Stations

This popular fertilizer was sold at local feed stores. Uncle Natchell ads, featuring cartoons sometimes, ran in the *Monroe Journal* from 1937 to 1949. There was also a radio program sponsored by the company.

A half-block south of the square, on South Mt. Pleasant Avenue at this site, was a mule barn, where a number of political deals were made. The probate judge, E.T. "Short" Millsap, was a mule trader and a well-known politician. He also served as state senator at one time. Politicians would come from all over the state and meet him at his mule barn to confer on politics. His rural constituents felt more comfortable meeting him there, too. He would rear back in his old oak chair, throw one leg over an arm of the chair, and stay there, sometimes, until nine o'clock at night. In his 1963 obituary, the *Montgomery Advertiser* said he had been one of the last political "bosses" of Alabama.

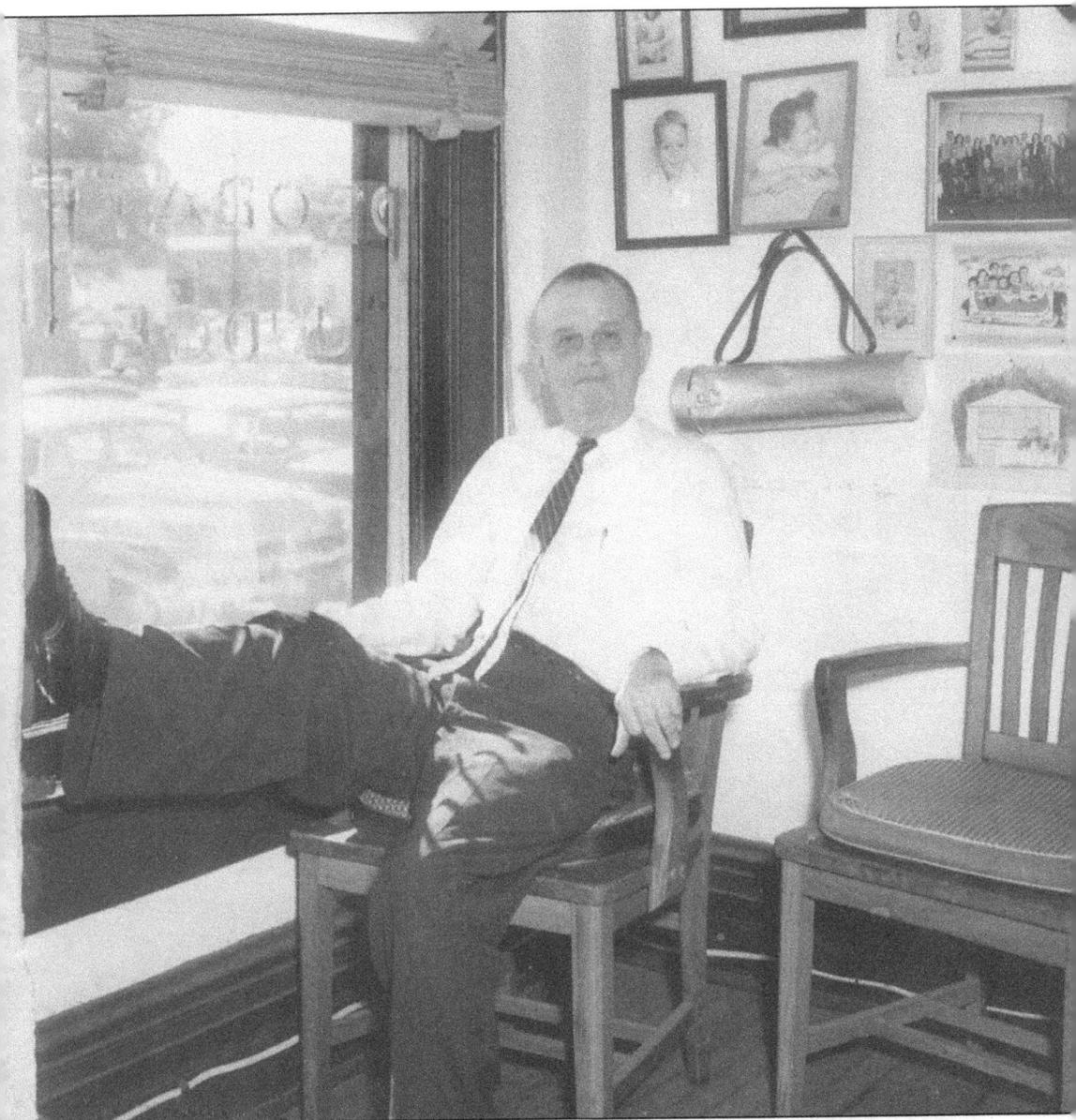

E.T. "Short" Millsap, seen here in his office in the 1903 courthouse, was probate judge of Monroe County from 1941 until his death in 1963. He commissioned the building of the newest courthouse, which was completed in 1963. He left an excess of a million dollars in the county coffers.

Current Probate Judge Otha Lee Biggs worked as clerk for Judge Millsap for many years. "My office was right next to his; all he had to do was call for me through the open doorway.

"This was his usual position—sitting in that chair by the window, watching the front door of the courthouse, looking out the window onto the Square, and thinking," remembers Judge Biggs. "In the summertime, people would come by the window to talk to him. If he saw someone he needed to see go in the post office across the street, he'd send someone over to tell them to come by. He kept another chair next to his for visitors. He ran this county from that chair by the window."

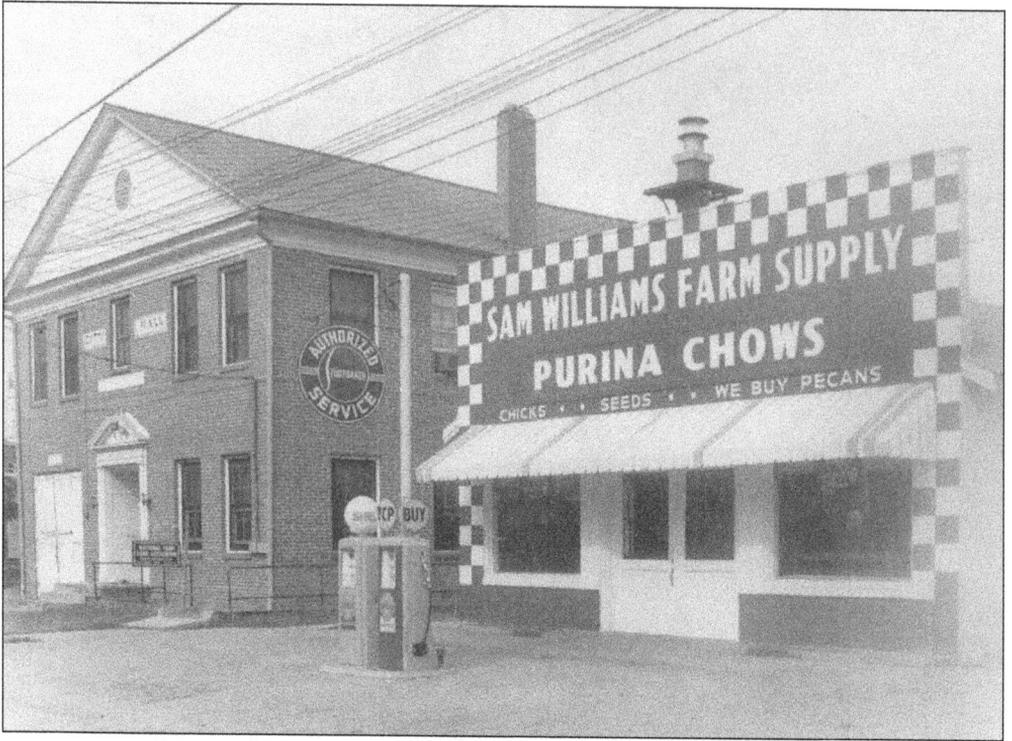

The city hall and the feed store were across the street from the mule barn.

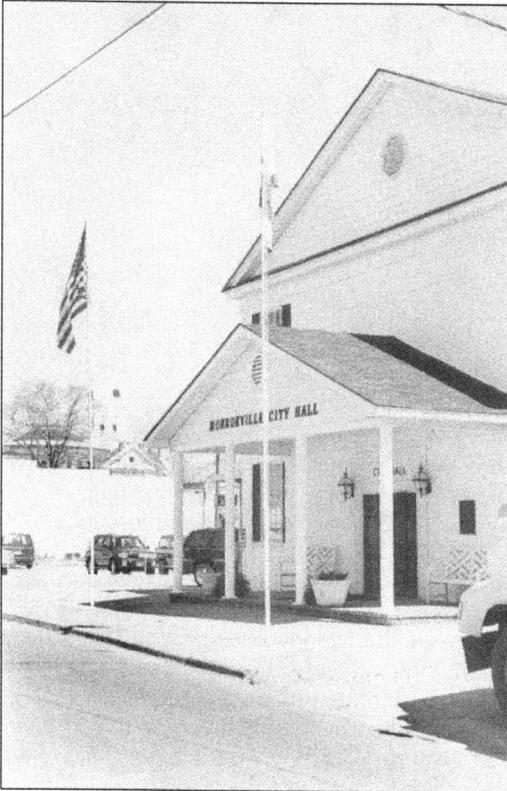

Today, the city hall is still half of a block off the courthouse square. The courthouse dome can be seen in the background.

This is the Mims's home. According to A.B. Blass Jr., "This family moved to town when roads were dirt and there were no telephones or lights. Mr. D.D. Mims decided to buy a Delco light plant which used batteries in glass containers that were charged by gasoline engines. He put them under this house, and hooked up three houses nearby (one being his wife's sister's). The probate judge's house was down this way and his house was hooked up, too. He added about seven houses to his string of lights on this street. He also installed plumbing for water and later a telephone. So this family was a sort of pioneer for this community for water and electricity— and he built a nice house. Later, in 1923, he went into business with Mr. J.C. Hudson to build a power-generating plant and ice-making house for the town."

Across from Mr. Mims's house was his pasture and barn, where this empty field is now. This pasture was behind the Lees' and Faulks' houses. One time, around 1920, an airplane had to make an emergency landing here. Dr. Woodrow Eddins recalls it being the first time an airplane ever touched down in Monroeville.

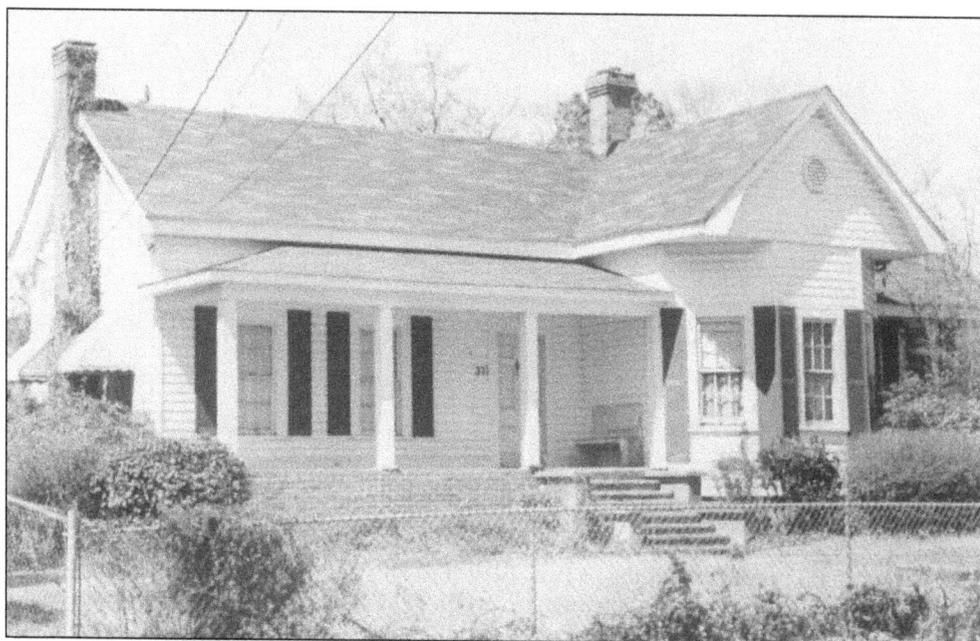

Probate Judge Millsap's house is in the next block of South Mt. Pleasant Avenue, between the Square and the school.

The Hudsons' home was built in 1931, right across from the brick entrance pillars to the school. It was the first brick residence in Monroeville. Mr. J.C. Hudson was in the utilities business with Mr. D.D. Mims. Hudson and Mims ran an ice plant and generated electricity for the town.

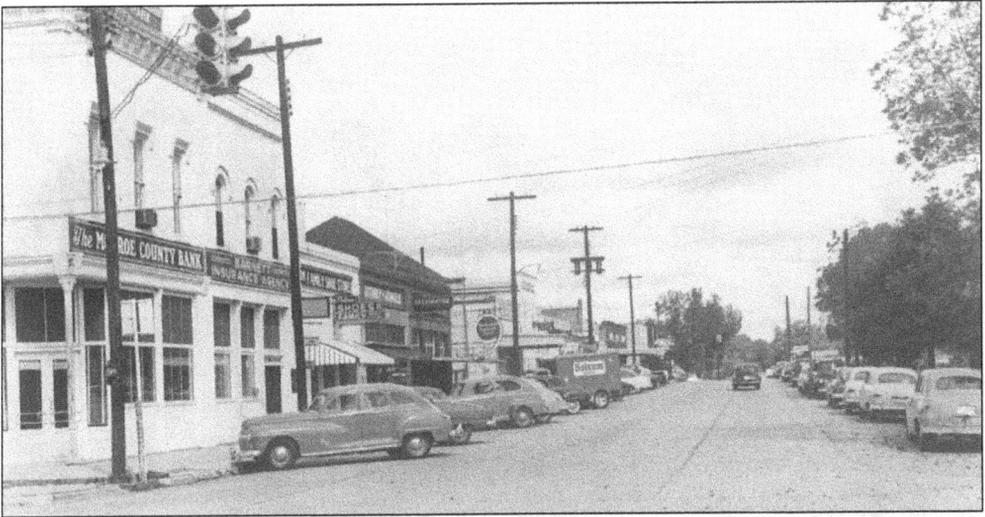

"Past the old bank building, was the Jitney Jungle Grocery Store, then my store next, then the old jail, and the *Journal* was past there," A.B. Blass Jr. recalls. "When Gregory Peck came into town for three or four days in 1962, he came in my store to try and pick up the language of the people and the stories that had happened. My dad started the store in 1939, and I ran it several years myself. Gregory Peck came in and said, 'I've had coffee until I'm about to die. Do you have any soft drinks?' It was 10 o'clock, and I said, 'Well, you're supposed to drink Dr. Pepper at 10, 2 and 4.' He said, 'I want a Dr. Pepper, then.' So I gave him one and he and I drank a Dr. Pepper together while we talked.

"The bank was just down at the corner. A neighbor of mine now, Shirley Bowden, was in there, a young girl working as a teller. Mr. Peck came in and said, 'I'd like to cash a check.' She said, 'Sorry, you'll have to have some identification.' Her boss was nearby and heard her say that. He said, 'Shirley, I think we can take Mr. Peck's check.' "

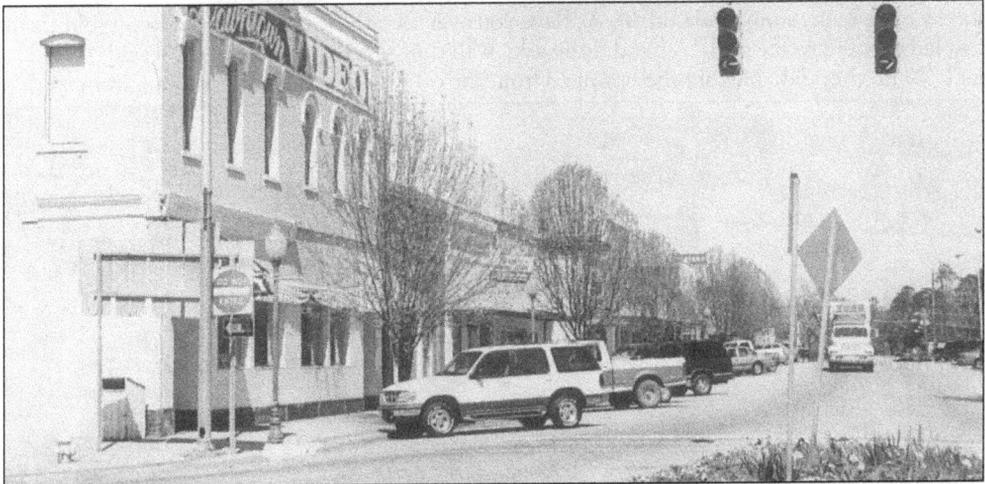

This was the location of the Monroe County Bank and the law offices of Barnett, Bugg, & Lee (the Lee being Harper Lee's father, A.C.). "Mr. Lee kept an old typewriter there," according to Walter Nicholas of Greenville, Alabama. "I used to spend summers in Monroeville with relatives and frequently, we'd go to town with Nelle and Truman to the office and we'd type on the typewriter. Mr. Lee didn't mind having us around," Mr. Nicholas said. He even heard Nelle call her father "A.C.," something unheard of in most families around here.

Mary Tucker, retired local teacher, recalls, "This building, used as a jail in the 30s, was still used into the 50s to house criminals. When the jail door was open, you could see the landing on the iron stairs with the trapdoor. They left the hanging rope over it for a long time after the electric chair took its place in 1927, I guess, as a deterrent to crime.

"At the jail, the windows on the outside had these screens on them over the bars," A.B. Blass Jr. remembers. "One day a lady came into my store, and she said to me, 'Do you have any hacksaw blades?' And I said, 'Yes, we have some.' She said, 'Do you have any real good ones?' I said, 'Certainly, we have some very good brands,' and I showed her some. She asked me if they would saw through jail bars. I said, 'Sure, they will.' She said she'd take three. The next day, the sheriff came to my store, and said, 'A.B., have you ever seen these blades?' I told him I sold them to a lady yesterday. He said, 'What did she ask? Will they saw through jail bars?' I said, 'Yes.' He said, 'Well, they did.' He said they escaped from the other side and went down a sewer pipe."

In the 1960s, the old jail was converted into the town library. Today, it is used for county government offices. During Monroeville's Centennial in the 1930s, Al Martin (shown above with group) portrayed the local sheriff.

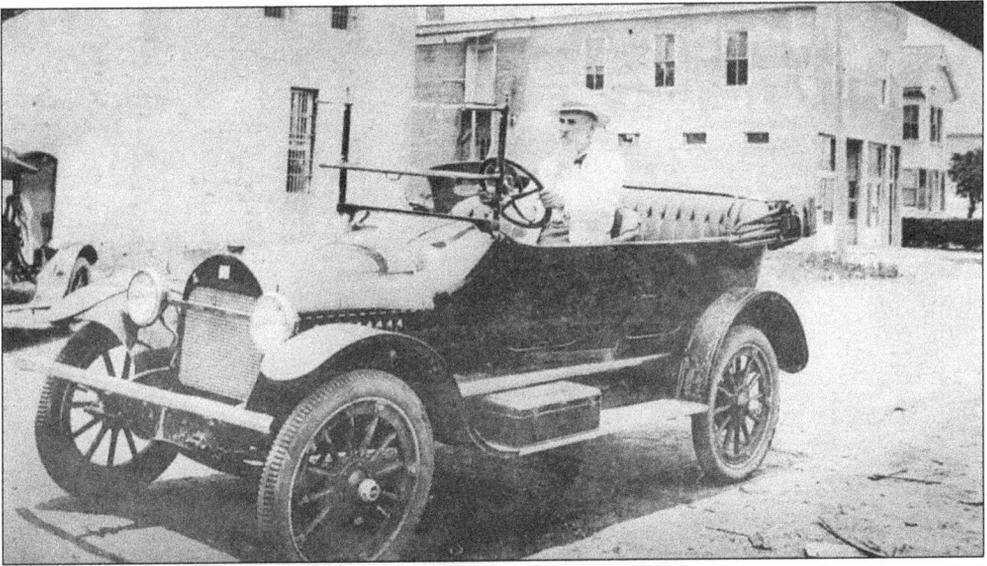

This picture was taken around 1915, on Captain John L. Marshall's 75th birthday. He traveled to Mobile for a Confederate Veteran Reunion in 1931. The Monroe County High School Band also went to play for that reunion. Mr. A.C. Lee was a pallbearer for Capt. Marshall's funeral in 1934.

The newspaper had an office in the building on the right. The jail is the building on the left. They were side by side then, with no other buildings in between. If the newspaper editor was in the upstairs window, he could have looked down and seen what was going on at the door of the jail.

The old jail building, with the pointed roof, is in the middle of the west side of the Square, as it is today. The old newspaper office is to the right in the two-story building. It has since moved. Other buildings have been built in between. To the left of the jail is A.B. Blass Jr.'s old Western Auto Store building.

A.B. Blass Jr. recalls, "The masonic hall was upstairs of the old newspaper office. Mr. Lee used to sit on the bottom floor and type when he was editor of the newspaper. Our store was just down the street. There is a little space where we shimmied up between the buildings one day to go through the window into the top floor of the hall. We didn't know what was up there. It was sort of a spooky thing—wondering what was up there. When we got into this upstairs room, we opened a thing that looked like a casket. When we did, a skeleton sat up in it. When I told my dad, we found that it had something to do with the Masonic Lodge. He said, 'Son, don't ever do that again. That's something you don't do.' "

THE MONROE JOURNAL

VOLUME 66 NO. 45. THE MONROE JOURNAL, MONROEVILLE, ALA. THURSDAY, NOVEMBER 10, 1932. SUBSCRIPTION $1.00 PER YEAR

Monk Gets Loose, Bites 2, Arouses Orleans Section

Grand Jury Will Probe Jordan Case

Baby Has 4 Legs, 3 Arms, 20 Toes

Treasury Faces Task Of Raising $5,000,000,000

Gov. B. M. Miller Proclaims December 2 As Arbor Day

Livestock Boosted for Alabama Farms

Fall Planting Of Fruit Trees Okey

MARKET STAGES MILD RECOVERY

BUSINESS REVIVAL WEEK NOVEMBER 12th to 19th

A Proclamation

NAME LONESDALE FRISCO RECEIVER

TWO WOMEN, AGES 99, VOTE FOR ROOSEVELT

PUSH FOR VIRGINIA

Buy It From Home Merchants

The *Monroe Journal* was established in 1866. A.C. Lee was editor from 1929 to 1947. Some of his editorials informed the people on issues to be voted on. In a 1934 editorial, he said, "The people can be trusted to express themselves properly when they are dealing with a question they can understand in a large measure." He always gave both sides of an issue to help explain in plain language what the vote was about.

In 1934, he printed an article in the *Monroe Journal* written by a reporter named Atticus Mullien of the *Montgomery Advertiser* newspaper. "Mullien was at the *Advertiser* when I got there in the 30s," said nationally known storyteller and author Kathryn Tucker Windham of Selma, Alabama. "He was a senior writer who had been there a long time."

72

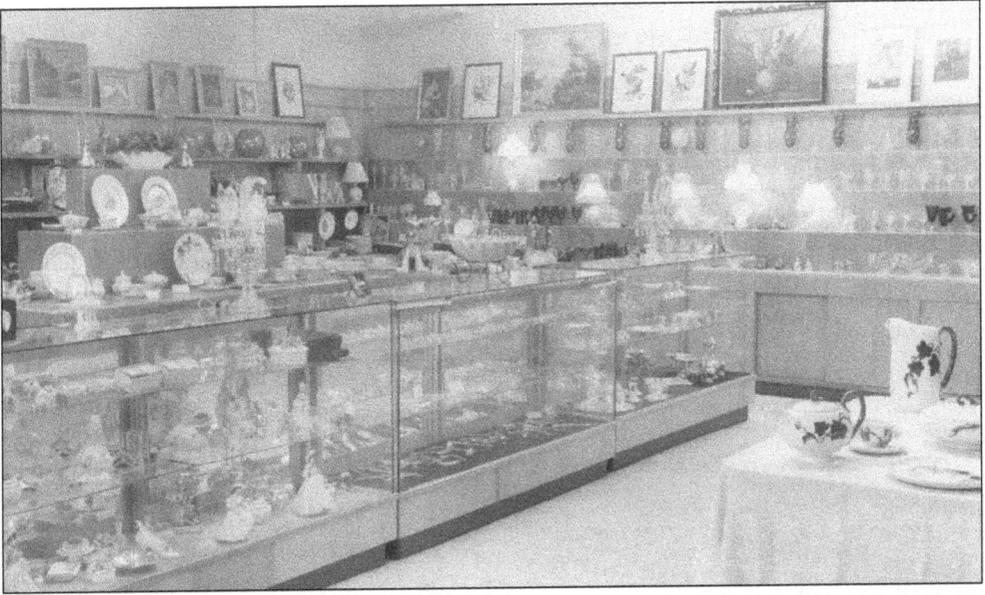

Earnestine's Gift Shop was on the north side of the Square in the 1960s and 1970s. "If you purchased the book, *To Kill a Mockingbird,* in the early days," recalled Dr. Margaret Murphy, English Department head at the local community college, "you would have purchased it from Earnestine's. Harper Lee did her only book-signing in Monroeville there."

"Recently I asked people around Monroeville what their response was to the novel when it first appeared. I'm not sure whether I was getting 1960s responses or 1990s responses.

"Most of the time I was told that they were delighted that a small town girl had done well. Monroeville is a community of 7000 people now, so you can imagine that we were very delighted that she had done well."

Frances Reid Nettles's *Monroe Journal* column "Ad Addenda" on September 1, 1960, reported, "Nell Harper Lee, author of 'To Kill a Mockingbird' will be at Ernestines Book and Gift Shop . . ."

THURSDAY, SEPTEMBER 1, 1960

Ad Addenda

By

FRANCES
REID
NETTLES

Nell Harper Lee, author of "To Kill A Mocking Bird" will be at Ernestines Book and Gift Shop Friday, September 2, from 9:30 to 5 p.m. where she will autograph copies of the book that have been sold and those that will be sold

HARPER LEE

Friday. Nell Harper arrived in Monroeville Monday from New York City where she will visit her father, Mr. A. C. Lee and her sister, Miss Alice Lee. "To Kill A Mocking Bird" ranked 7th on the Best Sellers Book List last week.

ALABAMA LAW

(Regular Session, 1961)

Act No. 19 H. J. R. 14—Jones (Monroe)

HOUSE JOINT RESOLUTION

WHEREAS, Miss Nelle Harper Lee, of Monroeville, widely acclaimed daughter of a distinguished father, Honorable A. C. Lee, who ably served several terms in the House from Monroe County, has won a Pulitzer Prize in letters and fiction with her best-seller, "To Kill a Mockingbird," and has thereby taken a place alongside such writers of reknown and great talent as Allen Drury, James Agee, McKinlay Kantor, and William Faulkner; and

WHEREAS, Alabama is tremendously proud of the illustriousness of Miss Lee, and of her accomplishment, which made her a celebrity; now therefore, be it

RESOLVED BY THE LEGISLATURE OF ALABAMA, BOTH HOUSES THEREOF CONCURRING, That we offer homage and special praise to this outstanding Alabamian who has gained such prominence for herself and so much prestige for her native State.

RESOLVED FURTHER, That the Clerk be directed to send an enrolled copy of this resolution to Miss Lee at Monroeville; that a copy be sent to the Monroe Journal; and that copies be furnished members of the capitol press corps.

Approved May 26, 1961
Time: 11:01 A.M.

I hereby certify that the foregoing copy of an Act of the Legislature of Alabama has been compared with the enrolled Act and it is a true and correct copy thereof.

Given under my hand this 29 day of May, 1961.

OAKLEY MELTON, JR.,
Clerk of the House

This Alabama Legislative Resolution of 1961 was held up, two weeks after Lee's Pulitzer Award, by Senator E.O. Eddins of the Black Belt region, just north of here. The *Montgomery Advertiser*, May 20, 1961, reported, "Eddins later explained he had decided to withdraw his protest lest it make a martyr of the author."

"Not everybody loves the book, and one person—frequently, its just one person—can cause censorship to take place," according to Dr. Margaret Murphy, English teacher. "*To Kill A Mockingbird* has been censored on the basis of references to the sex act, the slang (grammar), the curse words and other obscene words, and racial slurs, such as—if you will forgive me for using a word that I do not use—'nigger.'

"The censorship also includes some of the portrayals of rebelliousness in children. Our saying is 'children should be seen and not heard.' And also, some of the values expressed in the book have been objected to.

"In the 1960s, censorship was at its height. The first real objection came from the state of Virginia. One man, W.C. Borsher, looked around and noticed that *To Kill A Mockingbird* was not on the approved list. It had not been on the list for six years, but they were still teaching it. Well, he suddenly said, 'We can't teach it anymore. It is not on the approved list.' This seemed to come from out of nowhere. He said it was immoral literature. And, of course, they condemned many other books.

"Not all the people of Virginia agreed with him. One young man said, 'You anger those of us who have minds. We can think for ourselves.' One other said, 'If it is so bad, why am I not bad for having read it?'

"The objections to it went throughout the states, primarily, for the racial slurs in the book. In the 70s, censorship began to dwindle away. In the 80s, there was very little. In the 90s, I found only one trace of that. One lady thought it should be completely banned around the world because of the racial issue. But, that's part of our history. History has many instances of many things we would like to change if we could, but we just can't change that, so, as teachers, we want to present it as realistically as possible.

"There is little trace of censorship at this time. We have, as they say, 'Bigger fish to fry': we are trying to deal with pornography on the internet now!"

74

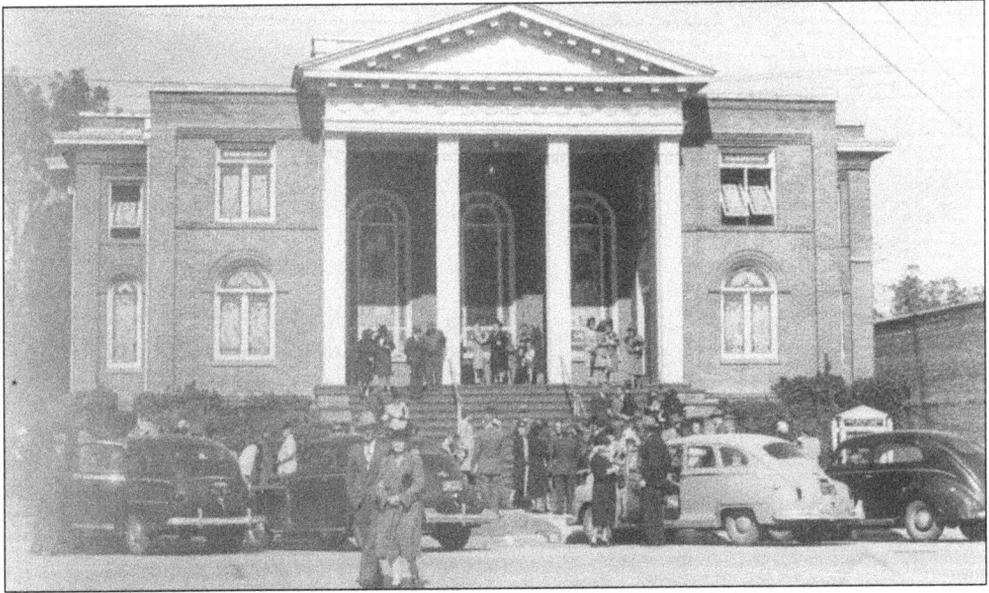

The First Baptist Church, a two-story building with beautiful stained-glass windows, was on the north side of the Square. In 1959, the congregation moved to a new building east of town on Pineville Road, across from the cemetery.

The Methodist Church of Monroeville was on the southeast corner of the Square. In the 1920s, all of the churches in town were on the square. The Baptist church was on the north, the Methodist on the southeast (shown here), and the Episcopal and Presbyterian churches were on the west.

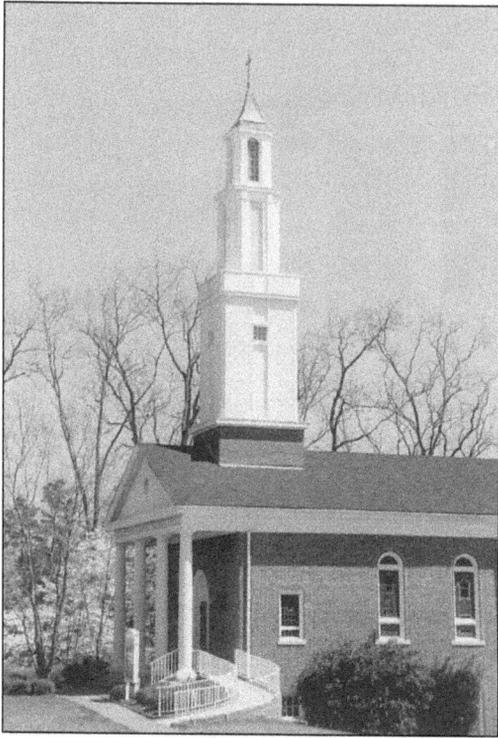

The First United Methodist Church, on Pineville Road, is the Lee family's church. "It was A.C. Lee's habit to sit by himself down in front in the small, intimate sanctuary," says David Stallworth, local resident who was born and raised in this church. This building was erected on this site after the old church on the Square burned in 1929. Beyond this building, is the town's largest cemetery, actually three distinct cemeteries side by side. The Lees are buried there, as well as the Faulks, Stallworths, Katzes, and other families in town. The northeastern town limits are just beyond the cemetery.

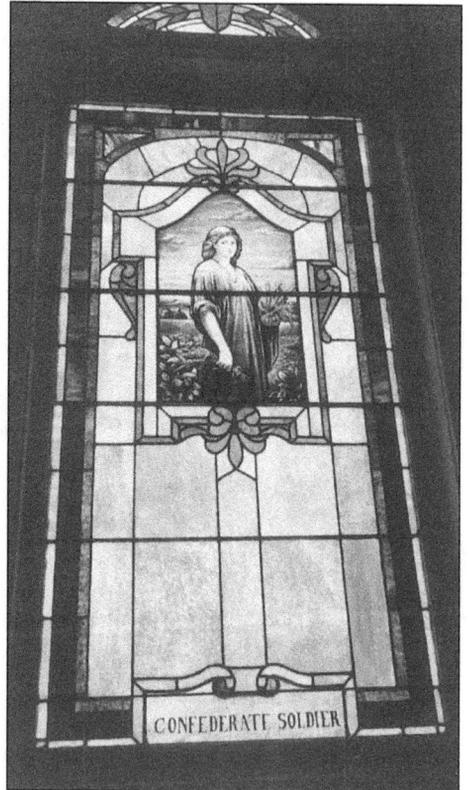

CONFEDERATE SOLDIER

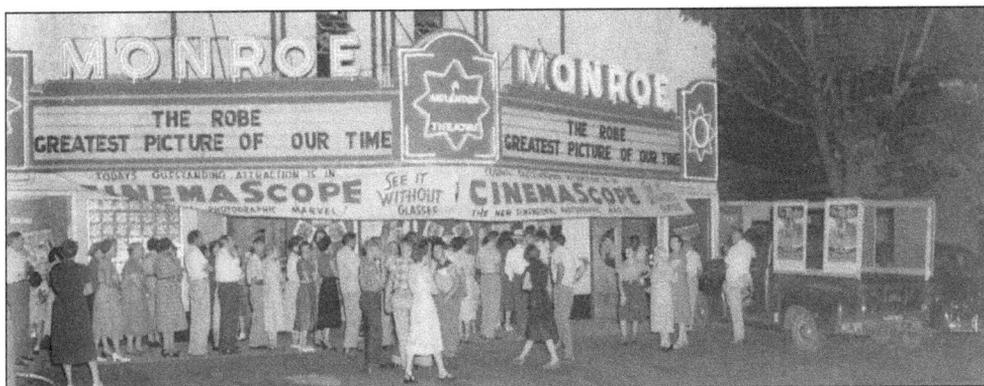

The Monroe Theater opened as the Strand in 1927, later changing its name. When it burned in the 1970s, it was never reopened. Jane Hybart Rosborough, who grew up in the northern part of the county, remembers being taken to town one weekend to stay with her aunt. She went to the picture show, and Harper Lee and Truman Capote were there. "We were all in the theater laughing, joking, and playing around, but Nelle and Truman were playing word games. They were a little above the rest of the kids in town," she recalls.

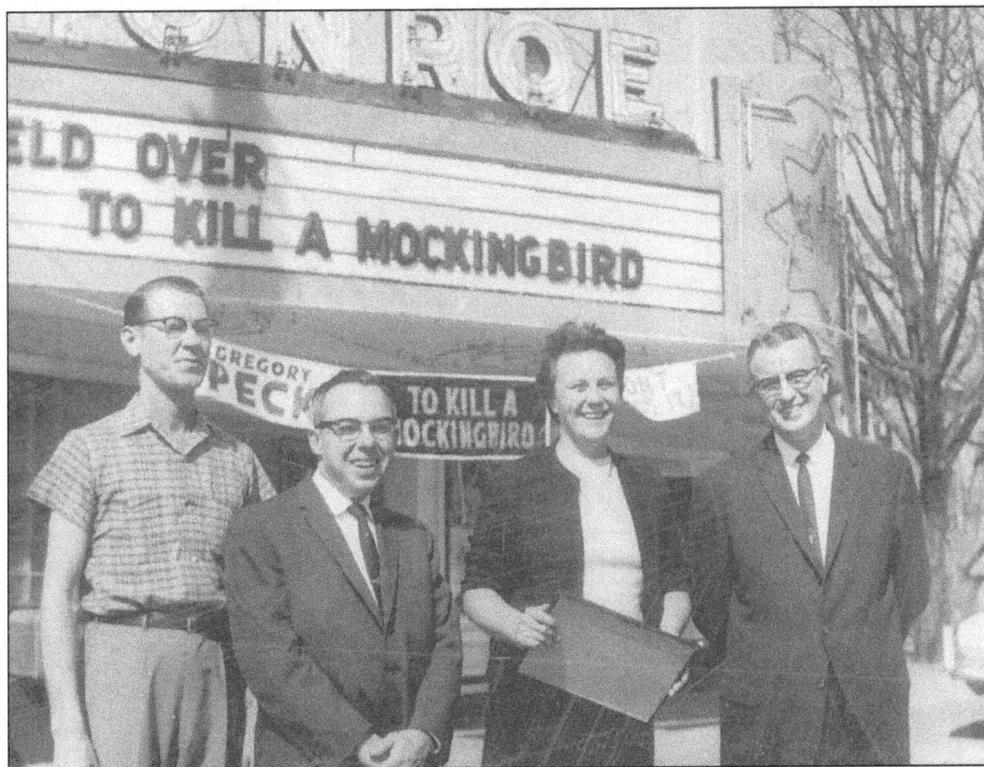

To Kill a Mockingbird played in Monroeville at the Monroe Theater. "We would have liked to have had the premiere here," remarked Dr. Margaret Murphy, local teacher, "however, Monroeville just was not large enough, and the premiere was held in Mobile. Nelle Harper is standing here with (left to right) Milton Dorriety, Sam Bowden, and John Barnett Jr. (right).

"I happened to be with my husband in Mobile during the week of the premiere of the movie. My husband taught science and we had taken the science fair students down to the district competition. We all attended the movie during premiere week in Mobile."

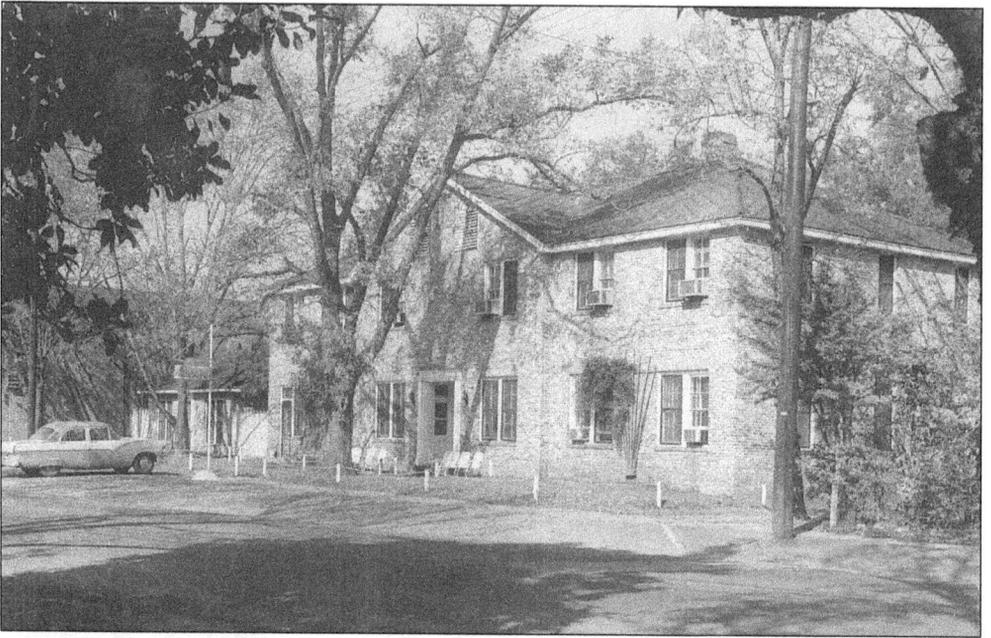

The LaSalle Hotel is where Gregory Peck and his wife stayed when they were in town in 1962. "My husband was teaching at the time and he said it was almost impossible to teach with Gregory Peck in town," said Dr. Margaret Murphy, local teacher.

This building is now our library, with an extensive Alabama Authors Room. According to the *Montgomery Advertiser-Journal* newspaper on December 23, 1962, Lippincott Publishers, who originally published *To Kill a Mockingbird*, donated 300 books to the town's library, then located in the old jail building. Each book was inscribed, "Given in memory of A.C. Lee to the Monroe County Library," and were displayed on the memorial shelf of the library.

East of the library, on Pineville Road, is the site of Judge Nicholas Stallworth's original home. He was the probate judge who commissioned the building of the 1903 courthouse, which remains on the Square today. He was widowed and raised his 11 children here. The first house burned, and the present one (below) was built on the site.

Judge Nick's daughter, Mary, and her husband, Judge Frances Hare (right), inherited his house. Judge Hare was the circuit judge in the 1930s, presiding over cases in the Old Courtroom, made famous by the movie, *To Kill a Mockingbird*.

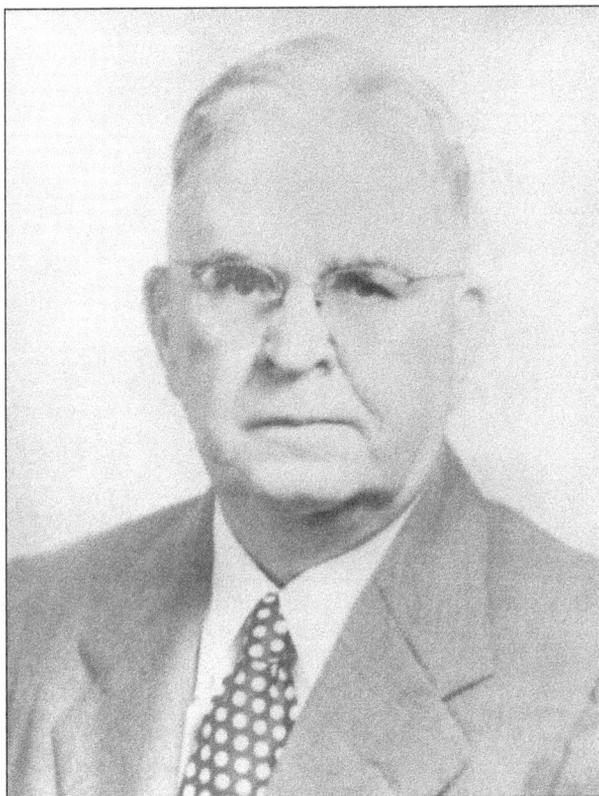

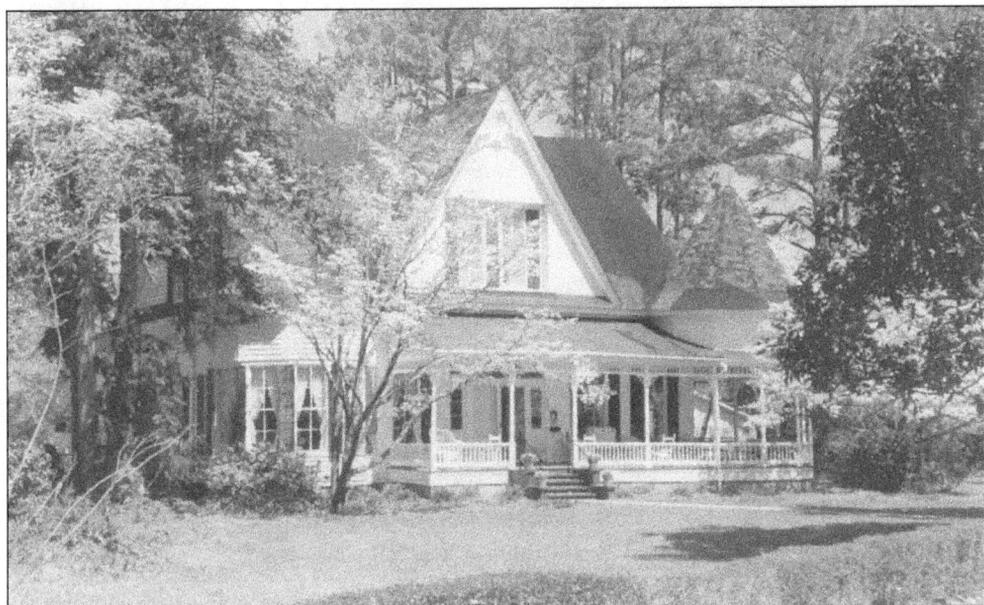

"Mary Stallworth Hare came closer than anybody else in town to having a flower garden like Miss Maudie Adkinson's in the book," Mary Tucker, local retired teacher, believes. "Her son, lawyer Nick Hare, lives there now and keeps the flower beds looking as beautiful as ever."

Mimosa trees, with their puffy, pink, fragrant flowers, were introduced from the tropics and escaped cultivation. In the United States, they grow on the coastal plain surrounding the Gulf Coast. They have spread all over southern Alabama now. A mimosa tree next to the porch smells heavenly on a warm summer night.

The old, traditional southern yard had many pass-around perennials. Friends gave friends cuttings, seeds, and root dividings. The overhanging tree is a live oak, a tree that grows only on the coastal plain from North Carolina to Texas. The leathery, evergreen leaves and dark, furrowed bark distinguish them from the more common water oak.

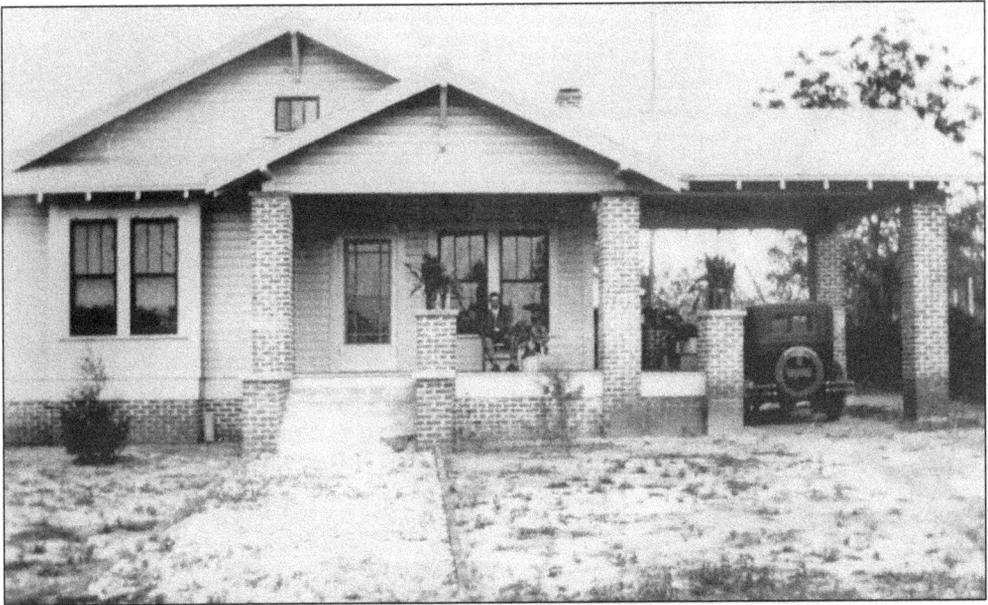

This modest bungalow, built in 1928 by Jesse B. Wood and Tom Davis, is located on Johnson Street, in a neighborhood between what is now the Monroeville Elementary School and the Monroeville Junior High School.

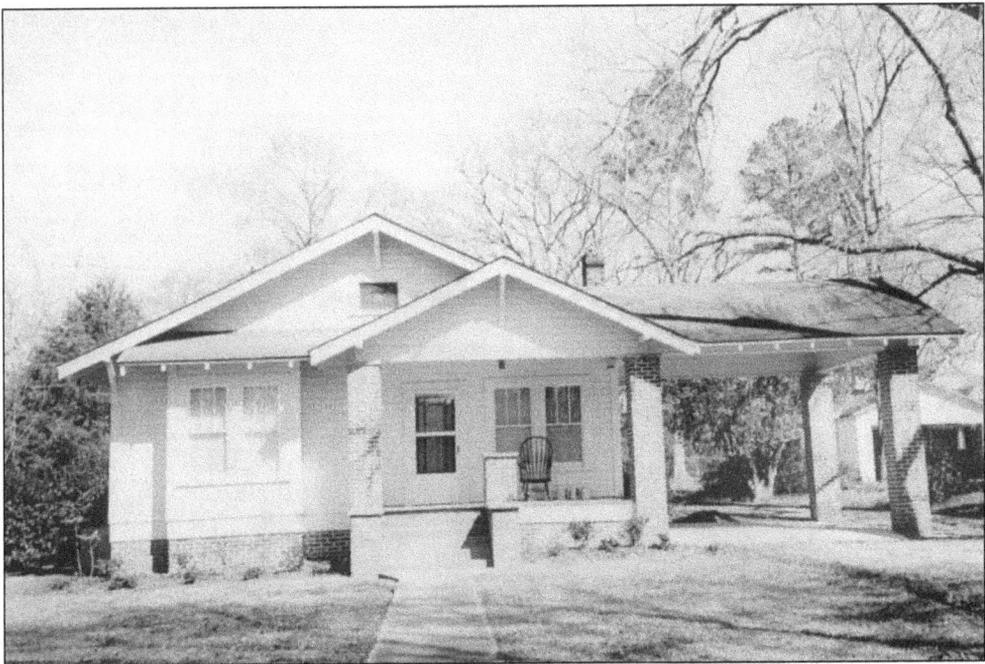

The house is still here and virtually unchanged. The neighborhood has always been popular with young families, whose children can walk to and from school every day.

Colorful Canna Lilies are heat-loving perennials that bloom all summer in the southern half of the United States. Easily grown from tubers, gardeners prize the large, showy plant with its yellow, red, or orange flowers.

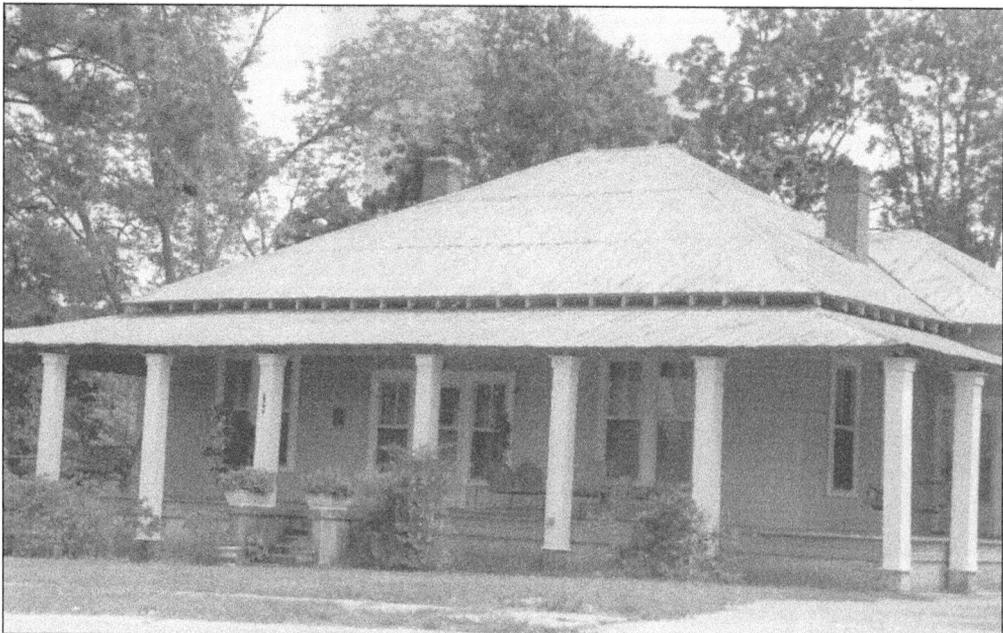

The Russell house, across from Nick Hare's house on Pineville Road, has long, wide porches and two porch swings. In Monroeville, the big elaborate houses are mixed in with the more modest houses, but all have porches and places to sit on the porch.

Wisteria vines are planted to shade porches from the hot summer sun. The spring blooms cover the vines with purple clusters. Then, the thick growth of leaves completely shields the porch from view. Southern families use the porch as an additional room. It is always cooler there than in the house.

Kathryn Tucker Windham of Selma is originally from Thomasville, right across the river from Monroe County. She said recently, in her weekly story on public radio, that she fondly remembers her mother sewing new cushion covers and filling the front porch rockers with them, signaling the summer season.

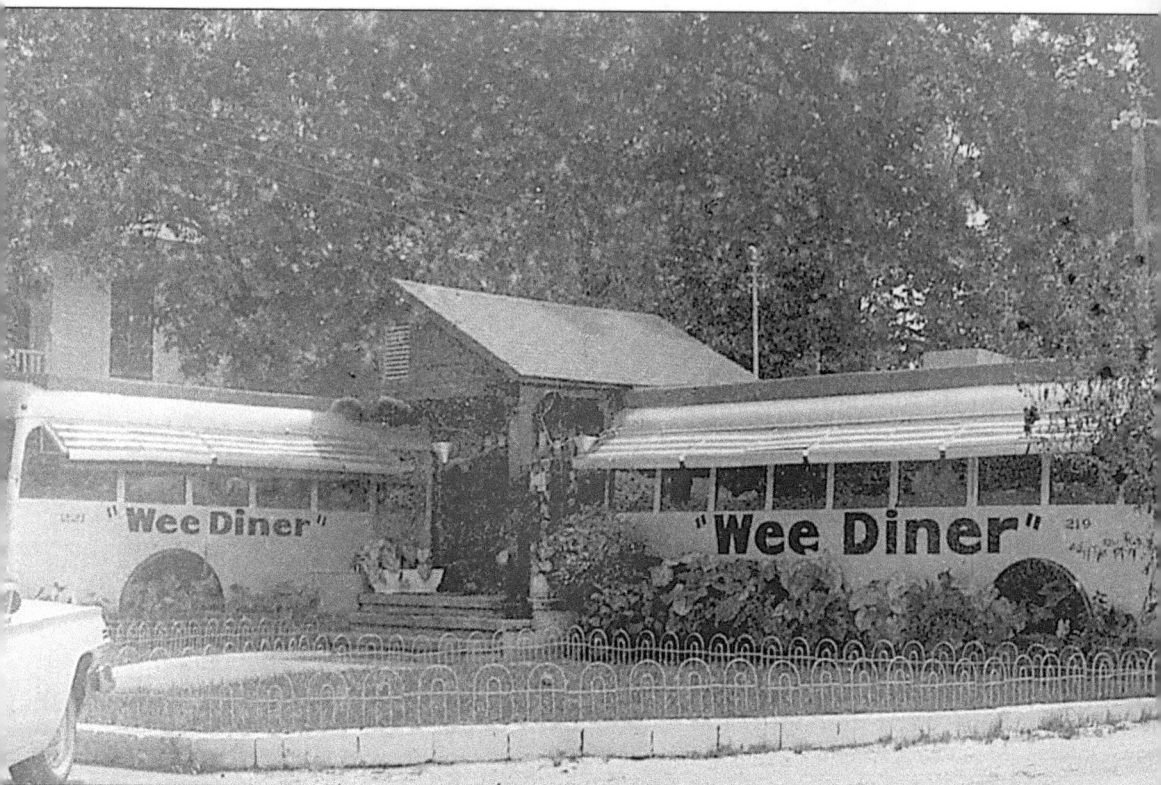

The Wee Diner, a famous Monroeville eating place, was run by Frank Meigs, Sally Montgomery's father. (Sally plays Miss Maudie in the Museum's annual production.) A.B. Blass Jr. remembers how The Wee Diner came to be. "We all pitched in and went to Mobile and bought these two buses, drove them here, and tore them apart and located them in this area in the back parking lot of the First National Bank, and made a restaurant out of them. We knew Frank would make a great chef.

"The way it got important, other than having great food, was—Gregory Peck stayed in the hotel across the street and he ate meals there. He enjoyed the wonderful food there—delicious Greek salads and fabulous steaks.

"It was in this location for about 5 or 6 years, before it was moved out by the new junior college. It closed sometime after that. Even now, once in a while, I sure wish for one of his steaks."

Margaret Murphy remembers Gregory Peck's visit to Monroeville. "My mother-in-law called me one morning and said, 'I know you're going to hate me for this.' And I said, 'What *are* you talking about?' She then said, "Gregory Peck was going in the Wee Diner to have coffee this morning, and I would have called you, so that you could have come down, but I didn't have a minute to spare." But, at least *I* had coffee in the Wee Diner with Gregory Peck.' "

Martha Jones Moorer was in high school the year Gregory Peck came to town. One night she and some friends were riding around town trying to find him. "We were crazy teenagers and we wanted to see him." Martha remembers, "We finally found their cars at the Monroe Motor Court and decided which room they were having a meeting in—trying to get away from people like us! My friends dared me to knock on the door. Miss Nelle herself opened it and, boy, was she mad. She said, 'Martha Louise, what *are* you doing here?' I told her I just wanted Gregory Peck's autograph. He was sitting right there and spoke up, 'I'll be happy to give you my autograph.' There was a nice-looking blond lady in there, too, and another man, Mr. Lee, maybe, but I really don't remember much more because I didn't tarry."

The First National Bank was on the east side of the Square, diagonally across from the other bank in town, the Monroe County Bank, on the west side of the Square. This building is now a lawyer's office, one of the 26 lawyers now with offices on the Square!

Finklea and Finklea Department Store was next to the bank. "Mrs. Nannie Swanson, an accomplished seamstress, had an alterations room in the back of the store with her own entrance in the back," recalls Jane Hybart Rosborough, former resident of the county. "We had two very good department stores in the 1930s, Finklea's and Katz's."

Barnett and Jackson Hardware Store was in business on this location from 1904 to 1989. Mr. Gus Barnett and later his son, Norman, carried everything their customers needed to maintain their homes, farms, and businesses, changing with the times until the last, when Mr. Norman retired and went out of business. Their motto was "You name it, we sell it."

The Barnett & Jackson Building was built from bricks brought up on the train from Manistee, south of Monroeville, which was a lumber mill town that closed when all the timber had been cut out. Mr. A.C. Lee had been a bookkeeper there for the lumber company. In 1913, his law firm, Barnett, Bugg, and Lee, bought the stock, trains, and rails and changed the name to the Manistee and Repton Railroad. He remained general manager until his death in 1962.

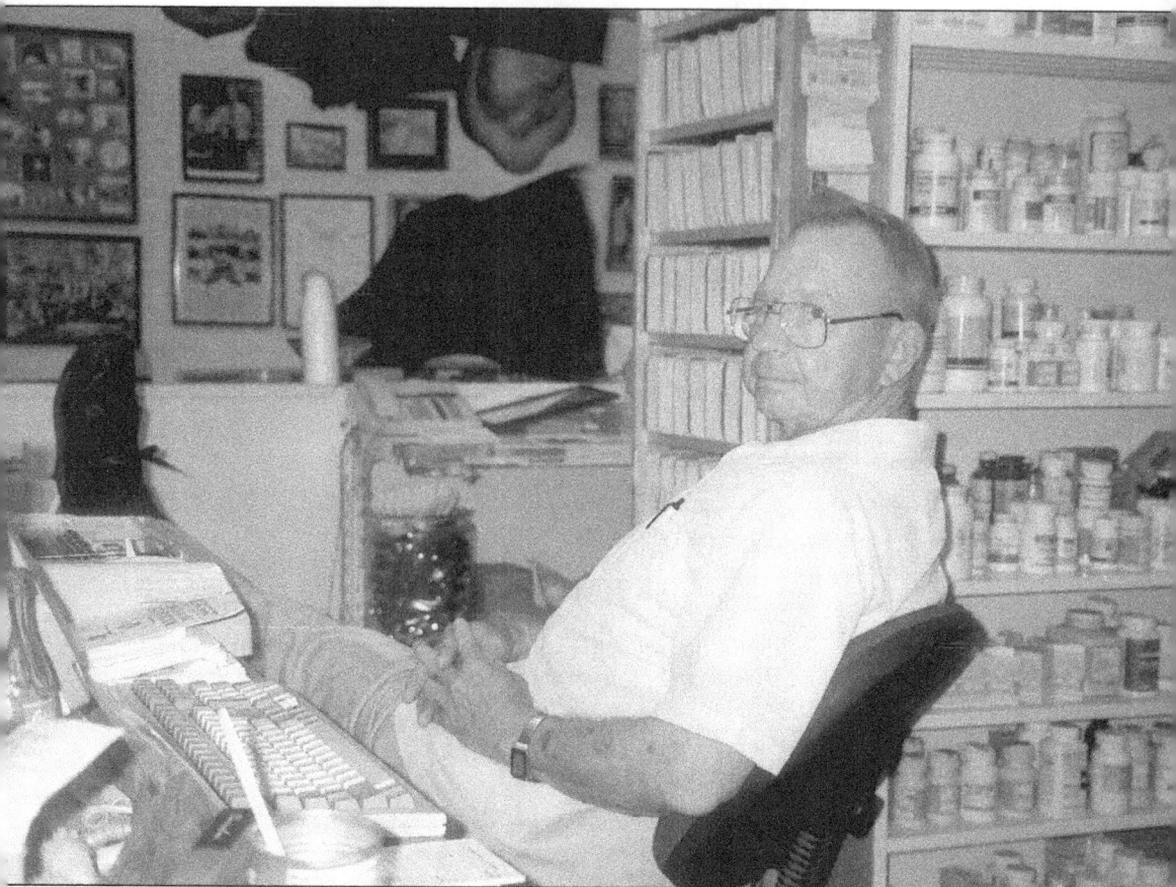

Dickie Williams, owner of William's Drugs on the Square, is Harper Lee's cousin. "As far as being rich and fancy, Nelle's not," Dickie Williams told a reporter from the *Washington Post* recently. "I call her my rich kinfolk, but you wouldn't think she had a nickel." The June 10, 1999 article by Sue Anne Pressley continues, "As family, Williams has not shied from asking the million-dollar question: I asked her, 'When are you going to come out with another book?' And she said, 'Richard, when you're at the top, there's only one way to go.'"

In another article in the *Tuscaloosa News*, May 23, 1999, by Katherine Lee, Williams said no one in Monroeville seemed to pay attention to the book when it first appeared. "It wasn't anything sensational," he said. "When the movie crew came to town, no one could care less. After it won all those prizes, people got interested. Most people are proud of her, but some old folks still have that old feeling about it. The story wasn't sensational; it went on every day. Desegregation was right about that time."

The article goes on to say, "The increased focus on 'Mockingbird' in turn brought attention to the Square. 'They were going to tear down the courthouse in the 60s,' said Williams. 'They didn't even think about Mockingbird.'"

Williams Drugs, on the east side of the Square, is the last of the old-style pharmacies in town. The store is full of the many local fossils and Native American artifacts found by Dickie Williams, the owner, in the streams and woods of Monroe County.

Reporters coming to town for a story are frequently sent to William's Drugs to meet Dickie and the members of the D.P. Club, who irregularly gather in these chairs to discuss politics and swap gossip. A reporter, from *The Oxford American* magazine was there one day when Miss Alice Lee came in. According to the August/September 1995 article, Miss Alice said "Well, . . . the D.P. Club is here, I see. That's Displaced Persons, I assume." (Dickie Williams, though, says it means Distinguished Persons.)

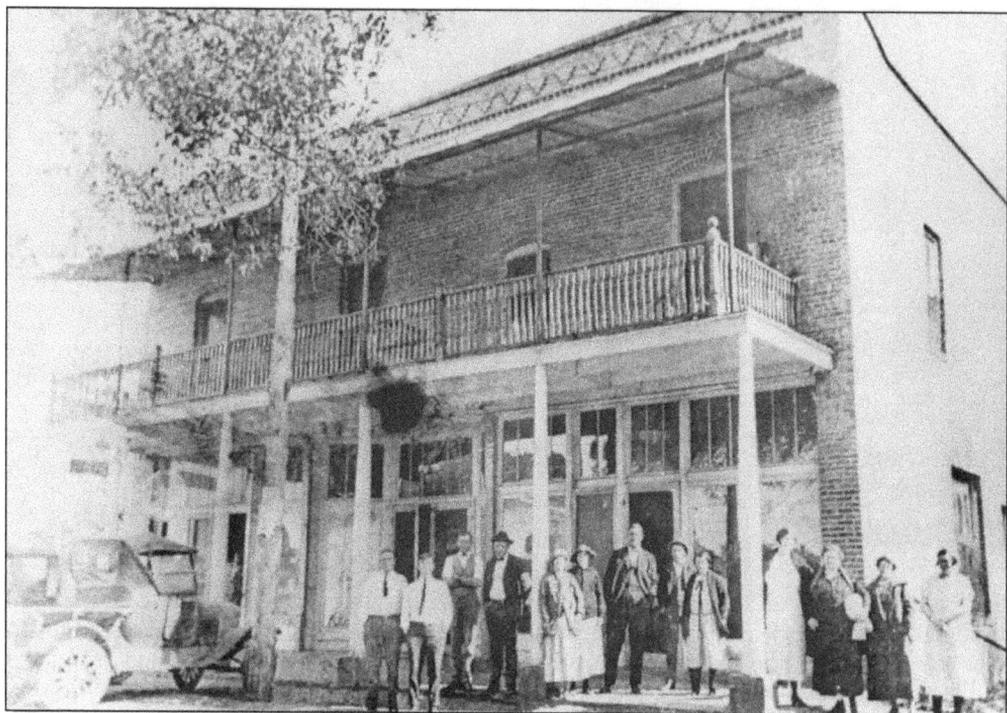

Faulk's Millinery Shop was owned by Miss Jenny Faulk, Truman Capote's cousin, with whom he lived as a child. Miss Jenny is standing in front of her store, fifth from the left. Standing next to her, sixth from the left, is her sister, Miss Callie Faulk, who helped in the business.

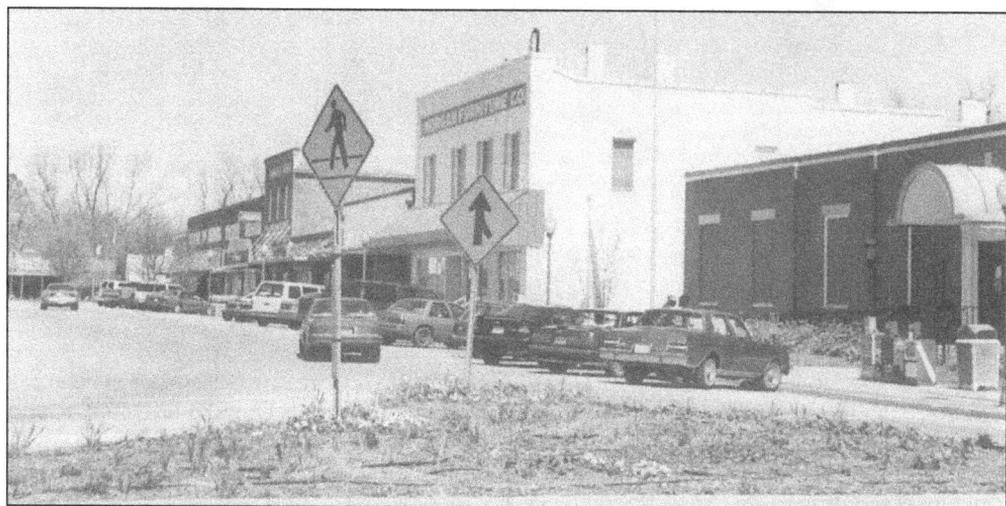

The Morgan Furniture Company Building is the location of the old Faulk Millinery Shop on the east side of the Square.

The Monroeville Post Office has always been on the Square, first on the north side in a small wooden building, then in a brick building on the south side, and, since 1937, in this brick building on the east side of the Square.

Inside today's post office is a mural painted by a WPA (Works Progress Administration) artist during the Depression. The WPA hired people who were out of work, including artists, writers, and photographers, to work around the country. Monroeville was fortunate to have this mural painted on the town's post office wall.

Mary Tucker, local retired teacher, remembers the WPA during the 1930s. "I've heard that those WPA workers tested Truman Capote and found out that he had a genius IQ, although he never did do well in school. Truman went to the first and second grades here in Monroeville."

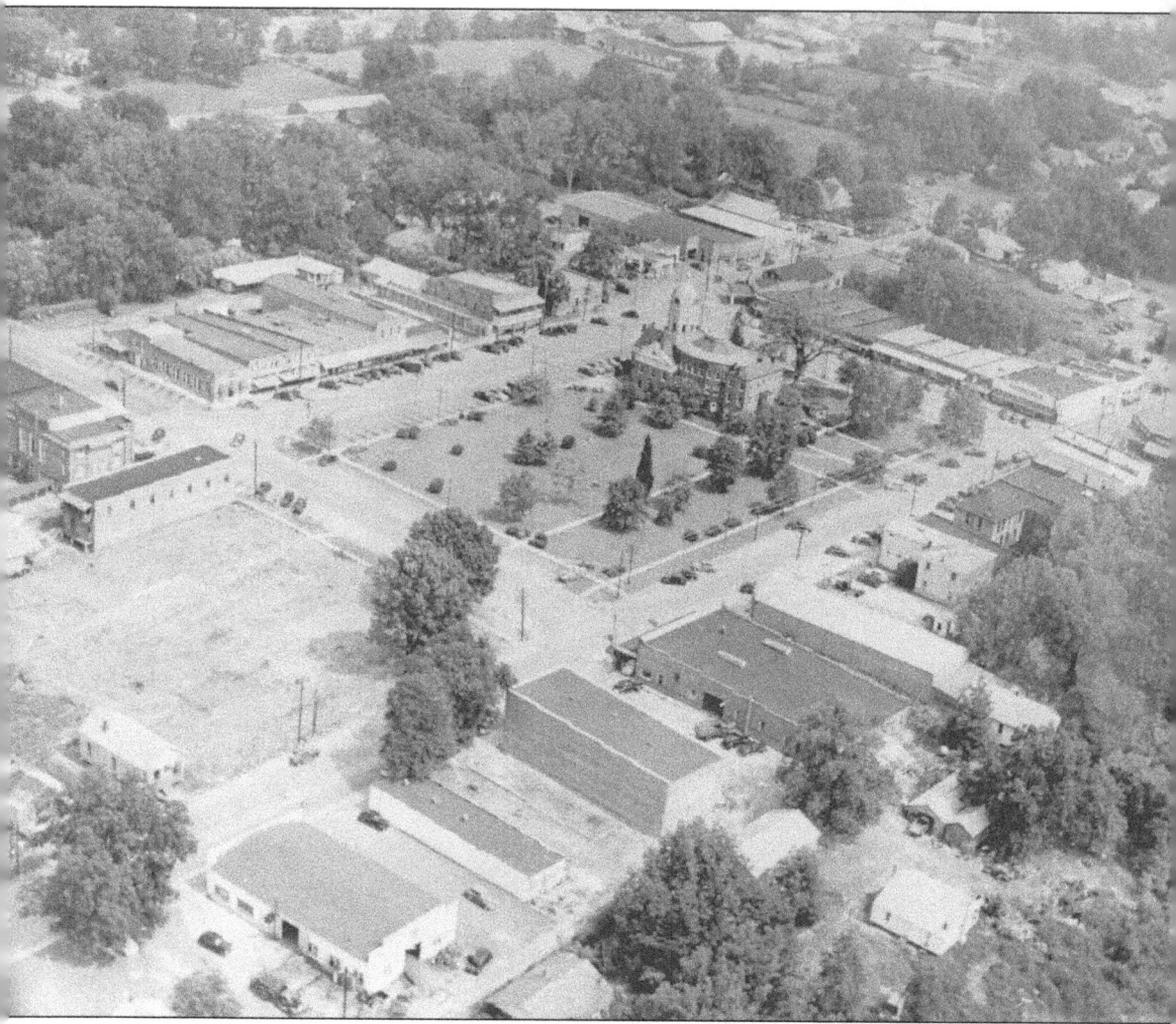

The Old Courthouse dominates the downtown Square in this 1940s aerial photo. All of the town's businesses, doctors, dentists, lawyers, and the post office were located on the Square.

A.B. Blass Jr. moved to this town in 1939 when his father bought the Western Auto Store on the Square. "Harper Lee was born in 1926, and I was born in 1927, so we were one grade apart in school," recalls Mr. Blass. "I have known her all my life. My dad had a store just on the other side of the jail, a small hardware store, on the west side of the square. The jail was in the middle of the block on the right in this photo. The open lawn, north of the old courthouse, is where we boys used to play football on the Square after school. One afternoon, a boy who would later become my doctor, was in charge of selecting the teams. Nelle, as we call her here, came up with a couple of friends, Anne Hines (Farish), now our mayor, and Sara Ann McCall (who later married Ed Lee) and sat around with us and asked what we were playing. We said, 'Football,' and she asked if they could play. We said, 'Sure.' One girl said, 'I'll be a cheerleader.' Nelle said, 'I'll play football.' We had some of the team halfbacks (high school players) who looked at Nelle and said, 'You're in for trouble.' So, she was chosen to be on my team, and we gave her the ball, thinking that no one would touch her. She said, 'Are we playing tackle?' We said, 'No, it's two-hand touch.' She went around to the right and then stiff-armed the local high school hero and knocked him under a tree. She said, 'I thought we were going to play ball!'

90

Seven

COURTHOUSE

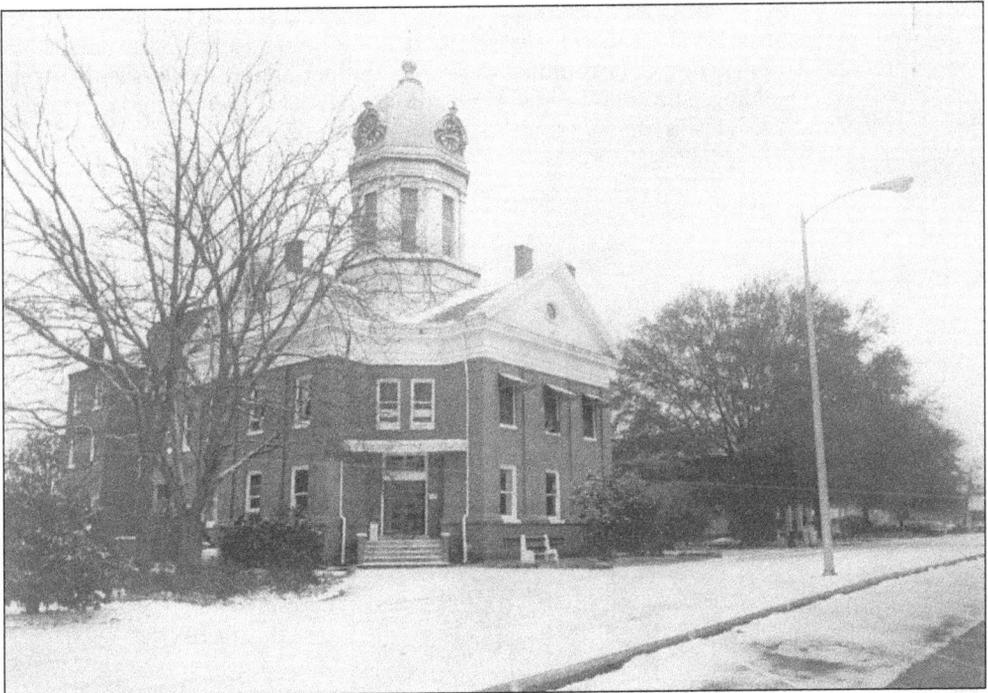

Built in 1903, the Old Courthouse now houses the offices of the Monroe County Heritage Museums, and the Monroeville Chamber of Commerce. This was in the 1970s during one of our rare snows.

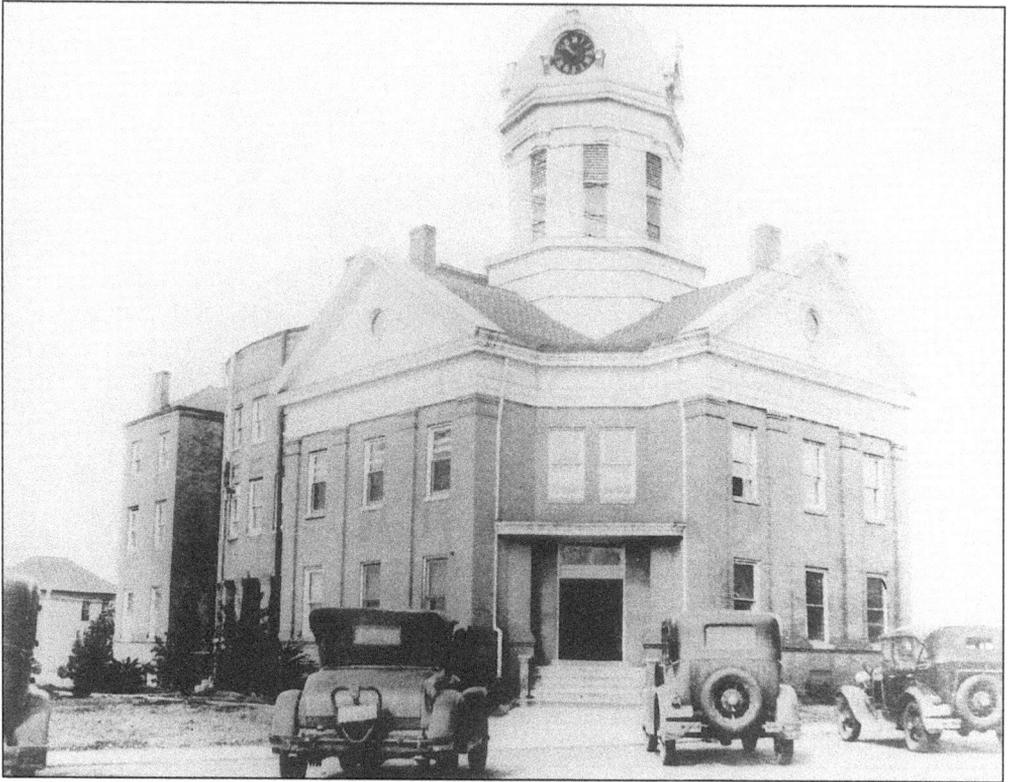

This is the 1903 courthouse pictured in the early 1920s. It was literally open to the public. No doors were installed originally. County offices were on both floors. All the judges and lawyers had offices in this building. The jail is located behind it, on the square, west of the courthouse. Between 1929 and 1963, it was the only courthouse on the town Square.

The domino-playing house, originally a voting house, was a fixture on the courthouse lawn in the 1960s.

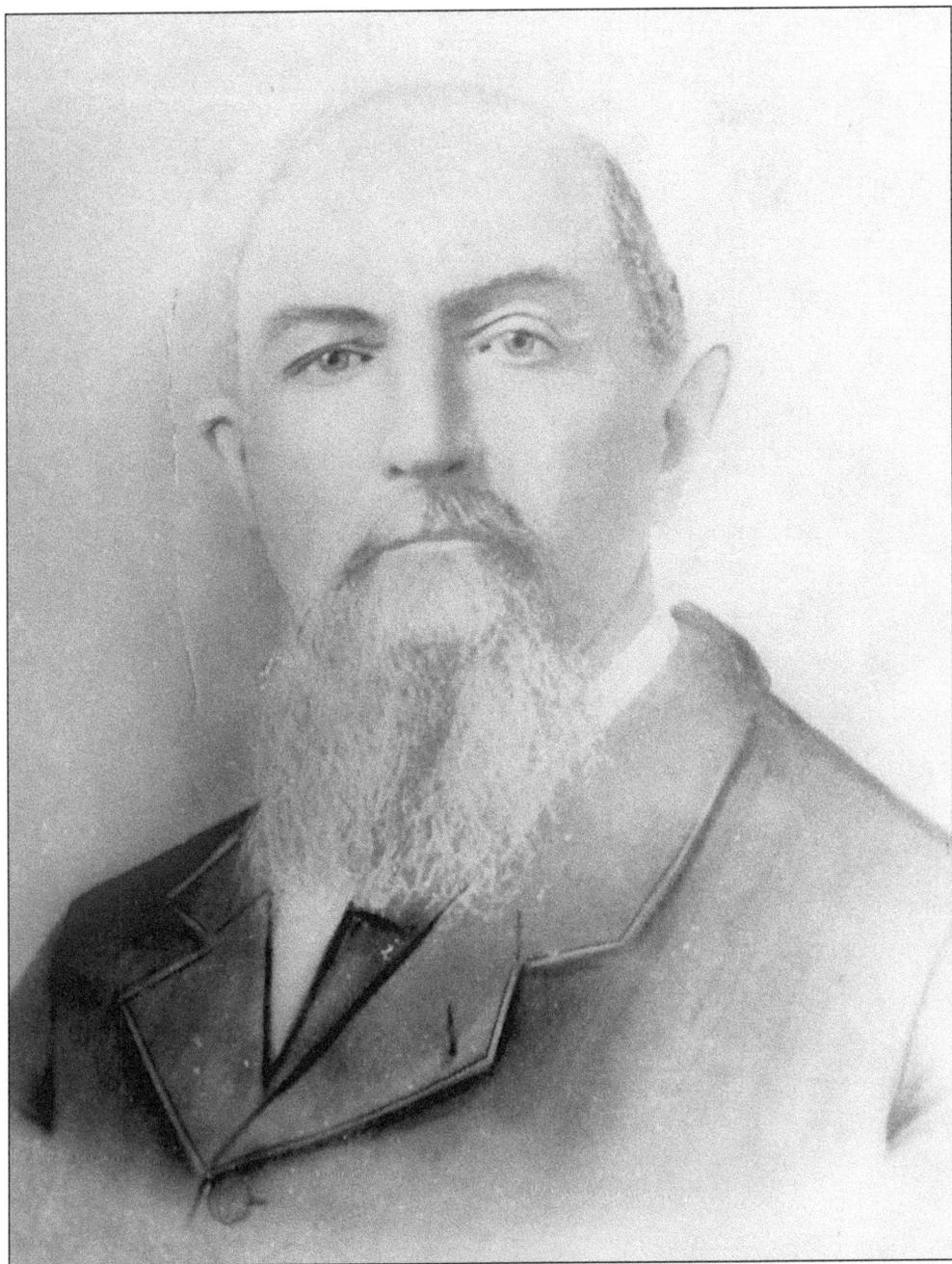

"The courthouse was commissed by Probate Judge Nicholas James Stallworth, who is my great-grandfather," says Jane Ellen Cason, museum education curator. "Judge Nick had a vision for Monroe County. In 1900, the L&N Railroad had come through the county, about 2 miles east of town at Monroe Station, but all the roads were dirt. Transportation was very difficult then. He had this vision of a beautiful courthouse for our county, though. So, he hired an architect from New Orleans and a builder from Kentucky, and had all the materials shipped in by railroad. He went way over budget and was not reelected as probate judge. He became the postmaster of Monroeville, until his death in 1911.

The south lawn of the Old Courthouse now has over 50 varieties of camellias, planted in the 1950s under the oak trees. Water oaks, like this one on the left, frequently have knotholes where a limb fell off. There were also large Monkey-Puzzle trees which have since died. Imported from Asia, this tree is fairly common in yards and parks over the South. The branches grow at "crazy" angles with flattened, sharp-pointed leaves and leathery, round cones.

Snow-on-the-mountain, a popular sasanqua variety of camellia, produces an abundance of pure-white blooms. These and other varieties are grown on the south lawn of the old courthouse. Camellias are evergreen shrubs that bloom from November to March. Walter L. Agee, of Agee Clothing Co. on the Square, enjoyed growing camellias.

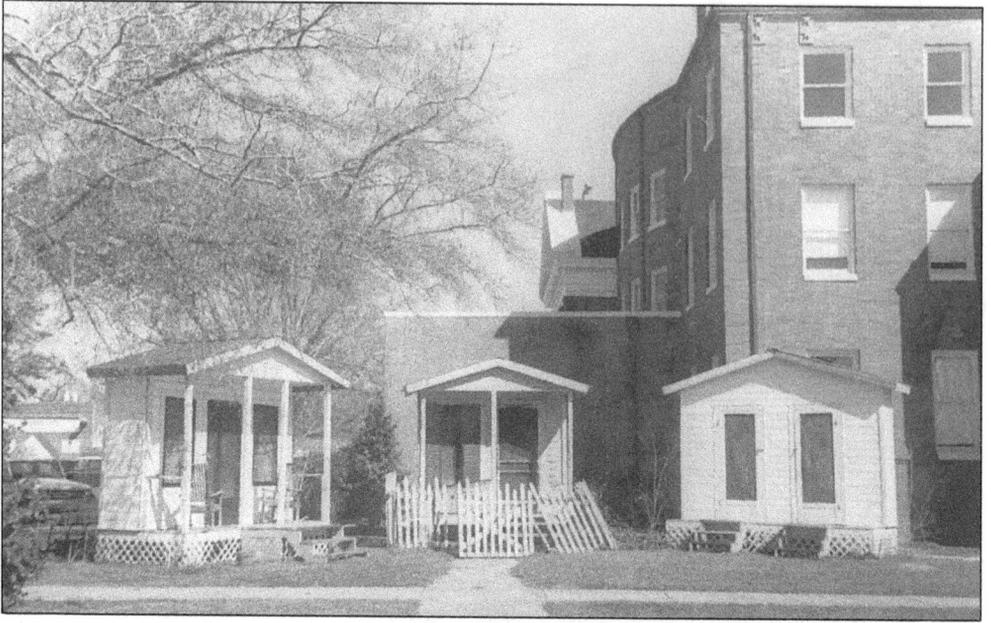

The Maycomb Street sets for the Museum's annual *To Kill a Mockingbird* play has houses for the Finches, the Radleys, Miss Maudie and Miss Stephanie, and Mrs. Dubose.

Each year in May, thousands of visitors come for the play presented by the Mockingbird Players. In 1996, the troupe was invited to perform at the Jerusalem Festival in Israel, and in 1998, they traveled to Hull, England, for performances to enthusiastic audiences there.

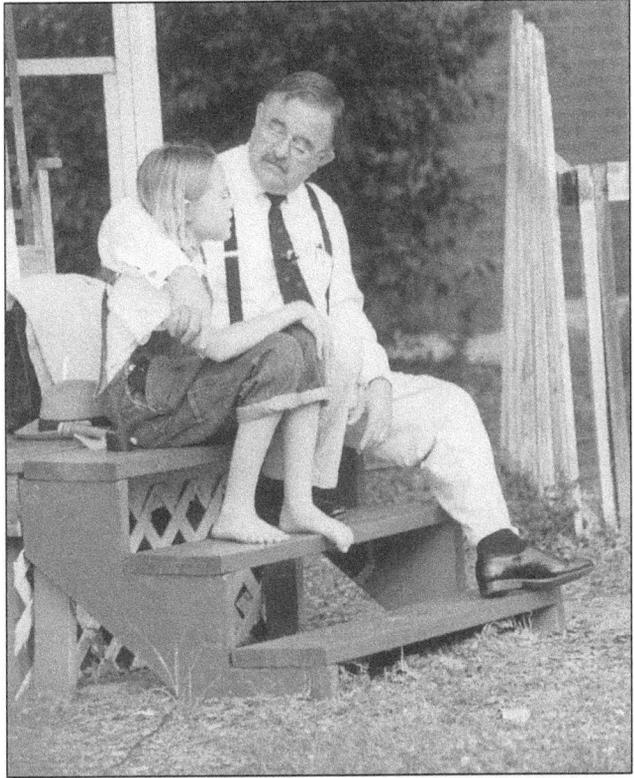

Scout (Haller Smith) and Atticus (Everette Price) discuss the Tom Robinson case.

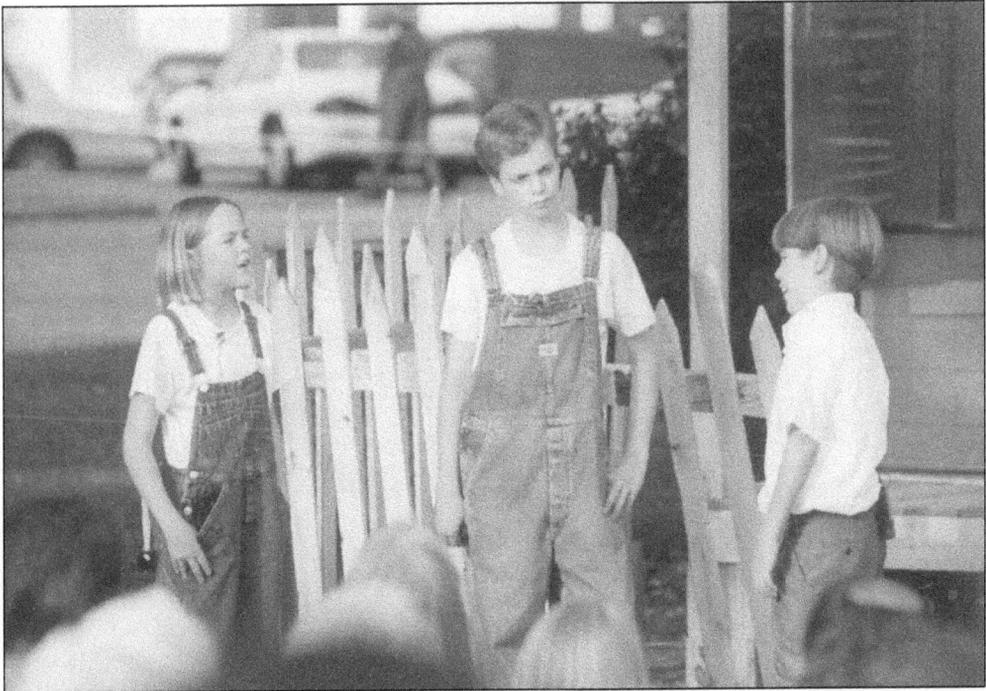

Scout (Haller Smith), Jem (Watson Black), and Dill (Shane Dougherty) talk about Boo Radley in Act I of the annual production.

Mrs. Henry Lafayette Dubose (Sherrie McKenzie) waits to accost Atticus' children.

Atticus (Everette Price) and Sheriff Heck Tate (Butch Salter) worry over Tom Robinson's safety.

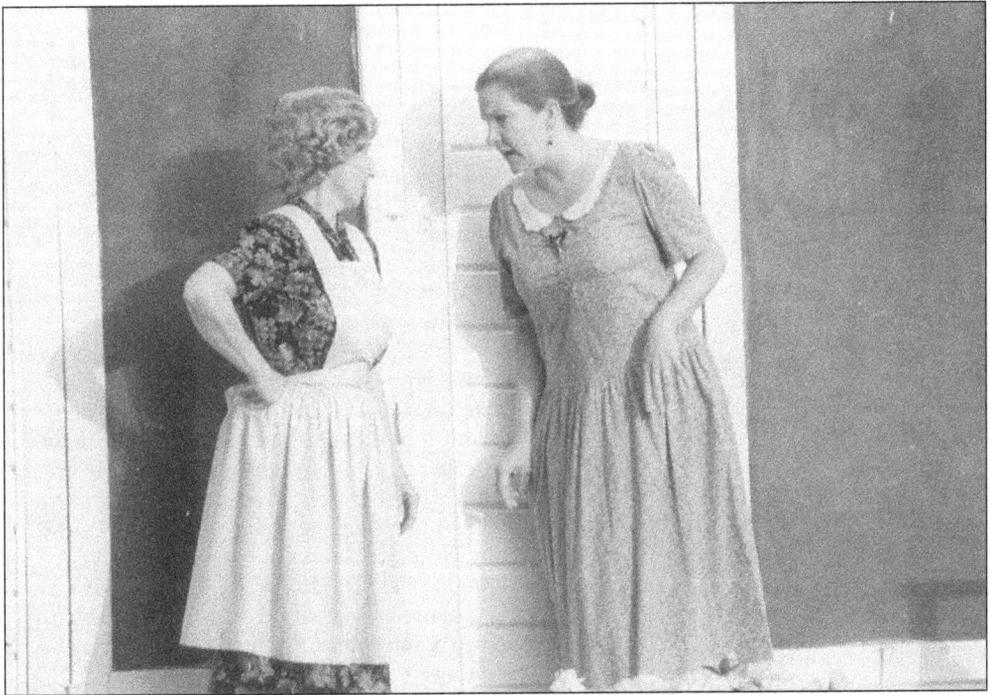

Miss Maudie (Sally Montgomery) and Miss Stephanie (Dawn Hare) discuss the neighbors.

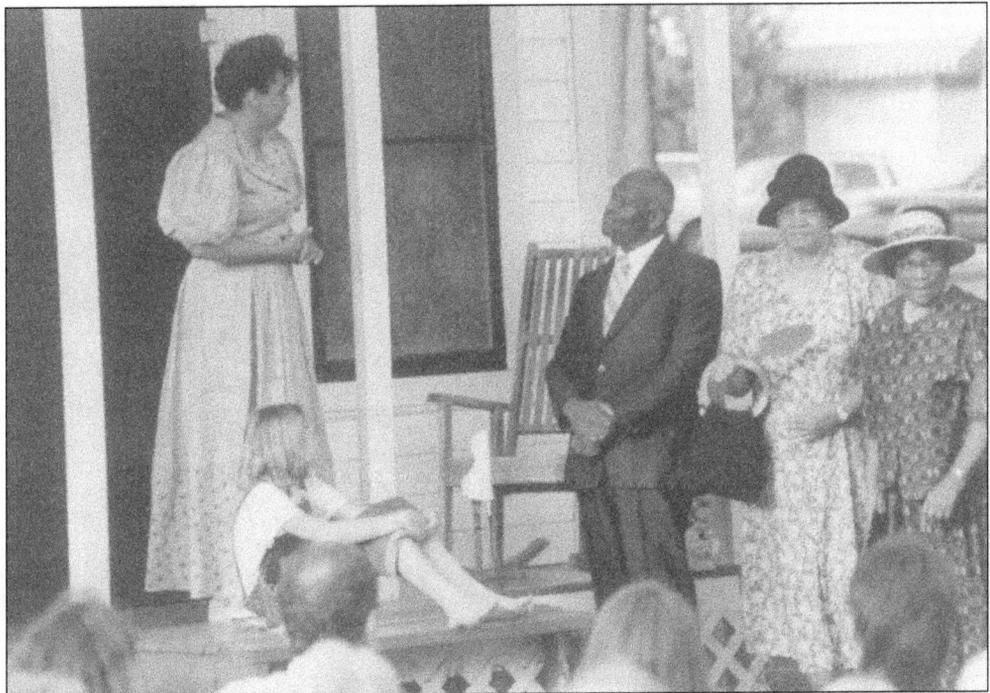

The Monroe County Interdenominational Choir adds a soulful dimension to the play. On the porch are Calpurnia (Dott Bradley) and Scout (Haller Smith), with Rev. and Mrs. Sykes (Lavord and Doris Crook) and choir members who came to tell Cal about the Robinson case.

The Courthouse Clocktower rises over the entrance. A.B. Blass Jr. remembers the dome well. "When I was 13 or 14, we used to go up into this dome. We would go up at night and there was a ladder that went up to the top. This clock was run by some weights that weighed about a ton that came down into the bottom, and were wound up about once a week by a man in town. We found that a big piece of pipe hit on the bell (which was about 2 feet in diameter) made the same sound as the clock. We were there one Saturday night waiting for it to strike 12, and you'd have to cover your ears it was so deafening. After it struck 12, we took the pipe and hit it again. The next day in church, a lot of people said, 'Did you hear the clock? It struck 13!' 'No, we didn't hear that. You're mistaken.' So the next week, we did it again. Finally, the third week, we did it again. The man who wound the clock said, 'We're going to have to get a man to come all the way from Atlanta to come fix the clock.' So I said, 'Well, I can tell you now. There's nothing wrong with that clock. It will not strike 13 again.' And that's the end of that story."

The Monroe County Heritage Museums was created in its present setup in 1991 with the hiring of Museums Director Kathy McCoy, from Louisville, Kentucky. Under her guidance, the Museums has published a bi-annual magazine on county history, hosted exhibits from the Smithsonian, and acquired three more structures now serving county residents as museums.

Our current probate judge is happy with the full-time status of the Museums offices. The Historical Society volunteers were not able to keep the old building open all the time, and he had tired of having to go unlock the courtroom so visitors could see it.

100

At the top of the steps to the second floor is the museum guest book, full of names of people from all over the United States and from many countries of the world. One look at the Visitors' Register will convince visitors of the far-reaching magnitude of Harper Lee's book. On one page of 15 entries from May 1999, visitors came from England (2 entries), Germany (1), Louisiana (1), Massachusetts (1), New Jersey (1), Texas (1), Florida (3), and all across Alabama (3), including Monroeville (2).

The upstairs foyer lies between the gift shop and the courtroom.

The museum's gift shop contains books, artwork, and t-shirts by Alabama artists and authors. Gift shop sales go to restoration and maintenance of this building.

To the right, framed and hanging in the courtroom is this hand-written note (framed in the bottom left corner) from Harper Lee, signed "Nelle."

This room was used as the model for the trial scene in the film: "To Kill A Mockingbird." The set was designed by Henry Bumstead, Universal Studios.

Nelle Harper Lee

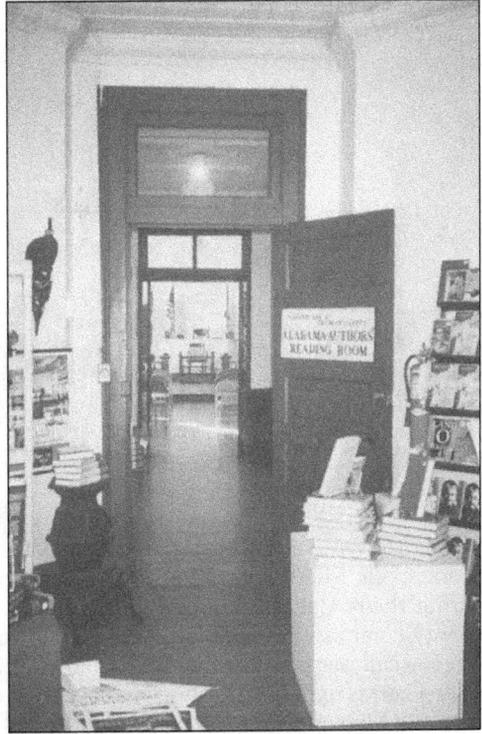

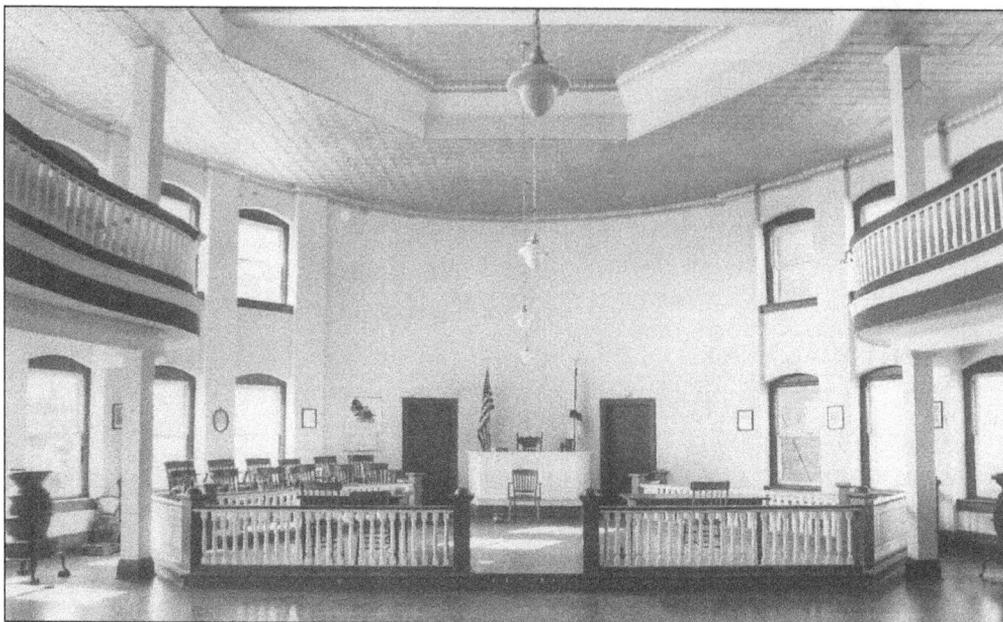

The courtroom was used as a model for the movie *To Kill a Mockingbird*, starring Gregory Peck. The jury sat on the left of the judge's bench.

The courtroom has served as a lecture hall for many important speakers coming to Monroeville. William Jennings Bryan spoke here in 1918. The *Monroe Journal* reported the visit but did not give the reason or the text of the speech. Bryan won the democratic nominations for President in 1896, 1900, and 1908. In 1925, he helped prosecute J.T. Scopes for teaching Darwinism and won the famous Scopes Trial.

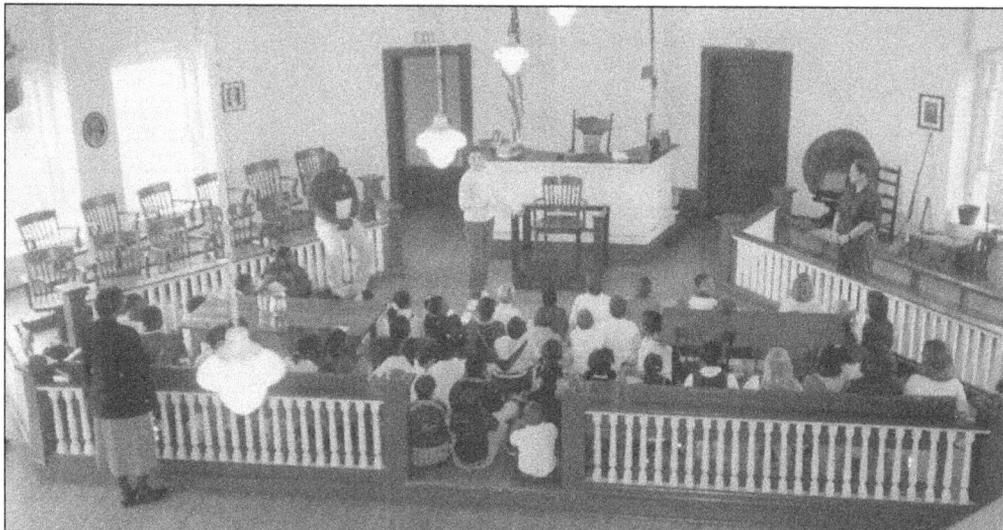

Monroeville Middle School fourth graders come each year to the Old Courthouse Museum during their Alabama History class. Charlie McCorvey, their teacher (left front), is also a county commissioner and has played Tom Robinson since the first performance of *To Kill a Mockingbird* was presented in 1991. Kathy McCoy (center front), Museums director, and Jane Ellen Cason (right front), Museums education curator, explain county history by showing items from the Museums' archival collection.

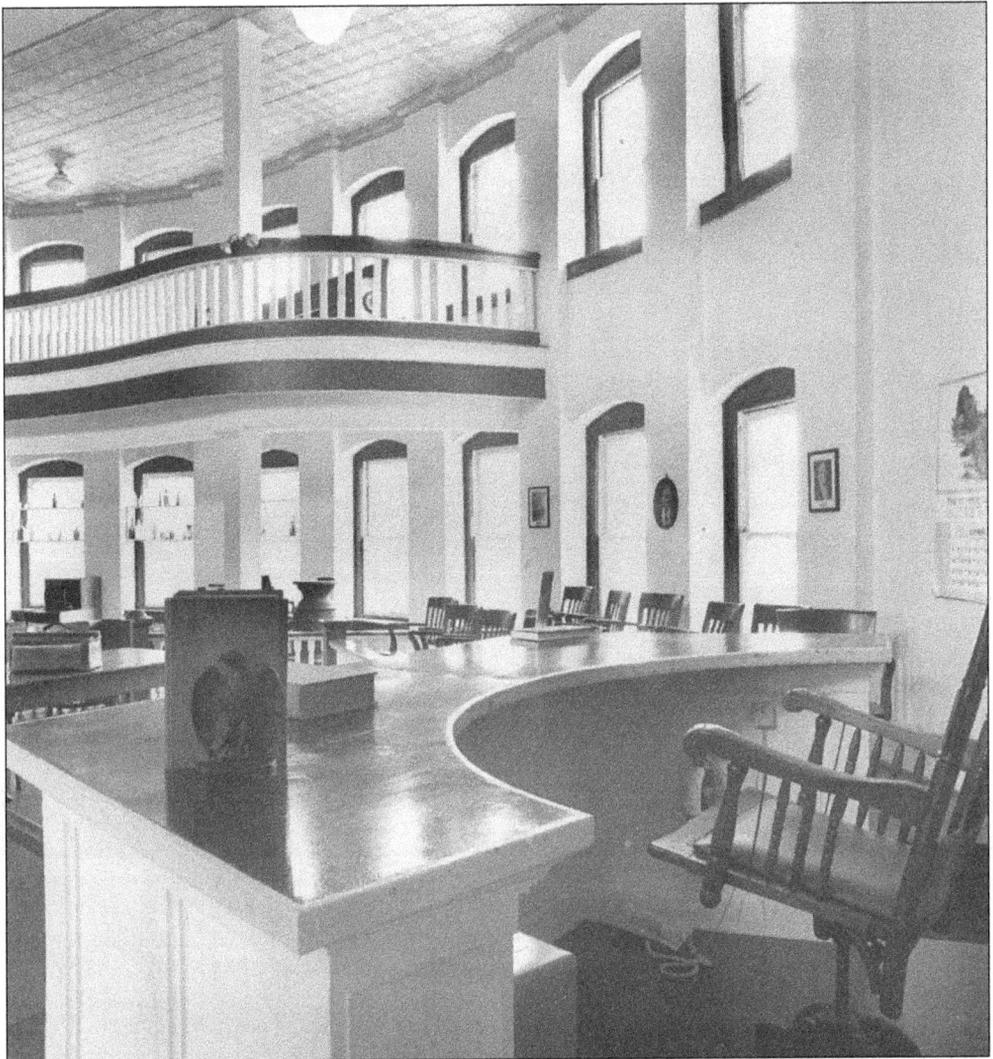

The judge's bench was photographed by Richard Maloney, an Australian photographer, who came to Monroeville in 1996 to photograph residents for his exhibit, "In search of Atticus." The old courtroom was heated by a coal-burning stove and cooled in the hot summer with funeral-home fans. (These fans are hand-held fans with a wooden handle on a piece of cardboard imprinted with the name of a funeral home or other business sold in the gift shop.) Today we have no heat in the courtroom, and it is still cooled with funeral-home fans. Restoration plans include installation of heating and air conditioning.

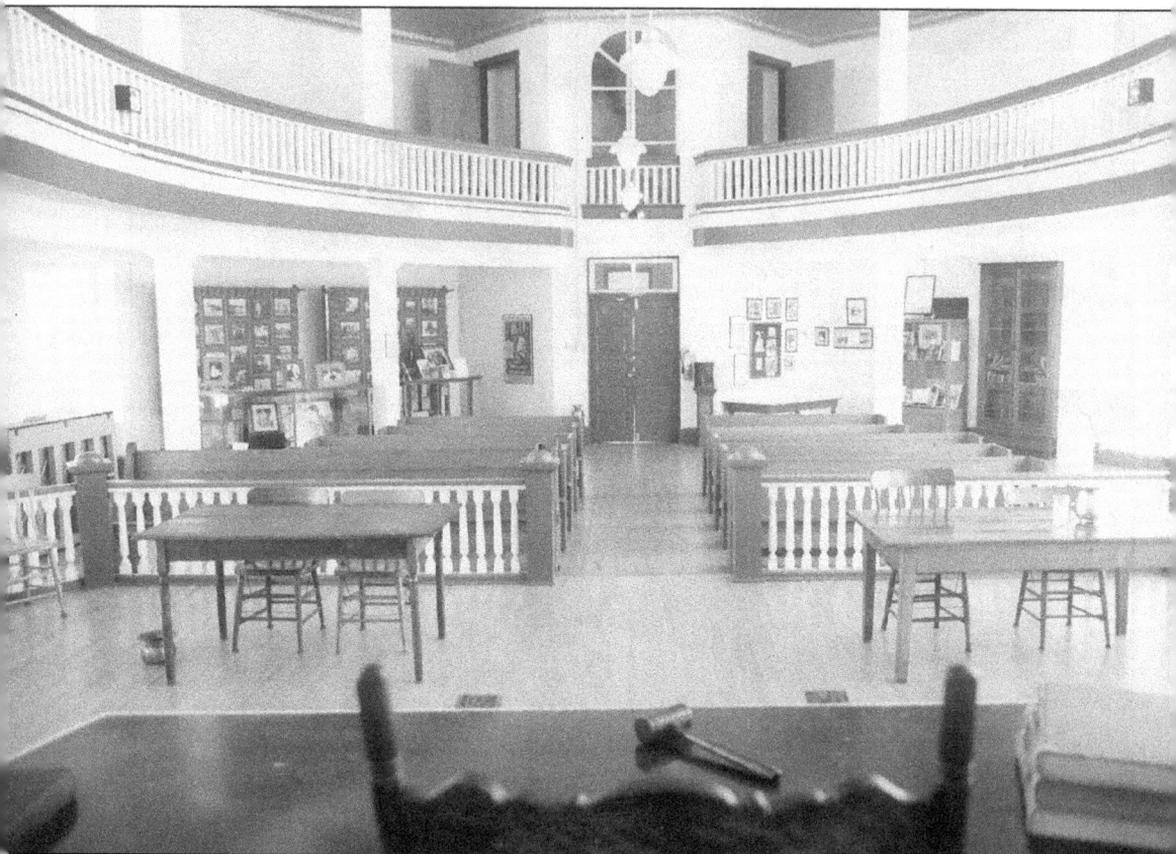

This courthouse was in use from 1903 to 1963. During that time, segregation was the practice. All black citizens sat in these balconies.

"Some people have told me that there really was such a case," remarks Jane Ellen Cason, Museums education curator. "So, I began looking in the old newspapers to see if I could find it. I found a few cases that were similar.

"One was very similar. Walter Lett was arrested in 1933 for raping a white woman—it even gave her name. The newspaper account said he must be moved to a jail in a nearby county for fear of a mob. (Lynching was a real threat then. The Department of Records in Tuskegee, Alabama, reported six lynchings in Alabama in 1930.)

"A later article in a 1934 newspaper reported that the trial had occurred, and he was found guilty. He was sentenced to death. The verdict came at 9:00 that night.

"Later, I found an article stating that the governor commuted his sentence to life imprisonment because many citizens of Monroe County had written to the governor expressing doubt in the man's guilt.

"Finally, the Alabama State Archives records revealed that Walter Lett had died in prison of tuberculosis in 1937."

Circuit Judge Sam Welch conducted civil court in the old courtroom on May 12, 1997, because the construction noise was too loud in the new courthouse that day, according to the May 15, 1997 *Monroe Journal*. "Court has not been heard in the old courtroom— now part of Monroe County Heritage Museum—since 1963 when county offices moved to the new courthouse."

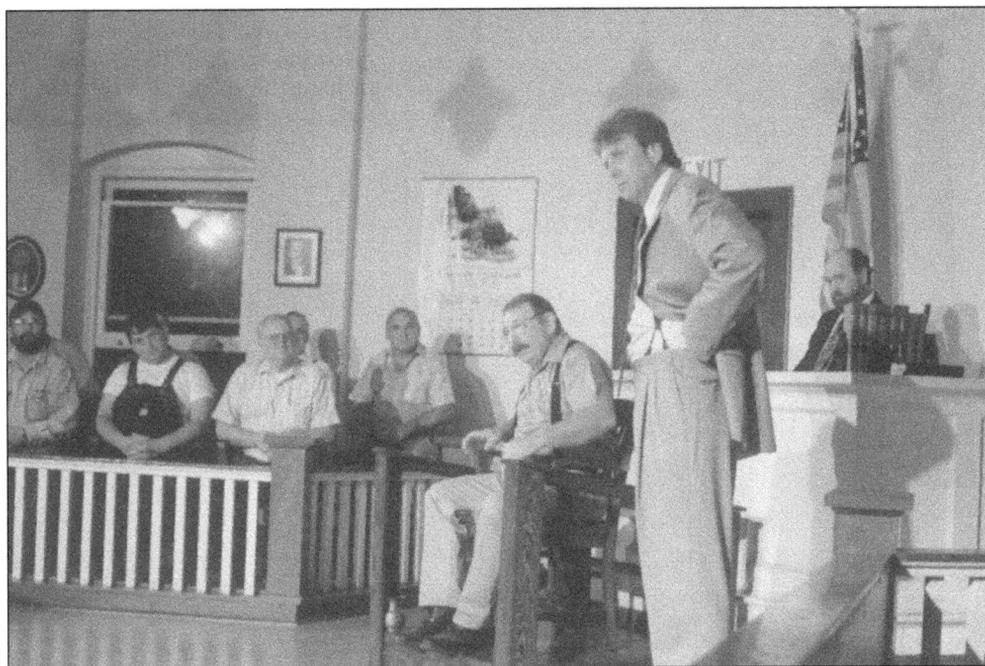

Mr. Gilmer (Dennis Owens) questions Sheriff Heck Tate (James Maples) in the 1996 play, while the Judge (Ray Sasser) and the jury listen intently. The jury is drawn from members of the audience for each performance by Sheriff Tate.

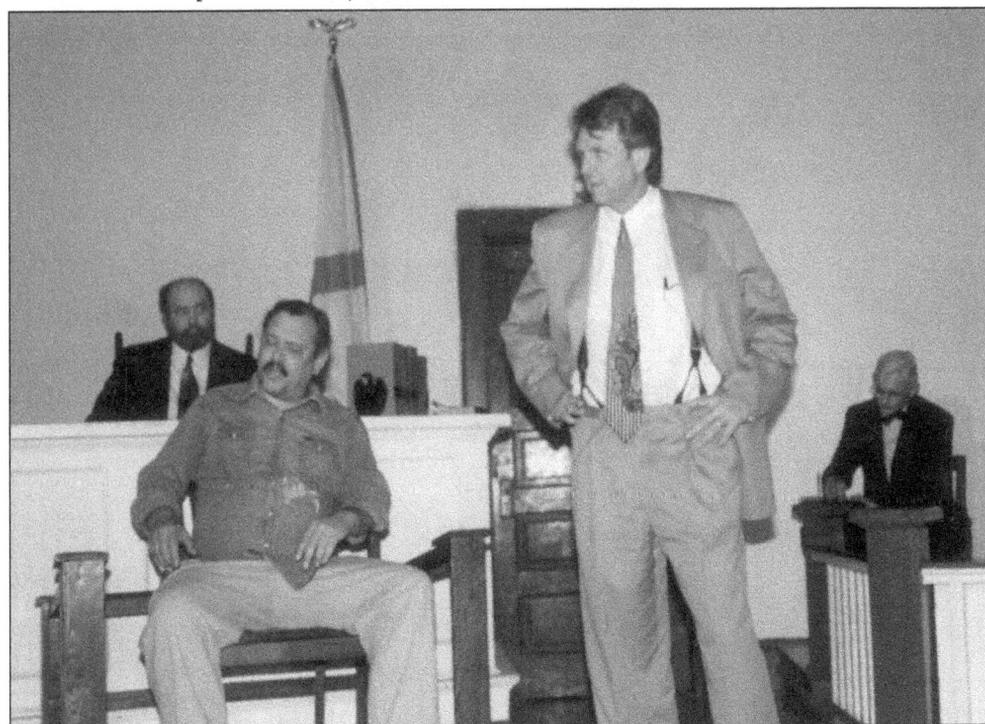

Judge Taylor (Ray Sasser) watches as Mr. Gilmer (Dennis Owens) questions Bob Ewell (Bruce Ulmer).

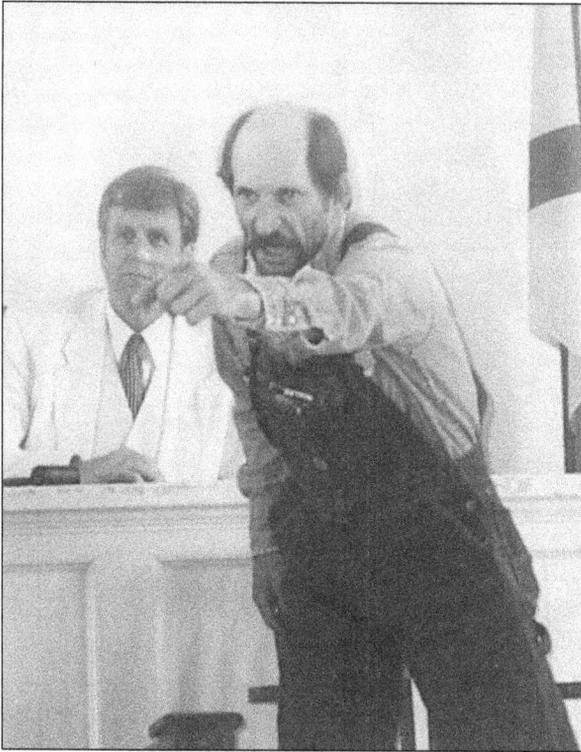

Donnie Evans, who also plays Bob Ewell (he began in 1999), knows he has performed well if he gets some booing from the audience.

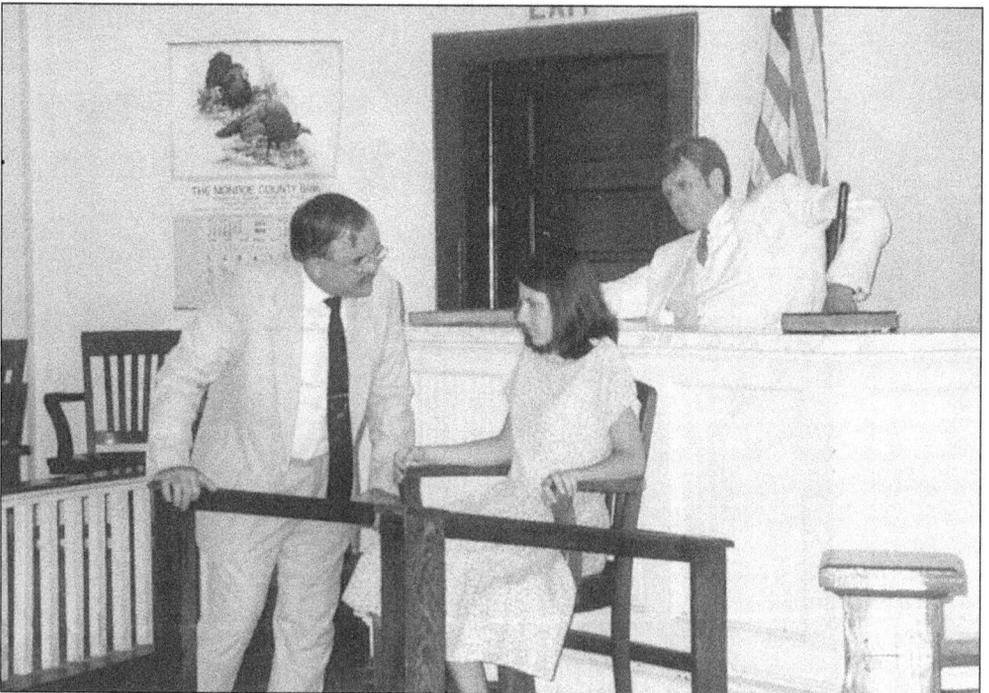

Atticus (Everette Price) tries to make cross-examination easy for Mayella (Lesley Coats). Judge Taylor (Dennis Owens) observes.

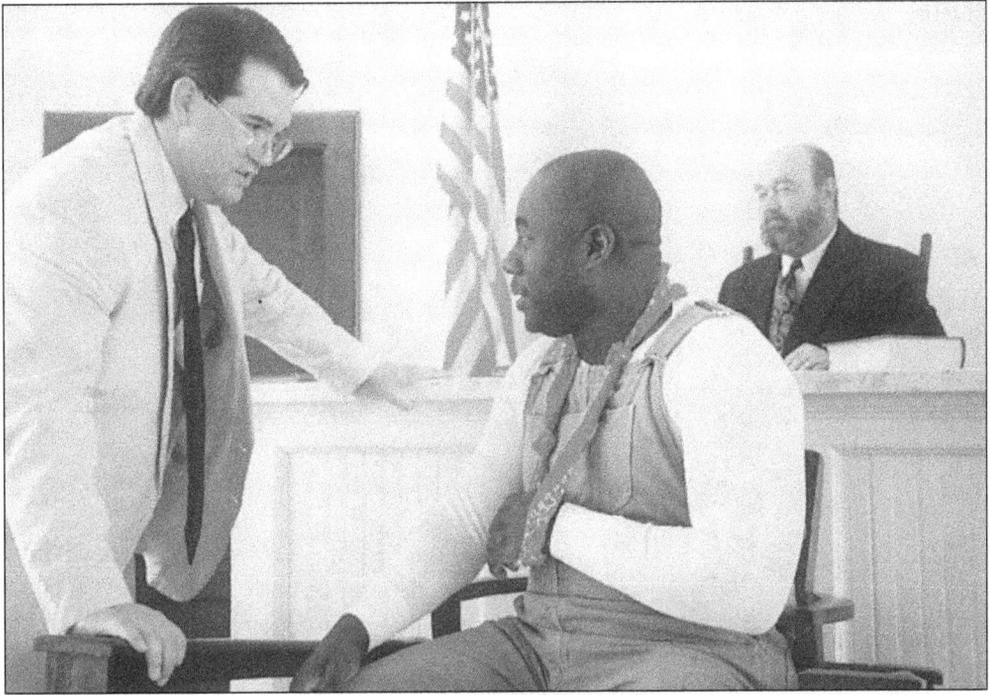

Atticus (Jimmy Blackman) asks Tom (Charlie McCorvey) to recount the day he walked by the Ewell's place.

Jem (Watson Black), Scout (Haller Smith), and Dill (Shane Doughtery) join Rev. and Mrs. Sykes (Lavord and Doris Crook) in the balcony during the play. The Crooks are retired teachers. Mr. Crook is a member of the Museums' board of directors.

"There are two balconies; they mirror each other," points out A.B. Blass Jr., who joined the cast in 1998 as court clerk. "I was privileged to sit in the balcony next to Nelle Lee a couple of times. From high school, they would let us come over and view cases during the day from our civics class. We sat there together and discussed what transpired. In the daytime in the 1940s, the women and children sat up there during the trials; it was not just for blacks."

Actor Phillip Alford, who played Jem Finch in the movie version of *To Kill a Mockingbird*, attended a play in Monroeville's Old Courthouse Museum in 1996. Alford, from Birmingham, is shown here with Kathy McCoy and the cast. He remarked that day, "This brings back a lot of memories!"

The Monroe County Interdenominational Mass Choir, led by Jackie Nettles, performs a cappella during the jury's deliberation in the trial scene of Act II.

Charlie McCorvey, who plays Tom Robinson, talks to the audience and signs autographs after the play.

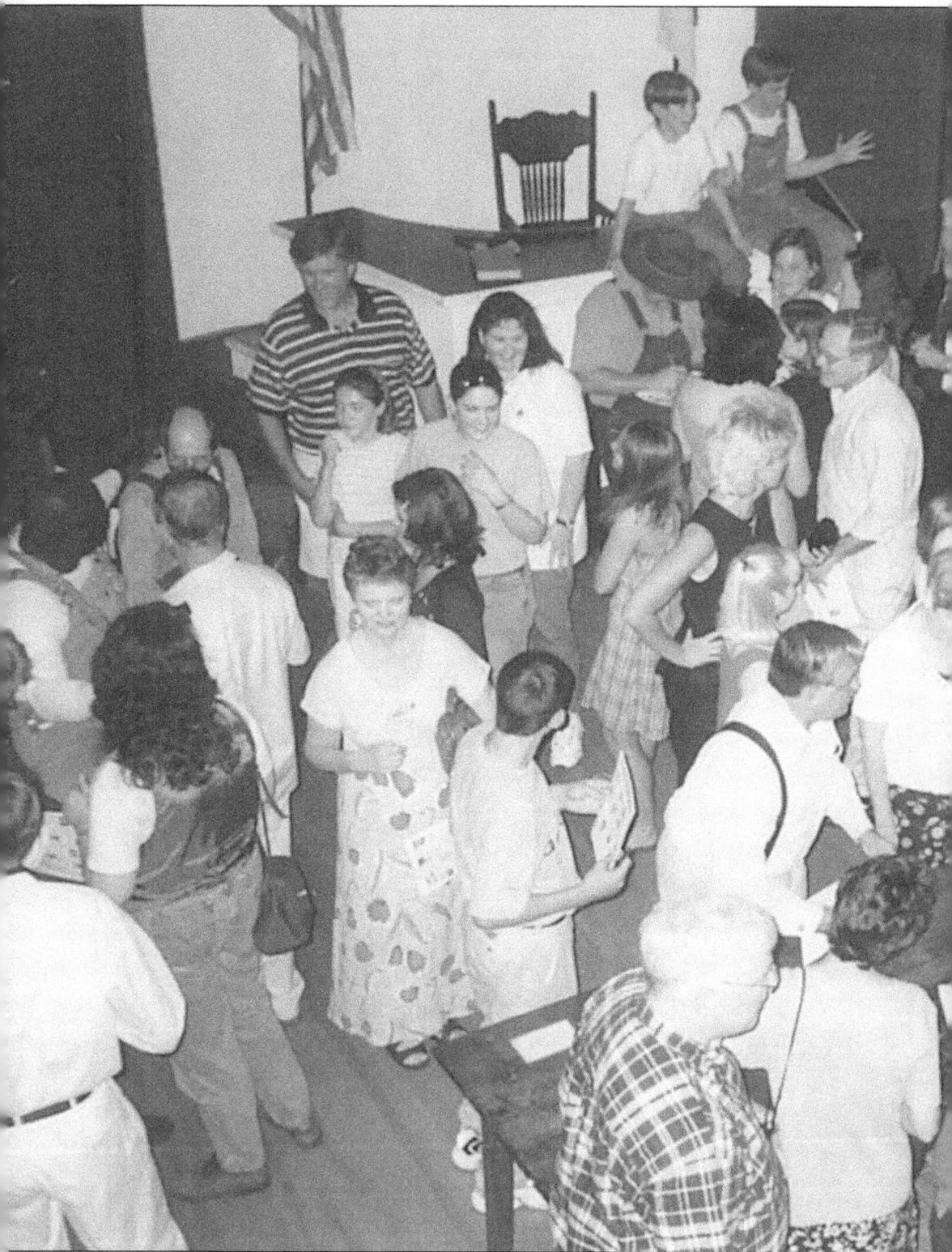

The audiences
enjoy meeting
the actors after
each performance.
This is the biggest
reward for the all-
volunteer cast.

111

Stewart Coxwell (left) and Kelli Myers (right) played Scout in 1993. Matthew Eubanks (center) played Jem.

The young people in the cast are usually asked the most questions after the play. Most members of the audience want to know if they enjoy the hard work of acting. Their answer is a unanimous, "Yes!" Watson Black (Jem), Haller Smith (Scout), Lesley Coats (Mayella), and Shane Dougherty (Dill) relax in the courtroom during the May 1999 performances.

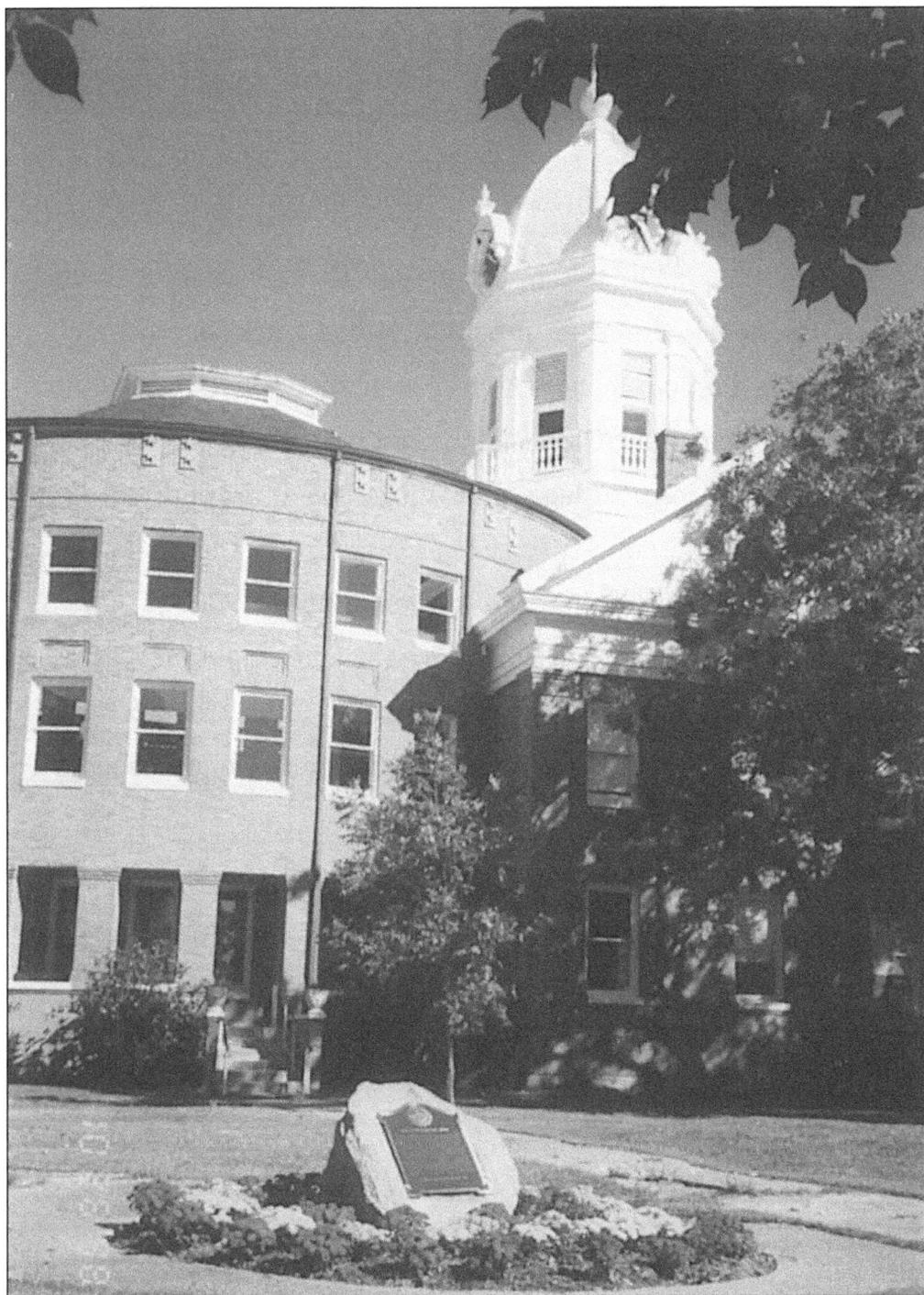

In 1997, the Alabama Bar Association erected its first Legal Milestone Monument on the south lawn of the Old Courthouse Museum, in memory of a fictional character, "Atticus Finch, lawyer—hero."

May 13, 1997

Dear Mr. Lightfoot:

Although I was unable to be present at the inaugural ceremony of the Legal Milestones program, please accept my heartfelt thanks for a unique honor. Atticus would have been a bit nonplussed by the tribute, but deeply grateful!

Pat Graves's idea for legal milestones was an inspiration. In spite of some alarming specimens, in its history the Alabama bar has had some real-life heroes—lawyers of quiet courage and uncompromising integrity who did right when right was an unpopular and sometimes dangerous thing to do. They deserve permanent and visible reminders of their presence, and should be models for all who make the law a career.

Would you please convey to Mr. Graves and the Alabama Bar Association my gratitude for Atticus's milestone and the generosity of spirit that prompted its creation?

Sincerely yours,

Harper Lee

In a rare communication from Harper Lee to the Alabama Bar Association, printed in the July 1997 issue of the *Alabama Lawyer* magazine, Miss Lee says thanks to the Association for the honor.

ATTICUS FINCH: LAWYER - HERO

"Lawyers, I suppose, were children once." These words of Charles Lamb are the epigraph to Harper Lee's *To Kill A Mockingbird*, a novel about childhood and about a great and noble lawyer, Atticus Finch. The legal profession has in Atticus Finch, a lawyer-hero who knows how to see and to tell the truth, knowing the price the community, which Atticus loves, will pay for that truth. The legal profession has in Atticus Finch, a lawyer-hero who knows how to use power and advantage for moral purposes, and who is willing to stand alone as the conscience of the community. The legal community has in Atticus Finch, a lawyer-hero who possesses the knowledge and experience of a man, strengthened by the untainted insight of a child.

Children are the original and universal people of the world; it is only when they are educated into hatreds and depravities that children become the bigots, the cynics, the greedy, and the intolerant, and it is then that "there hath passed away a glory from the earth." Atticus Finch challenges the legal profession to shift the paradigm and make the child the father of the man in dealing with the basic conflicts and struggles that permeate moral existence.

Symbolically, it is the legal profession that now sits in the jury box as Atticus Finch concludes his argument to the jury: "In the name of God, do your duty."

PLACED BY THE ALABAMA STATE BAR - 1997

Justice J. Gorman Houston of the Alabama Supreme Court, who wrote the inscription engraved on the plaque, commemorated the milestone on Law Day, May 1, 1997, in Monroeville.

Alice Lee, along with other local attorneys, looked on as Alabama Supreme Court Justice Gorman Houston, with his grandchildren, dedicated the monument to the character based on her father, Amasa Coleman Lee.

Miss Alice Lee's portrait hangs in the conference room of her church. "It's probably safe to say that Alice Finch Lee has spent a good portion of her life in meetings," begins the *Monroe Journal* article on January 22, 1998. "In addition to meetings for her work, the well-known Monroeville lawyer has served on various boards and committees for many years.

"So, when her friends at First United Methodist Church decided to honor her, they thought the perfect gesture would be a conference room. Rev. Dr. Thomas Lane Butts, pastor of First United Methodist, said it is the type of honor Miss Lee would appreciate."

Eight

MUSEUM

The Museums staff greets visitors from every state in the union and from many foreign countries. Pictured from left to right are Sandra Standridge, Dawn Crook, Wayne Calloway with Sassy, Kathy McCoy, and Jane Ellen Cason.

Bethany Baptist Church, a property donated to the Museums in 1997, is located in Burnt Corn, in the eastern part of the county. Each year in October, friends of the old community gather for Homecoming, which is celebrated with a morning service, dinner on the grounds, and a gospel concert in the afternoon.

The River Heritage Museum was opened in 1999 at the Claiborne Lock and Dam on the Alabama River, northwest of Monroeville. Featured in this museum are exhibits of area fossils, Native American artifacts, and the 19th-century steamboat era.

Rikard's Mill Living History Park, located 22 miles north of Monroeville, has a restored 1845 water-powered gristmill. Situated on Big Flat Creek, the 8-acre park is dedicated to the preservation of folk traditions. Along with the mill is a restored blacksmith shop, 19th-century barn, cane syrup mill, carriage house, cabin, and covered bridge gift shop.

The Monroe County Heritage Museums began in 1991, with the Old Courthouse Museum in Monroeville. The play presented here by the Mockingbird Players is held annually in May.

In 1994, restoration of Rikard's Mill on Flat Creek near Beatrice had been completed, and the Mill began grinding corn into cornmeal and grits as in bygone days. The covered bridge gift shop, 19th-century blacksmith shop, barn, carriage house, and cabin have all been added to the park. Several events are staged in the Rikard's Mill Living History Park every year.

Bethany Baptist Church in Burnt Corn was initiated into the Museums in 1997 when membership had dwindled to four members. The annual Homecoming and Christmas Pageant fill the 1874 building with visitors.

The River Heritage Museum at Claiborne Lock and Dam on the Alabama River is the newest museum for Monroe County. The permanent exhibits are enjoyed especially by local residents who camp and go boating nearby.

The Monroe County Heritage Museums and Mockingbird Players have been honored to perform at the International Cultural Festival in the Khan Theatre, Jerusalem, Israel, in 1996, the Supreme Court Justice Building in Montgomery, Alabama, in 1998, and in Hull, England, in 1998, all with sell-out performances.

The Museums also presented an Alabama Cultural Symposium in England, giving seminars on Alabama music, cooking, agriculture, and the teaching of *To Kill a Mockingbird*.

The Monroe County Heritage Museum,
Monroeville, Alabama
Presents

The 5th annual production of
Christopher Sergel's stage adaptation of
Harper Lee's Pulitzer Prize-winning novel,

To Kill a Mockingbird

on June 4, 5, 6 at 7 p.m.

in the Khan Theatre, Jerusalem.

The first act will be performed in
the Khan Theatre's courtyard
and the second act in the theatre itself.

Tickets at NIS 36 can be purchased at
Bimot, tel. 02-240896
Klaim, tel. 02-256869
Khan, tel. 02-718281

with the assistance of:

The Ministry of Foreign Affairs,
The Israel Festival, Jerusalem,
The Khan Theatre, Jerusalem.

The flyer promoting the Mockingbird performances in Israel was distributed throughout Jerusalem.

Miss Stephanie (Dawn Hare) and Miss Maudie (Sally Montgomery) catch a ride on a camel during the visit to Israel.

Shown here is the Mockingbird Players cast inside the Supreme Court Justice Building in Montgomery, the State's capitol.

Alabama cooking was one of the seminars held in England. Shown in the kitchen, from left to right are the following: Joann Deas, Doris Crook, Beatrice Rogers, and Dorothy Deas Hautman. The food cooked at the seminar was greatly enjoyed by the attendees: fried chicken, okra and tomatoes, and sweet potato pie.

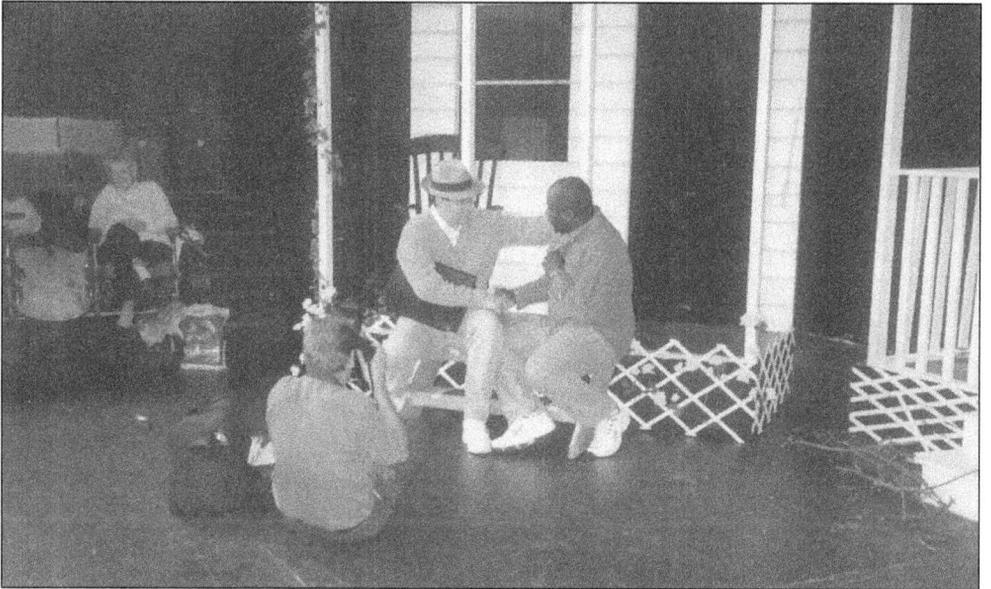

The production in England was covered heavily by the press. Shown above are Jimmy Blackman, Charlie McCorvey, and a photographer from the media.

MONROEVILLE 1930

N. Mt. Pleasant · Pineville Rd. · W. Claiborne · E. Claiborne · Alabama Power Co. · Freezing Tanks · Pan-American Oil Co. · Standard Oil Co. · Sherrill Oil Co. · S. Alabama Ave. · Hines St. · M & R Railroad Spur to L & N · Mims St. · S. Mt. Pleasant · Oak St. · Gulf Refining Co. · Ivey St. · Sinclair Refining Co. · Hudson-Mims Gin · Bigger St. · Canning Factory · Drewry Rd. · Maple St.

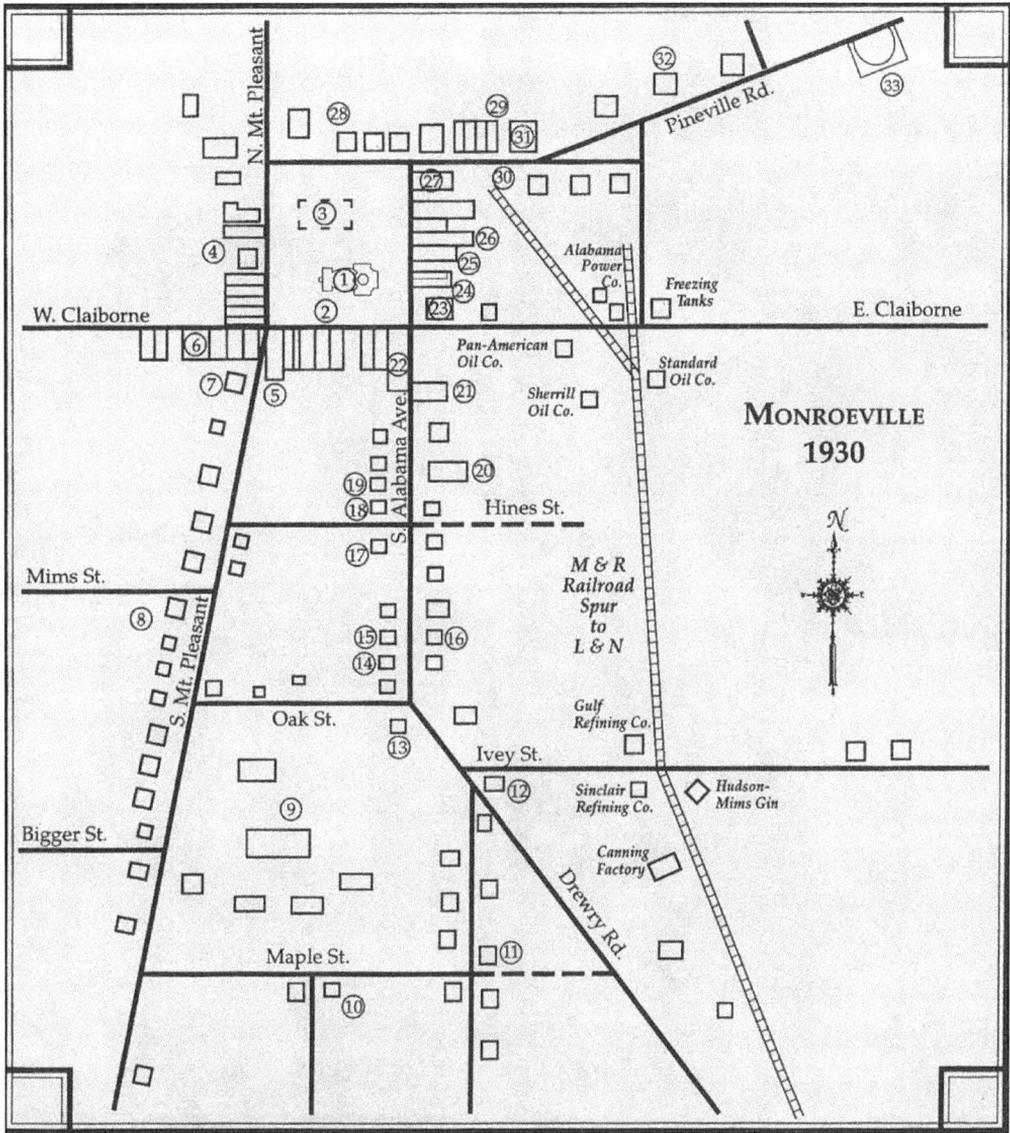

A self-guided walking tour of Monroeville takes visitors back to the 1930s. Brochures, which include this map, are available in the Old Courthouse Museum.

The Walking Tour: 1) Old Courthouse, 2) South Porch and Camellia Garden, 3) New Courthouse, 4) West Side of Square, 5) Katz Dept. Store, 6) Puckett's Bakery, 7) E.T. Millsap's Mule Barn and Feed Store, 8) South Mt. Pleasant Houses, 9) Schools, 10) Maple St., 11) Vanity Fair Mills, 12) Nu-Modern Cleaners, 13) Cannon Oil, 14) Site of Harper Lee's Childhood Home, 15) Site of the Faulk House, 16) Site of Dr. G.C. Watson's House, 17) Site of the Jones Hotel, 18) Site of the Monroeville Telephone Co., 19) B.H. Stallworth's, 20) Site of City Hotel, 21) Lee Motor Company, 22) Eugene Ward's Gas Station and Machine Shop, 23) Post Office, 24) Morgan Furniture Co., 25) William's Drug Store, 26) Barnett and Jackson Building, 27) First National Bank Building, 28) North Side of Square, 29) Site of the Monroe Theater, 30) Site of the Wee Diner, 31) The Monroe County Library, 32) Pineville Road Historic Houses, 33) Pineville/Old Baptist/Hillcrest Cemetery.

PHOTO CREDITS

Many of the photographs contained in this publication were contributed by several people and institutions. The Monroe County Heritage Museums wishes to express their gratitude for these contributions.

Alabama Bar Association
Alabama Southern Community College
Norman Barnett
Jane Ellen Cason
Joan Embree
Marilyn Handley
Nick Hare
Doug Howell
Richard Maloney
Kathy McCoy
Whitney McHugh
Monroe County Heritage Museums Collection
Monroe Journal

Suzanne Nicholas
Walter O'Neal, Eufaula Tribune Staff
 Photographer
K.T. Owens
Mitzi Ramsey
Mobile Register
Diamond Solomon
Spring Hill College
Sandra Standridge
Rhonda Turberville
University of Alabama
Dickie Williams
Clinton B. Woods

Aaron White's photos and photos from the Max McAliley collection appear on pages: 12, 15, 16, 17, 20 (top), 32 & 33, 38 & 39, 40 (top), 44, 47, 50, 52 (top), 54, 57 (top) 58, 62, 69 (top), 70 (top), 75 (top), 77, 78 (top), 84, 85 (top), 90, 92 (bottom), 102 (top), 120 (bottom). For copies of the Aaron White or Max McAliley photographs, please contact: Aaron White Photography, 211 Pineville Road, Monroeville, Alabama 36460; (334) 743-2755.

ACKNOWLEDGMENTS

This book was produced by the Monroe County Heritage Museums' staff:

Kathy McCoy, director, is originally from Louisville, Kentucky, and has a B.F.A. in art and art history, with graduate work in Anthropology. She is the director of the production of *To Kill a Mockingbird* and author of *Monroeville, Literary Capital of Alabama*.

Dawn Crook, manager of sites and collections, grew up in Nevada and is a career NCO reservist with the U.S. Navy Seabees, 20th RNCR.

Jane Ellen Cason, curator of education, grew up in Pensacola, Florida, but her "roots" are in Monroe County. She has a B.S. Degree in Secondary Education in English and math and has taught in public schools in Birmingham, Alabama, and in Monroe County for many years.

Sandra Standridge, public relations manager and graphic artist, grew up in Georgia. She has a B.A. in studio art, is a professional artist, and is the Museums' artist-in-residence.

Wayne Calloway, Rikard's Mill on-site manager and miller, grew up in Castleberry "scooping cornmeal in a steam-powered gristmill." He brings 30 years of experience in construction and machinery to the Museums.

We gratefully thank the following people for their stories, help, and support in putting this book together:

Norman Barnett
A.B. Blass Jr.
George Thomas Jones
Riley Kelley
Rivard Melson
Dr. Margaret Murphy
Walter Nicholas
Jane Hybart Rosborough
Cecil Ryland

Charles Ray Skinner
David Stallworth
Mary Tucker
Aaron White
Also, the staff at:
The Monroe Journal
The Eufaula Tribune
Aaron White Photography

Special thanks goes to English teacher Garry Burnett of Hull, England. He has taught *To Kill a Mockingbird* for many years without knowing anything about Monroeville or Harper Lee's life. After reading an article in a London newspaper, he wrote to Probate Judge O.L. Biggs in 1997.

In his letter, Garry commented, "I read recently that Abraham Lincoln, when he met Harriet

Beecher-Stowe, the author of 'Uncle Tom's Cabin,' said 'So you're the little lady that started our grand war then.'

"I suppose history will remember Nelle Lee in much the same way. She seems to have crystallised the conscience of the nation at a pivotal moment in the history of the Civil Rights Movement and provided a living dramatic context for people to identify their feelings about injustice and prejudice with. More than that I suppose, because nearly forty years on the appeal of the book, it is still alive and relevant and in communities as far away as my own."

He went on to write that he was "hoping to organise a visit to your area to produce, with a group of youngsters a video-film all about *To Kill a Mockingbird* set in the context of its community and social history. As I said in my previous letter, I would hate people to feel we were intruding or being inconsiderate and the main aims of the project would be to celebrate the success of Miss Lee's masterpiece as well as to gather material to help us understand and study the novel in England. We have been told that our project would, with the permission and co-operation of the citizens of Monroeville, be given national publicity in England and would also be distributed into nearly every secondary school in the country."

Kathy McCoy traveled to England with the Alabama Bureau of Tourism and Travel in January 1998. There she met with Garry and organized the Mockingbird Players performances in Hull in September 1998.

On May 21, 1999, Garry, his students, and his film crew arrived in Monroeville to film the documentary. Their arrival allowed them to attend a performance of the play.

We thank Garry Burnett for his enthusiasm on finding Monroeville and the Museums, and for the encouraging words about this book project. He continually repeated, "We are hungry for this information."